— Looking Back at —
ELYRIA

Looking Back at ELYRIA

A Midwest City at Midcentury

MARCI RICH

Foreword by Brooke Horvath

THE
History
PRESS

Praise for *Looking Back at Elyria*

"Do yourself a favor. Find a comfortable chair, take off your shoes, have a glass of wine or tea in a pretty cup, and read Marci Rich's stories about people when life and times were sweeter. They're a joy to read in today's hectic world. You won't stop smiling and doing your own remembering."

—Ilene Beckerman, author of *Love, Loss, and What I Wore*

"Marci Rich takes her readers on a trip down memory lane with her colorful tales of Elyria's local history. From the women who worked in [the] budding telephone industry to a child's trip to the local corner store, Rich gives her readers the sense of being there. Rich takes that step back to another time when she describes the rise and demise of the local movie theaters as well as her childhood memories of the first trip to the library. Her description of the Cascade Park and those who lovingly kept its inhabitants, the local bears, safe imparts a sense of innocence. Rich's love of her town shines throughout her writing."

—The Press Club of Cleveland,
2019 All Ohio Excellence in Journalism Awards

Published by The History Press
Charleston, SC
www.historypress.net

On the front cover: (*top*) Photo of Judy Hawkins, Elyria High School's 1956 Homecoming Queen, being chauffeured at Ely Stadium by the author's father, George Abookire. *Author's collection*; (*bottom*) See page 95.

On the back cover: (*top*) Undated postcard of Elyria, Ohio. *Author's collection*; (*bottom*) See page 207.

First published 2019

Manufactured in the United States

ISBN 9781467141888

Library of Congress Control Number: 2019947302

Portions of this work originally appeared, sometimes in different form, in the *Chronicle-Telegram*, copyright © 2017–2019 by Marci Rich. The author is grateful to Lorain County Printing & Publishing Company for permission to include those works here.

Notice: The information in this book is true and complete to the best of our knowledge. It is offered without guarantee on the part of the author or The History Press. The author and The History Press disclaim all liability in connection with the use of this book.

*For Elliott and Eva, Matthew and Jenny—that they may know
where it all began*

In memory of my parents, George and Angela—because they were there

The scene: A seacoast. Enter Viola, a Captain, and Sailors.
VIOLA: "What country, friends, is this?"
CAPTAIN: "This is Illyria, lady."
VIOLA: "And what should I do in Illyria?"

—*William Shakespeare,* Twelfth Night, *Act 1, Scene 2*

Contents

Foreword

A world ago, the now largely forgotten T. Texas Tyler had a hit with a now largely forgotten song called, ironically, "Remember Me," in which he wistfully lamented that "the sweetest days are days that used to be." *Looking Back at Elyria* is Marci Rich's loving attempt to help midcentury Elyria avoid the fate of both Tyler and his song. The 1950s and '60s are, Marci has told me, her temporal "sweet spot." They are mine, as well, so Marci prompts my own recollections—of my favorite corner stores (Sam's Cut-Rate, where I got Marvel comics, and Marsh Guenin's, my destination, later, for the *Magazine of Fantasy and Science Fiction*), ribbon candy at Christmas from the Paradise, and Cascade Park, where my girlfriend and I lazed through hot summer mornings. Like Marci, when I was small, I was often taken shopping with my mother (we had a Little Golden Book to convince me this was fun), and so I, too, remember Merthe's, where the pneumatic-tube system that delivered change and receipts proved fascinating even if the shopping did not. And so it goes. The past comes back. A lost world reappears.

Through the many interviews conducted for this collection, Marci has produced "a multi-voiced memoir" (her term), and having encouraged those she interviewed to look back, she succeeds in animating us all to do the same. If you do not live in Elyria or arrived here after much of what Marci discusses had disappeared—the telephone company and the hospital's school of nursing, Betty Bishop's dance studio, and the Cascade Park playground, with its spiral slide—you may well find yourself looking back through these

pages to the unforgotten but rarely thought-of places and people of a later Elyria or of your own hometown.

Even should you have lived as an Elyrian through the years of Marci's midcentury sweet spot, *Looking Back at Elyria* will doubtless tell you many things you didn't know. I, for instance, never knew the Black River was once called the Canesadooharie (the "stream of freshwater pearls"), and that Eries and, later, Wyandots inhabited the area before being pushed out by Europeans. Nor did I know that in the early twentieth century, Elyria was home to "the largest independent manufacturer of complete phone systems in the country." Again, although I went to school with Dave Anderson and watched (over my shoulder) his performances as Sancho Panza in *Man of La Mancha* from behind my drums in the pit orchestra, I'd no idea of his subsequent theatrical successes. Neither, I am ashamed to say, did I know the names of the eighteen Elyrians killed in Vietnam. There is, in short, much here to inform, surprise, and move the reader.

Because I don't wish to seem sentimentally soft-headed, let's acknowledge that midcentury Elyria did not constitute the sweetest of days for everyone. The reasons why hardly need detailing. Racial strife periodically rippled through Elyria High in the late '60s, and classmates ended up jailed or dead at too early an age, but except for trips to the ER for stitches, lost girlfriends, and the threat of getting drafted that eventually settled over me

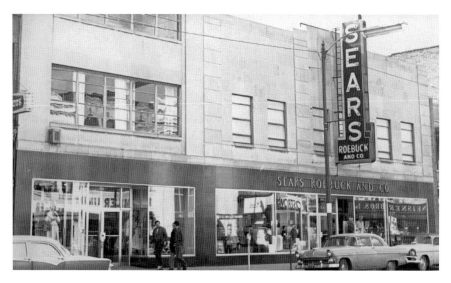

Sears, Roebuck and Company, 328 Broad Street, circa 1960. *Courtesy of the Lorain County Historical Society.*

like an olive-drab cloud, mine were halcyon days. Many of you reading this book will recall worse and more numerous bad times. *Looking Back at Elyria* acknowledges as much, particularly in its chapter on Vietnam, but elects to primarily remember what once brought us together.

"Where have we come from?" and "Who are we?" are two of the abiding questions, and thinking about the former helps answer the latter. Unless you are lucky and know that you are presently living through the days and years of your temporal sweet spot, yours is a gone world—but it is still the world from which you came. In the world of Elyria at midcentury, there were caged bears in Cascade Park, milkmen who delivered right to your door, and a thriving downtown. A ride on Merthe's elevator (run by an actual elevator operator) was a treat, and a Nehi cost twelve cents at your closest corner store (or ten cents if you drank it there and gave the bottle right back). I am glad to be reminded.

In a note to me, Marci writes that she hopes her book will help us "get to know a place we thought was so familiar we didn't even think about it." As I hope I have made clear, she has done this for me, and she will do it for you.

—Brooke Horvath
Emeritus professor of English at Kent State University
Elyria High School, class of 1971

Acknowledgements

There would not be a book without Julie Wallace, my editor at the *Chronicle-Telegram*, who asked: "Would you contribute some articles to our Elyria bicentennial supplement?" This question led me down a rabbit hole so fascinating that I didn't want to leave; I proposed a feature-length series of articles called "Look Back, Elyria," to which she said yes. Thank you, Julie. I'm grateful to the Lorain County Printing and Publishing Company and to Andy Young, editor emeritus of the *Chronicle*, for permission to include edited versions of my *Chronicle* writing in this book. I'm also indebted to the *Chronicle* for maintaining such a robust digital archive of articles. I stand on the shoulders of many local history *Chronicle* writers from days gone by, especially Connie Davis and Norma Conaway. Bruce Bishop, Brad Dicken, Vince Guerrieri, and Kymberli Hagelberg have also earned my thanks.

Every writer digging through the past should have access to an organization as richly stocked as the Lorain County Historical Society. My deepest gratitude to Kerri King Broome, Bill Bird, Eric Greenly, and Donna McGuire for never tiring of my research questions and photo requests. I'm thankful to Jeff Sigsworth for reading an early version of this manuscript; he made sure my Elyria facts were on spot-on. Any mistakes in this book are my own.

Endless appreciation to those who shared either their stories or their priceless photographs with me, especially Norma Abookire, D.C. (Dave) Anderson, Paulette Tomasheski Baglyos, Bob Bailie, Agnes Baldwin, Mindy

Beller, Harry Berg, Sharlet Jacoby Berman, Kathy Boylan, Connie Conry Brent, Rick Camp, Karen Donovan Cohagan, Carol Gerber Czarnecki, Marilyn Firment Detmer, John Dixon Jr., Mary Wirscham Encinias, Dianne Maddock Fenbers, Mike Fenik, Barbara Kasper Folds, Ken Frankel, James V. Gallagher, Richard "Dick" Gibbons, Jack Golski, Carol Edwards Greentree, Richard Hales, Phyllis Wasserman Harvey, Nancy Dunkle Horvath, Susan Murbach Hunt, Loryn Wasserman Hutchins, Marlene DeLaVars Jacobs, Susan Guastella Jordan, Patricia Keefer, Katie Keys, Alice Klinect, Judy Wasserman Kuperman, Kim McCray LeMaster, Alan Lichtscien, Conni (Mateer) Little, Bradley Loomis, Rose Standifer Lucas, Ben Mancine, Harriet Lichtscien Margolis, Mary E. Jones Mauldin, Patty Machock McBain, Lila McGinnis, Richard McGinnis, Jennifer Toth Moneagle, Sandee Brown Murphy, Robert Muller, Ron Nagy, Mary Ann Novak, Nancy Glover Oates, Sharon Clark Pierce, Colleen Moore Pollack, Joe Pronesti, Lilly Rosa, Michele Ross, Marie Wagner Russert, Michael Schilke, Gary Siwierka, Jim Smith, Richard "Smitty" Smith, Jerry Spike, Sally Staruch, Barbara Yarish Stydnicki, Gary Merthe Taylor, Kim Tonry, Sharron Vanek, Joan Larkin Villarreal, Bill Wagner, Madeline Whited, Crissy Wilczak, Cindy Mason Young, Joyce Pope Zickefoose, and Fran Gerdine Zimmerman.

Others helped in other ways. My thanks to Jessica Beaty; Ilene Beckerman; Jennifer Bracken; Holly Brinda; Liz Clerkin; Lyn Crouse; Jonathan Eaker; Judy Firment; Judith J. Friedman; Lakesha Gage; Tony Gallo; Larry Gaskalla; Joe Gaughan; Lynn Goodsell; Jami Mateer Gwin; Linda Hamann Hadfield; Mark Holbrook; Gene Horvath; Kim Jones-Beal; Bill Kaatz; Dave Kaszubinski; Terry Kayden; Mark King; Vanessa Klesta; John Kosto; Brian Kurtas; Kristen Kutina; Al Leiby; Ingrid Lucas; Marcus Madison; Adam Matthews; Kate Modock; Tom Moore; Scott L. Morris; Gail Brown Murphy; Douglas Nelisse; Charlotte Norris; Jeff O'Donnell; Karyn O'Toole; Mark Price; Jerry Rosen; Ken Schaefer; Thomas Schatz; Ann Schloss; Thomas Fairchild Sherman; Kristi Sink; Kathy Allan Smith; Peggy Nedwick Springer; Kelsie Stites; Rick Stoffer; Joe Vondruska; Sandy Strawderman Walczak; Nancy Peck Wemer; Sister Mary Elizabeth Wood, SND; Mary Wright; Joyce L. Young; and James Ziemnik. For their enthusiasm for our hometown, special thanks to the members of the Facebook groups "Vintage Elyria" and "Connect Elyria."

Brooke Horvath, thank you for your love of Elyria and for your lovely writing.

For lifelong friendship and steadfast support, my thanks to Mary Pronesti Siwierka. For new friendships in publishing, thank you to Liz Carey and Kathryn Smith. I'm indebted to everyone at The History Press, especially my editors, John Rodrigue and Sara Miller, whom I thank for their intelligence, good humor, and patience.

My first full-length book seems like an apt time to thank and acknowledge these professors and teachers: Bruce Weigl, Stuart Friebert, David Walker, David Young, and Dani Shapiro. They have taught me about writing and language, craft and style, in ways too numerous to list here. Their words have often echoed in my head while I worked on this book. I tell you, that has been a comfort.

To all of the Raucous Women Still Writing from Provincetown: Never stop believing in your words. Thank you for believing in mine.

My husband, John Rich, earns my deepest thanks and abiding love. He has championed this project from the start. Through his unfailing generosity of spirit, he made it possible for me to find the time to write.

Finally, to Elyrians long gone: my grandparents, Anthony and Marie Abookire, and my parents, George and Angela Abookire—thank you for settling in Elyria. And Dad, thank you for collecting so many pictures of the city you loved with all of your great big heart. My memories of you have infused this project. Your influence rests on every page.

Introduction

I'm an accidental historian.

I stumbled into this project two years ago, writing articles for the *Chronicle-Telegram* on the occasion of Elyria's bicentennial. My hometown, in case you didn't know, was founded by Heman (no *r* in his name) Ely in 1817. I always assumed that it was more than a touch of ego contributing to the city's appellation, and I wasn't wrong. One of the myriad things I learned researching my articles was that Ely, a Massachusetts native, was an intrepid traveler. Not only did he pioneer his way across the Connecticut Western Reserve, becoming so enamored of what he saw that he staked his claim at the fork of the Black River, but he had also toured Europe.

Local historian Jeff Sigsworth informed me that Ely's transatlantic sojourn included time in the Balkans, specifically, the Illyrian provinces. Ely created the city's name by combining his surname with the locale he so admired. (I like to think he was also inspired by Shakespeare.)

Unlike Heman Ely, my ancestral pioneers made no prairie crossing; their divide was water. My grandparents emigrated from Lebanon and found their way to Elyria in the early part of the twentieth century. Elyria is where my father was born in 1920. And Elyria is where I entered the picture in 1956.

My childhood ran on parallel tracks with the city's golden age, the 1950s and 1960s, when midsize industrial cities in the Midwest (called "legacy cities" in today's vernacular) were boomtowns—beneficiaries of the postwar era's growth, prosperity, and optimism.

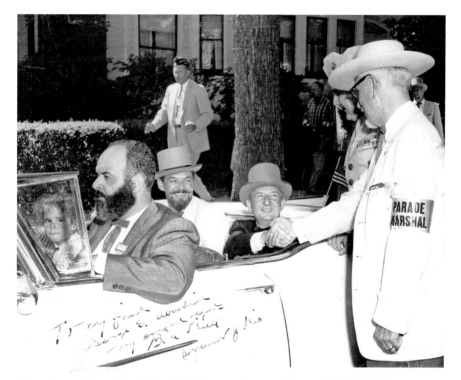

The author and her father during Elyria's quasquicentennial parade in 1958. Mayor J. Grant Keys is seated at rear left, and Governor C. William O'Neill is at right. *Author's collection.*

Perhaps this is why the Elyria of my youth was easy to love. Or perhaps it was simply because I was a child, and when you're a child, everything around you is fascinating, and the grown-up world of commerce, of intellectual and artistic endeavor, looks mysterious and lustrous.

Perhaps it is simply a case of the past improving with distance, as Dan Barry writes. He was thinking about Elyria when he wrote that for the *New York Times*. Or, as L.P. Hartley famously wrote (although not about Elyria), "the past is a foreign country: they do things differently there."

If you have read the play *Our Town* by Thornton Wilder (who, incidentally, attended nearby Oberlin College), you'll remember that he provided the coordinates for the fictional town of Grover's Corners. If he had been writing about Elyria, he would have told you this: latitude 41 degrees, 22 minutes; longitude 82 degrees, 6 minutes.

Like an expatriate, I had to leave those coordinates to truly appreciate my town. With the exception of nearly three years in Richmond, Virginia, I

didn't travel far: I lived in Oberlin because, in my previous career, I worked for Oberlin College. When I began writing this book, I lived in Rocky River, a Cleveland suburb. When the book was nearly finished, I moved to Avon, in Lorain County. I've traveled the roads to Elyria often these past two years, researching and interviewing for the articles that became this book.

It is only with the passage of time and the unfurled blanket of geography that I've really come to know Elyria, and I'm reminded of these lines from T.S. Eliot's *Four Quartets*:

> *We shall not cease from exploration*
> *And the end of all our exploring*
> *Will be to arrive where we started*
> *And know the place for the first time.*

This was an important lesson for me to learn.

After peaking economically and socially in the mid-1960s, Elyria began losing its vibrant luster in the 1970s. The storefronts had a down-at-the-heel look. The city's best days were behind it. It's probably only a coincidence that it was in 1966, with the gleam and sprawl of the new Midway Mall (today, a pale shadow of what it once was), that downtown Elyria began its inexorable downward slide. That was the year, writes English music journalist Jon Savage, that "began in pop and ended with rock." It was a year of rapid change and development in the various liberation movements, which were welcome and necessary, but it was also the year that the war in Vietnam escalated.

Nine years later, something happened in Elyria that foreshadowed the racial strife that would grip other U.S. cities in the twenty-first century. In the heat of August 1975, a white policeman shot a young black man, who had been seen climbing out the window of a tavern, in the back of the head. Rioting—complete with firebombs and smashed windows—gripped the southwest side of town. I was barely nineteen, and my mother, fearing for my safety, had a friend drive me to my aunt's home in Lorain. (I still marvel at the fact that my mother, a widow, remained behind alone.)

I tell you all of this because I want you to understand that I am not looking back with rose-colored glasses at an Elyria preserved in amber. Times change, people change, places change. Change is an immutable fact of life. When I walk through downtown Elyria today, I am aware of what I see: a gym where Merthe's used to be. A cell phone store in the old Loomis Camera and, next to that, in the Robinson Building, a vape shop. An assortment of

empty buildings—and parking lots where buildings used to be—punctuate the streetscape. But because of what I remember, I am able to look beyond the city's present façade and glean, in the cracks and crevices, the ghosts of what once stood there.

But this is a key point—it is because of what I remember.

One benefit of nostalgia, or of remembering, is that there is something to be gained by looking back, and perhaps that something is finding a new way forward. Elyria has found its way forward more than once. In 1994, the doors opened at a beautiful new branch of the Elyria Public Library on West River Road. That's optimism. You know that a city hasn't given up when one library isn't enough to contain the dreams of its readers.

On the morning I began writing this introduction, I read that Ridge Tool is expanding. This is in addition to other good news that has emerged from the town in the past few years: construction of new state-of-the-art school buildings; a new central branch of the Elyria Public Library, to be built on Broad Street (where the library's original patron, Charles Arthur Ely, wanted it to be all along); improvements to infrastructure; and a thriving downtown arts district.

There is another point I want to make about nostalgia. It is no accident that I began writing about Elyria in my fifties and sixties. There's far more to look back upon now than there is to look forward to, and this contributes to a sense of urgency I feel in getting as many of these stories recorded as I can.

The oldest Elyrian I interviewed was ninety-nine years old. As I write this, she is still alive, but will she live long enough to see this book in print? Those who remember Elyria in the 1950s and 1960s are leaving us at an alarming rate. Such is the nature of life's cycle, of course. But once these people are gone, who will be around to explain what a special place Elyria once was?

Who will be around to remember the things that I remember?

What I've learned by writing about the long-lost world of Elyria is that what I've really been doing is trying to find my way home. I had to move away to learn how deeply Elyria is bred in my bones and how much I love it still.

Writing this book has helped me to know Elyria better than I ever did when I lived there. And in that sense, I am home.

Part 1
LEARNING

To Be a Nurse:
The M.B. Johnson School of Nursing

If you were born in Elyria, there's an excellent chance you entered the world at Elyria Memorial Hospital (EMH). That's where I made my debut, weighing seven pounds and two ounces, at 8:00 a.m. on Tuesday, May 15, 1956. Dr. Overs was my mother's physician. My mother's room number was 358. I know this level of detail because my mother saved everything; I found my birth card and the information folder given to her upon her admittance to the hospital in an attic trunk. How she knew that I would one day write about Elyria's past is a mystery.

Chances are also excellent that the nurses taking care of you and your mother were educated at the M.B. Johnson School of Nursing (MBJ), a three-year diploma program affiliated with the hospital. Although modern architecture has changed the grand streetscape of the campus, the memories of the school's graduates are as strong as the classical columns that once graced the portals through which they passed.

BEGINNINGS

Forty-nine years before I was born, on Memorial Day in 1907, two streetcars collided on Middle Avenue. The devastating accident killed nine and injured scores more, some of whom lost limbs. Eighteen-year-old Homer Allen had just graduated from Elyria High School the previous day; he was among

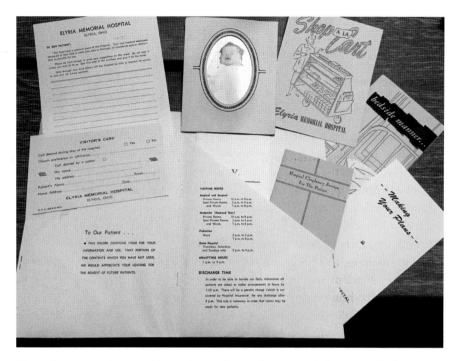

The author as a newborn and items given to her mother upon admittance to Elyria Memorial Hospital in 1956. *Author's collection.*

those killed. Two days before the tragedy, Homer's father, wealthy utility industrialist Edgar F. "Daddy" Allen, had sat in a committee meeting to discuss Elyria's need for a hospital. The lack of critical care contributed to Homer's death and that of others, including the son of Reverend John P. Sala, who was also on the committee. Heartbroken, the two civic leaders channeled their grief into establishing Elyria Memorial Hospital. Eighteen months after the tragedy, on October 30, 1908, EMH opened in a stately white-columned brick building at the corner of East Broad and East River Streets. The School of Nursing of Elyria Memorial Hospital, which opened the same day, was renamed in 1935 when the sons of prominent attorney Melvin B. Johnson made a gift in his memory.

Today, if you walk past the gift shop of what is now University Hospitals Elyria Medical Center, you can glimpse this bygone era. The corridor called M.B. Johnson Hall, dedicated in 2008 to coincide with the hospital's 100th anniversary, contains a permanent exhibit of artifacts. On display are photographs of the first two nursing school graduates, Martina Minnich and Ruth Celia Cowen, who earned their diplomas on August 25, 1911.

TO BE A NURSE

"I have always wanted to be a nurse and I should like very much to go into training in the new hospital," Martina told Dr. C.H. Cushing on the day the hospital opened. A 1933 *Chronicle* article marking EMH's twenty-fifth anniversary reported that Dr. Cushing was so convinced of her seriousness that he arranged for her to immediately enter the hospital as a student nurse.

Martina was placed in charge of the operating room and later became a supervisor. Given the choice to do it over again, however, she would not have become a nurse in her hometown. Years later, she told a *Chronicle* reporter, "One never knows whether accident victims who are brought in are going to be friends or relatives, and that puts in an element of anxiety with every case which is anything but pleasant."

At its opening, EMH's entire nursing staff consisted of the student nurses, the superintendent and her assistant, and three supervisors, all of whom worked twelve-hour shifts.

In 1915, thanks to the fundraising efforts of "Daddy" Allen, the Gates Hospital for Crippled Children opened its doors. Four years later, he raised funds from the Ohio legislature and from Rotary organizations nationwide to create the Ohio Society for Crippled Children; it became a national and then an international society, with Elyria as its headquarters, and in 1934, its fundraising apparatus became known as the Easter Seals Society.

By 1953, a wing had been added to the west side of EMH. Nine years later, with the opening of the Smythe Building, the hospital had room for 335 beds. An intensive care unit was added in 1965. When my father suffered a heart attack in June 1969, he was admitted to the ICU. We had just celebrated my thirteenth birthday the previous month. It might have been an MBJ graduate who quietly and kindly insisted that no, I was fourteen, thus allowing me to visit my father in the age-restricted ward. Less than two weeks after his heart attack, with his kidneys failing, an ambulance was transporting him to Mount Sinai Hospital in Cleveland. He died en route.

In 1962, Rose Standifer Lucas, now living in Detroit, became the first African American to graduate from MBJ. She had matriculated from Elyria Catholic High School, where she ranked in the upper third of her class. She had known what she wanted to be when she grew up ever since a public health nurse visited her Cleveland neighborhood when she was a child. "It fascinated me," she said in a phone interview. "If we had to go to a hospital or something, I always wanted to wander around and explore."

The 1962 MBJ yearbook listed the hometowns of young women who "wanted to be a nurse"; they traveled to Elyria from Ashtabula, Berea, Cleveland, Euclid, Homerville, Mayfield Village, and Seven Hills, drawn by the school's reputation.

ACADEMIC RIGOR

M.B. Johnson's requirements were famously exacting. Applicants took a pre-admission test and had to supply three letters of reference, and not everyone matriculating finished the program. Instructors were crisply professional, addressing students by their last names. There was no summer vacation—just two brief August weeks between one school year's end and another's beginning. "That's how we managed to do four years' work in three," said Joyce Pope Zickefoose of Lorain.

Karen Donovan Cohagan graduated from Elyria Catholic High School in 1959 with Rose Standifer Lucas and joined her at MBJ. Karen won a scholarship from a fund started by Harry Zahars, owner of the Paradise Restaurant; without it, she could not have afforded to pay the $750 necessary to attend the school. During her tenure (1959 to 1962), this included tuition, room and board, books, uniform, and transportation on the MBJ bus to and from Oberlin College for first-year science courses. At various points in the school's history, students traveled to either Oberlin, Lorain County Community College, Ashland University, or the old Kent State University extension at Elyria High School for their science courses. "The administration was trying to get the best education for us," Karen explained.

"You think [going to school at MBJ] is the hardest thing you'll ever do, and it probably was at that young time of our life," said Sharon Clark Pierce of Elyria. She graduated in 1969. "I didn't realize until after I got out of school how well prepared I was. At MBJ, if you got a 'C,' they were counseling you: 'You've got to get the grades up. You've got people's lives in your hands.'"

MBJ supported its students in the midst of this academic rigor by assigning each a mentor in the form of a "big sister," an older girl who had already completed a year of study. "When we first arrived at the dorm," Joyce wrote in an email, the big sisters "were on the front steps to greet us and show us around."

Standards of Excellence

MBJ, accredited by the National League for Nursing, consistently ranked among the top nursing schools in Ohio for state board results, a distinction referenced by several people I interviewed. Students "didn't even think about missing class, or having someone take notes" for them, said Rose. She passed her board exams in Columbus on the first try. "When that piece of paper came, it said, 'Rose Marie Standifer, R.N.'"

Kathy Boylan of Elyria first taught at the school in 1961–62, left to start a family, then returned in the late 1960s, remaining until Mayor Michael Keys asked her to lead the city's health department in 1985. She remembers the accrediting visits. "We were equal to any nursing school," she said. "One year we [ranked] at the top in state board scores in Ohio."

Harry Berg of Medina County graduated with MBJ's final class, in 1987, and remembers it as "tough. [You] had to maintain a 3.0 GPA or you were cut from the program."

Susan Guastella Jordan of Elyria, class of 1978, said that the school's high standards inspired a student "to be a person of excellence." To illustrate her point, she said that she almost flunked bed-making. She recalled her supervisor's admonishment: "I advise you to go back and work on your bed corners, because they just aren't up to par."

Hands-On Instruction

Students were learning how to become nurses in the best labs imaginable— Elyria Memorial Hospital and the Gates Hospital for Crippled Children, where classes were taught. "We gained hands-on experience in orthopedic and pediatric nursing at Gates," said Karen Donovan Cohagan.

The clinical program was excellent and thorough, said Susan Guastella Jordan: "When we got to our third year of nursing, they had us looking at every disease at the cellular level."

Harry Berg remembered working eight-hour days on the wards for four days a week by senior year. "At night, you [did] care plans, disease and patient treatment evaluations, drug cards for the medications that the patient was on. If you were not able to answer your instructor's questions about your patient's treatment, you would be sent to the library to find the answer to their satisfaction."

Communication skills were critical to an MBJ education, said Kathy Boylan. "You walk into a room and you say, 'Hi. I'm a student nurse. How are you today? Tell me what's going on with you?' Techniques will always change through the years, but communication is basic. You've got to be able to talk to people and listen with your eyes and ears."

Karen Donovan Cohagan noted three important things she learned at MBJ:

> *1. Have empathy for your patient and for everyone in your patient's family.*
> *2. If you don't use your brain, you're going to use your feet; think ahead of time of everything you'll need. Be organized.*
> *3. And, from teacher Janet Schroeder: "Stand tall, be proud of yourself, and hold your head up high."*

Dressing the Part

"Standing tall" came naturally in those blue uniforms and starched white pinafores that closed in the back. "We were not allowed to sit on the apron," said Joyce Pope Zickefoose, "so we had to fold the back-flaps on our laps to sit." Each student was issued a gray wool cape with her name stitched into the scarlet lining and "MBJ" embroidered on the collar.

The capping ceremony, which took place at the end of the first year, was an important rite of passage. One black stripe on a white cap signified a student's first-year status. After their second year, they received their second stripe. The third was bestowed at the start of their final year. After graduation, the stripes were removed. During the capping ceremony, students were given porcelain "Nightingale" lamps, invoking the legendary nineteenth-century British nurse Florence Nightingale. While the small candles were lit, the class recited, in unison, the nurses' national code of ethics—the "Nightingale Pledge":

> *I solemnly pledge myself before God and in the presence of this assembly, to pass my life in purity and to practice my profession faithfully. I will abstain from whatever is deleterious and mischievous, and will not take or knowingly administer any harmful drug. I will do all in my power to maintain and elevate the standards of my profession and will hold in confidence all matters committed to my keeping and all family affairs*

Two nursing students outside M.B. Johnson Hall, circa 1960. This frontispiece of the 1961 MBJ yearbook is from the collection of Karen Donovan Cohagan. *Author's collection.*

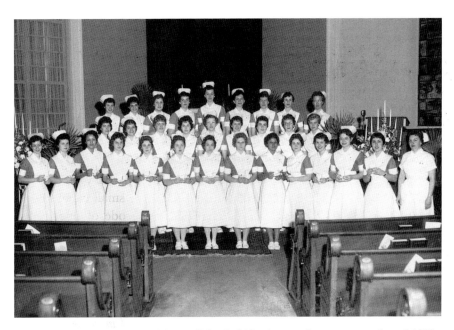

Group portrait from the M.B. Johnson School of Nursing capping ceremony, class of 1962. Karen Donovan is second from right in the third row, and Rose Standifer is sixth from right in the first row. *Courtesy of Karen Donovan Cohagan.*

coming to my knowledge in the practice of my profession. With loyalty will I endeavor to aid the physician in his work and devote myself to the welfare of those committed to my care.

Instructor Kathy Boylan recalled that students stopped wearing caps during their daily rounds sometime in the 1980s, when "equipment got so complicated and caps got in the way." Eventually, pantsuits replaced the white dresses. "Bulky clothes just got in the way," she said.

As early as 1967, though, one student wore neither cape nor cap, as MBJ had admitted Linton Sharpnack, the school's first male student. Understandably, it was necessary to make some adjustments to the capping ceremony. According to a *Chronicle* article from the era, Margaret Krapp, director of nursing, said that the young man would not have to wear the iconic grey wool cape, and the matter of the cap was resolved by having the black stripes appear on the upper sleeve of his uniform. His presence does invite the question: With the female student nurses living at M.B. Johnson Hall, where, pray tell, did the administration put Mr. Sharpnack? The solution was simple. He was allowed to live at home with his parents on Princeton Avenue.

Campus Life

The young women living at M.B. Johnson Hall in the 1950s and 1960s did so under the watchful eye of housemother Monica Durkin. Rose Standifer Lucas called her "a gem." A yearbook photograph of her includes this tribute: "The welfare and happiness of her 'girls' have always been her first concern, and her wise and sincere counseling has been of great assistance to each of us....She is a friend to all students. We...shall always be grateful to her."

The house rules were intractable. It almost goes without saying that male visitors were not permitted upstairs; their presence was restricted to the parlor or to "dating rooms," small areas on the main floor where a girl could host her beau. And there was a curfew. "[For] freshmen, it was lights out at eleven p.m.," said Karen Donovan Cohagan. "After that, Miss Durkin would check all the rooms. She was strict. Looking back, I can see where she had to be."

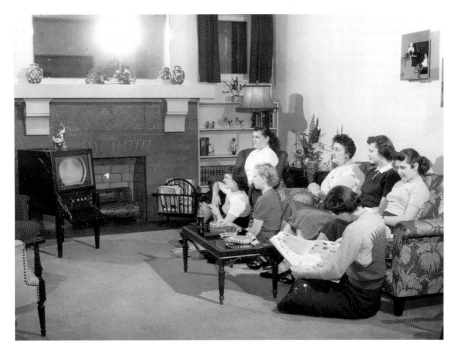

MBJ residence director Monica Durkin (*on sofa at far left*), circa 1959. *Courtesy of University Hospitals Elyria Medical Center.*

Only one phone was available on each dorm floor, and only for incoming calls. A pay phone on the main floor, located across from the housemother's office near the mailboxes, was for outgoing calls. Joyce Pope Zickefoose remembers girls waiting for mail from boyfriends in Vietnam, "and the excitement for all of us when they got a letter!"

Even with Durkin's eagle-eye, there were fun and games to be had and "a lot of camaraderie," said Rose. The nurses even played competitive basketball, traveling to Cleveland for matches against other schools of nursing. There were committees for planning the Christmas formal and Halloween parties, upholding the school constitution, dealing with infractions, managing the house, and editing the yearbook. There was even a choir with weekly rehearsals and performances at hospital and public functions and participation in an annual choir festival sponsored by the Student Nurse Organization of Greater Cleveland.

In 1969, the all-inclusive cost to attend MBJ for three years was $2,100.

THE END OF AN ERA

By the 1980s, the winds of change were stirring. Hospital-affiliated nursing schools, including those at Akron General Hospital and Cleveland's St. Alexis, were shuttering. On December 6, 1985, Donald R. Taylor, administrator of EMH, sent the alumni a letter announcing that the hospital's board of trustees had decided to permanently close the M.B. Johnson School of Nursing in 1987. That year's commencement ceremony would be the last in the school's remarkable seventy-nine-year history.

He acknowledged the school's reputation as one of the finest in Ohio but explained that escalating costs, changing reimbursement patterns, increasing hospital subsidies, and new trends in nursing education—specifically, the bachelor of science in nursing degree—necessitated the decision to close. In a *Chronicle-Telegram* article, Taylor called the board's decision "probably one of the most difficult they've ever had to make."

Although Harry Berg thought it was sad that his would be the last class, he felt "a huge sense of relief" that the group would be able to complete their three years at the school. When the Gates Building was torn down in 1987, he salvaged part of one of the two columns that had flanked the front doors, cleaned it up, and had all the students sign it. He and his classmates presented the keepsake to Dr. Ann T. Muller, director of the nursing school, "as a thank you for her leadership." Berg regrets the demise of hospital-based diploma programs.

Sharon Clark Pierce served as president of the MBJ Alumni Association for some forty years. "The nursing school was such a boon to the whole county and so well-respected," she said. "People would say to me, 'You went through a hospital program, didn't you? I could tell, because you fluffed my pillow.'"

Although Marie Wagner Russert was not surprised to learn that the school would close, she was disappointed. "I knew it was going to happen because the American Nurses Association was redirecting the type of education nurses should receive...either a bachelor's or associate's degree," she said. But she maintains that "three-year nursing diploma programs [were] the best. All of our work was hands-on; that's where our experience came from."

THE LEGACY TODAY

By 1983, no one was living at M.B. Johnson Hall, which had been home to more than one thousand young women over the years; it was demolished that spring. If you look at the image on the back cover of this book, you can see the Gates Hospital for Crippled Children pictured in the "R." By April 1987, Gates Hospital was gone. Barely visible from that old health-care constellation is its sun—Elyria Memorial Hospital, borne of tragedy in 1908, with distinctive white columns similar to those of its satellites, MBJ and Gates. "If one looks closely at the hospital today," wrote Benjamin J. and Anne Fischer Mancine in *Elyria in Vintage Postcards*, "it is possible to discern the shape of this old building among the many additions."

The legacy of the M.B. Johnson School of Nursing rests with its 1,304 graduates, some of whom went into teaching. Sharon Clark Pierce and Marie Wagner Russert taught in the nursing program at Lorain County Community College for decades. Countless patients at Elyria Memorial Hospital—and hospitals and clinics across the country—benefitted from the school's high standards, academic rigor, and the dedication of its practitioners to, in the words of the Nightingale Pledge, "the welfare of those committed to [our] care."

OLDEST LIVING MBJ GRADUATE TELLS ALL

Born in 1918, Alice Klinect was one week shy of her ninety-ninth birthday when I interviewed her. Asked about the secret to such a long life, she didn't miss a beat: "I lived so long because I didn't have a husband or kids."

We spoke in the house her father built in 1929, where she grew up and lived most of her life. Alice once dreamed of becoming an engineer. "I wanted to build bridges," she told me. But when she graduated from Elyria High School in 1937, career options were limited for women; one could be a homemaker, teacher, secretary, or nurse, and nursing school was the only postsecondary education that her father, who never went to school beyond the eighth grade, could afford. When Alice was admitted to the M.B. Johnson School of Nursing, tuition for the three-year diploma program was $300. This included room and board in M.B. Johnson Hall, books, and uniforms.

What Alice lacked by not having a family of her own she made up for with a rich and rewarding career. After earning her nursing diploma in

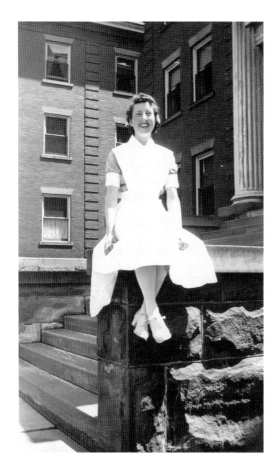

Alice Klinect outside M.B. Johnson Hall, circa 1938. A 1940 graduate of MBJ, Klinect taught there and worked at the hospital for decades. *Courtesy of Alice Klinect.*

1940, she did postgraduate work in surgical technique at the University of Pennsylvania, then joined the staff of Elyria Memorial Hospital, where she worked as a supervisor and an instructor in surgery. Her starting salary was fifty-five dollars per month, with five-dollar incremental increases upon taking and passing the state nursing board examination.

Alice's duties at EMH included supervising students at the nursing school and teaching them surgical techniques; she also served as a class advisor.

One of her many protégés over the years became a lifelong friend. Upon graduating from MBJ in 1953, Marie Wagner Russert did postgraduate work in surgery at New York Polyclinic Medical School and Hospital. She worked at EMH for eleven years; as head surgical nurse, she reported to Alice Klinect and was a clinical instructor at the hospital. Marie eventually developed a surgical technology program at Lorain County Community

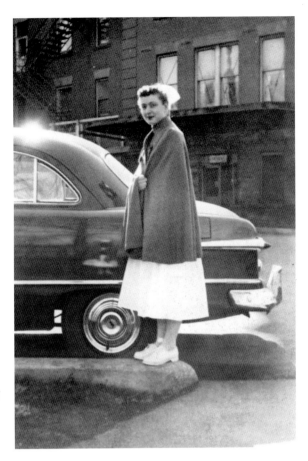

Student nurse Marie Wagner, circa 1950, wearing the gray wool nurse's cape issued to students with their uniforms. *Courtesy of Marie E. Russert.*

College as part of an associate's degree curriculum; she taught there for forty-two years.

In a joint interview at Alice's home, Marie spoke about her former mentor's generosity: "She was never reluctant to share her skills and knowledge. She was always available. She was one of the fairest people I've ever worked with, a complete professional."

By the time Alice retired from EMH in 1984 after forty-four years of service, she was assistant director of special services. Her broad range of responsibilities included the operating and recovery rooms (she was director of the OR for twenty-five years), the intensive care and cardiac care units, outpatient services, hemodialysis (at the request of Director of Nursing Margaret Krapp, Alice set up the hospital's first kidney dialysis unit), central supply (command central for all equipment preparation), and staff development. She published articles in professional journals and

was an active member of several associations and boards, including the Ohio Nurses and the American Nurses Associations, the Cleveland Area League for Nursing, and the Greater Cleveland Hospital Association. Her various awards include one from the Cleveland Area League of Nursing for outstanding contributions to in-service education.

These are stellar accomplishments for a young student to whom a supervisor once said, "You will never amount to anything."

By her own account, Alice was a lively, high-spirited, and slightly mischievous student who was, she said, often in "the doghouse." Some of the infractions that put her there included body-sledding on the hill of the school grounds, coming in after the 10:00 p.m. curfew, and roller-skating in front of the hospital.

"Nurses," she was told, "don't roller-skate."

2
Turning the Pages:
The Elyria Public Library

In the early 1960s, when I was a child just learning to read, the Elyria Public Library seemed like a church to me. It was in an old mansion on Third Street next door to an actual church—the one where the Methodists prayed. I walked down stone steps sparkling with mica to a hushed, magical place with a fragrance—not of church incense but of old books. It was known as the Children's Room. More officially, it was the Longfellow Room. I knew it simply as the library.

I remember standing at a low counter with my chosen books in front of me. One favorite was about a little girl named Rosa who reminded me of me; she had long, dark hair (hers in braids, mine in a ponytail) and a last name, Maldonado, that, like mine (Abookire), was difficult for people to pronounce and spell. An important plot point was relatable to any six-year-old: Rosa was getting her first library card.

Now, as an adult, I enter the keywords "Rosa Maldonado children's book" into Google and fall down the rabbit hole: There it is, *Rosa-Too-Little*, by Sue Felt, published in 1950. I locate it through an online used bookseller. When it arrives, I hold it in my hands, look through the pages, and feel time rush backward.

There is Rosa, sitting on a porch step, her chin in her hands, sad that no one is around to take her to the library. (As an only child with a mother who didn't drive, I knew that feeling, too.) And there is the page where Rosa printed her name, in pen, on the library card.

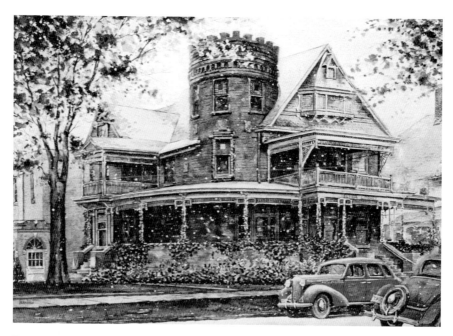

Dr. Karl Reefy's mansion, depicted in a Carl J. Mandoke painting, housed the Elyria Public Library from 1929 until 1967. *Courtesy of Mary Ann Novak.*

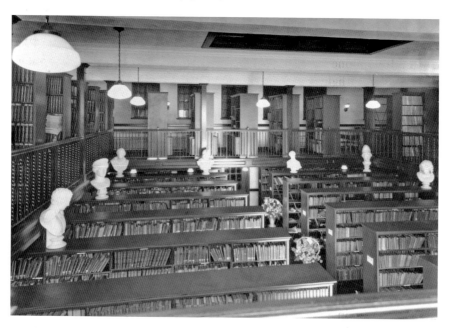

Busts of literary figures watch over the stacks in the Elyria Public Library, circa 1929. *Courtesy of the Elyria Public Library.*

I might have, on rare occasions, gone with an older cousin to the main part of the library, with its spacious, wood-paneled rooms, but I don't remember. This absence of memory fills me with longing and regret, especially when I look at old photographs of what was once the Reefy mansion. But the people I interviewed do remember them. Those beautiful, antique rooms were important touchstones of their youth.

"The Light of Another World"

Robert Muller grew up on Ohio Street. He and his brother James were frequent library visitors; in fact, both of them were photographed and identified as "Robbie" and "Jimmy" in a 1965 *Chronicle-Telegram* article about story hour in the children's room featuring the Library Lady. Robert shared his memory of entering the Children's Room with me on Facebook Messenger: "I remember the old stone steps," he wrote, adding that he really loved the feeling of entering the library. "I have frequently thought about the space, maybe because I was young but it felt like you were walking down through a dark tunnel and coming through into the light of another world."

Barbara Yarish Stydnicki, now living in Grafton, routinely walked up and down those stone steps. She was the Library Lady featured in the 1965 article. In a phone interview, she described the steps as seeming to contain "little flashes of light."

Barbara incorporated music and puppet theater in her story hours. "When I started, we had six kids," she said. "I worked on [the program] and got it up to about a hundred kids in various story hours per week." Two of the story hours were on Saturdays, with about twenty-five preschoolers and first, second, and third graders in each group.

She also prepared the displays in the Longfellow Room and decorated it at Christmas. "We had a live Christmas tree, and the janitor put it up for me. We got ready to decorate it, and they said, 'We cannot put lights on it because of the fire code.' I got an idea. I made red satin ribbons and covered the tree with bows and ornaments and set it under the ceiling lights so it would be illuminated from the top. It sat right in the middle of the room."

Barbara began working at the library in 1957. She helped with the library's move, in 1967, to its new location on Washington Avenue, but by 1970, she had decided to leave. She took a job in the display department at Sears at the Midway Mall, where she remained for thirty years.

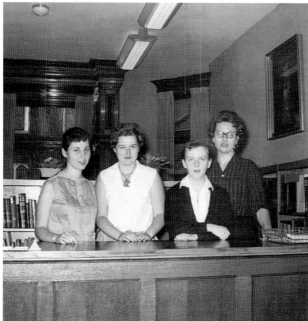

Above: Two young boys outside the old Elyria Public Library at the Reefy mansion, circa 1960. *Courtesy of the Lorain County Historical Society.*

Left: Library employees at the circulation desk in 1958. Pictured here are (*left to right*): Colleen Moore; Barbara Becker; Mary Ann Novak; and Barbara Yarish, the Library Lady. *Courtesy of Mary Ann Novak.*

NOOKS AND CRANNIES

Dr. Philip D. Reefy began construction on his mansion in 1902, starting a project that took nearly five years, according to a 1967 *Chronicle-Telegram* article by Connie Davis:

> *The doctor changed his mind frequently and had things ripped out and rebuilt....Much time was also required for the carved woodwork and paneling and for the numerous built-in alcoves, window-seats and other niceties. A shell and a cluster of oak leaves are motifs repeated in the woodwork embellishments. Dominant feature of the house* [sic] *is the circular tower rising from the basement to a castle-like battlement topping the third floor.*

Richard McGinnis grew up in Eastern Heights. He remembers the Reefy house as a stone castle with a turret and its "many, many, many rooms, and a large cubicle structure added on behind it which formed the main stacks, and down below in the basement of that cube was the children's section."

The annex Richard describes was built in 1929 and created by architect R.W. Silsbee when he redesigned the interior of the main house. The library opened to the public on February 12, 1929, with the children's section located on the second floor. It was subsequently relocated, in 1945, to the basement of the stack room—the "cube" recalled by Richard.

Children's author Lila McGinnis (Richard's mother) of Elyria wrote articles for national magazines in addition to caring for her family; she regularly took her children to the library in the Reefy mansion. In 1972, she joined the staff as the children's librarian—a post she held until her retirement in 1986. She shared Richard's reaction when he came to visit her at the Washington Avenue library for the first time: "Mom, there are no nooks and crannies in this library!" That, she said, is her most vivid recollection of the transition from the old to the new library. And although Richard did not recall the anecdote, he did say that he was very sad when the library closed.

Was he disappointed when he saw the new library? "Not disappointed," he said. "It was modern. It was open. It didn't seem to have as many shelves." What really impressed him, however, were the librarians. They were, he said, "incredibly helpful. I read a lot of science fiction [and] technical material in electronics. The librarians were always able to help me, no matter what strange question I'd throw at them."

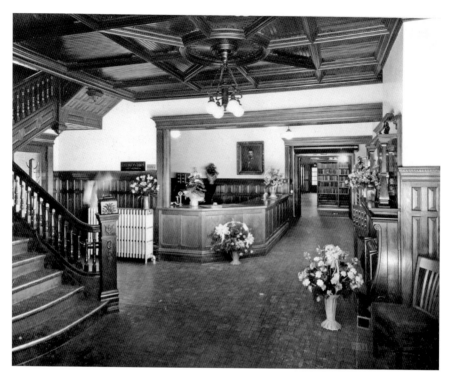

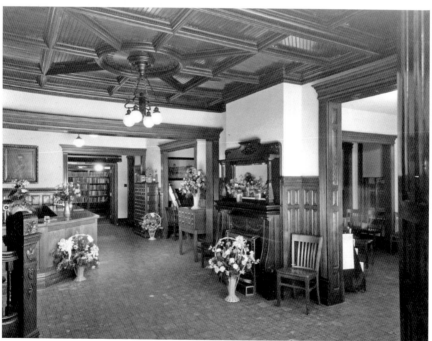

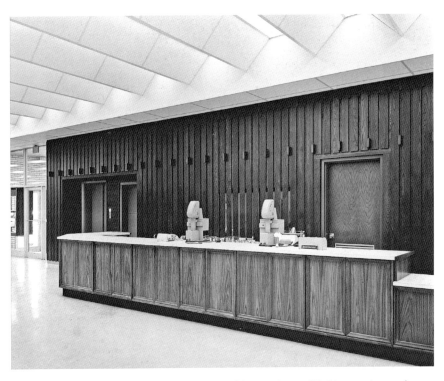

Above: The library's circulation desk at the time of its opening on Washington Avenue in 1967. *Courtesy of the Elyria Public Library.*

Opposite: The Elyria Public Library in the Reefy mansion on opening day, 1929. Note the coffered ceiling. *Courtesy of the Elyria Public Library.*

A ROUTINE AND A RITUAL

Two other children pictured in the 1965 article were Alan and Janet Lichtcsien. Alan now lives in West Palm Beach, Florida. Janet died in 2003. Alan remembers story hour "completely and totally. We never missed it. The library was part of a whole weekend routine."

The Library Lady "made a big impression on all of us," he said. "I remember what a sweet lady she was, and how she would try to pick out books each kid would like."

Alan and Janet's mother, Harriet Lichtcsien Margolis, still lives in Elyria within walking distance of the library. Looking at a digital file of the old

Harriet Lichtcsien Margolis examines a *Chronicle* article from 1965 featuring two of her children at the library's story hour. This picture was taken by the author on May 24, 2018. *Author's collection.*

article, she seemed to travel back fifty-three years to a time when her children were small and something as essential as a library opened up new worlds for them to discover and dream about.

"With five kids, we couldn't miss the library," she said. "It was a ritual by us. If it was story hour, or if they had homework, I had to go get them or they walked," she said. "The little ones I would take in bad weather. I'd be happy to take them, you know, because they were learning. That was it. They lived in that library, those kids."

MORE THAN BOOKS

In 1956, following a year at Bowling Green State University, Elyria native Mary Ann Novak was working at Romec Pump as a timekeeper when, she said in a phone interview, she spotted a help-wanted ad in the newspaper for "somebody who likes to read."

"I'm an avid reader. I'm always reading. I read everything."

TABLE 1: A SELECTION OF FICTION BESTSELLERS FROM 1950 THROUGH 1975

1950 *Across the River and into the Trees* by Ernest Hemingway
1951 *The Caine Mutiny* by Herman Wouk
1952 *East of Eden* by John Steinbeck
1953 *From Here to Eternity* by James Jones
1954 *Mary Anne* by Daphne du Maurier
1955 *Bonjour Tristesse* by Françoise Sagan
1956 *Peyton Place* by Grace Metalious
1957 *Eloise in Paris* by Kay Thompson
1958 *Doctor Zhivago* by Boris Pasternak
1959 *Lolita* by Vladimir Nabokov
1960 *Advise and Consent* by Allen Drury
1961 *To Kill a Mockingbird* by Harper Lee
1962 *Franny and Zooey* by J.D. Salinger
1963 *The Group* by Mary McCarthy
1964 *Herzog* by Saul Bellow
1965 *The Man with the Golden Gun* by Ian Fleming
1966 *The Fixer* by Bernard Malamud
1967 *The Confessions of Nat Turner* by William Styron
1968 *Couples* by John Updike
1969 *Portnoy's Complaint* by Philip Roth
1970 *Love Story* by Erich Segal
1971 *The Exorcist* by William P. Blatty
1972 *My Name Is Asher Lev* by Chaim Potok
1973 *The Honorary Consul* by Graham Greene
1974 *Jaws* by Peter Benchley
1975 *Ragtime* by E.L. Doctorow

She was hired to work at the circulation desk and stayed at the library for twenty-five years. "When the new books came in, I would go down and look at them and take whatever I wanted overnight or the weekend," she said. "I read all the bestsellers and all of those wonderful magazines on travel. We came out of the Depression…there was no television, so most of what I learned about the world, I learned at the library. I got the travel bug and traveled all over the world."

Mary Ann loved working with the public. "The people were all so nice… it was a warm, warm place." She also enjoyed working at the reference desk,

where every phone call brought a new and interesting question to research. She was eventually promoted to audiovisual librarian, taking care of the films and recordings in the collection. In 1948, the library had become a charter member of the first cooperative film circuit in the United States, circulating sixteen-millimeter films among its member libraries. This, said Mary Ann, was significant. "At the time, libraries were synonymous with books, not with visual media. This expanded the boundaries of what a library could do. Anyone—not just teachers—could check out the films."

By 1967, Elyria became the administering library for the Northern Ohio Regional Film Circuit. With a collection of more than seven hundred films, thirty-five thousand annual bookings and a total audience of two million, this was the largest film circuit in Ohio and one of the largest in the United States. Then, in 1969—the year of the moon landing—NASA came calling, awarding the library a contract to serve as the administrator of its thousand-film library serving seven states in the Midwest.

Knowing the Patrons by Heart

Colleen Moore Pollack, now of Vermilion, graduated from Elyria High School in 1955. After two years at Kent State on an education scholarship, she knew that teaching wasn't for her, so she came home. An employment agency led her to library director Merlin Wolcott, who hired her in September 1957 for the first job she ever had: working at the front circulation desk (see image on page 44). Although she only worked at the library for a year and a half, she remembers her time there fondly.

She was well-acquainted with the library before she ever started to work there, walking to it from her home on East Thirteenth Street when she was just six or seven years old. "I went down the steps and would find the books that I wanted and I would sit on the floor and read. I just loved reading. I was interested in science fiction and the biography series with the orange covers. I read all of those books. I remember reading about Jane Addams."

Colleen also took her little sister, Kathleen Ann, to the library. "When she could print her name," Colleen said, "she wrote 'Kathleen And' on her library card."

The librarians knew the patrons by heart. "People who came in on a regular basis, we became so familiar with them that we knew their library numbers," Colleen said. "Every book had a card in the back pocket with

the name of the book, the author, everything. We took that card out of the book, wrote their number on the card, and put it in a daily file so that at the end of the day, we knew what books went out. Then, we stamped the date when it was due on another card and put that in the back of the book."

Colleen Moore Pollack, Barbara Yarish Stydnicki, and Mary Ann Novak became such good friends that they still get together to reminisce about the old days. "We were happy young women," Barbara said.

THE ELYRIA PUBLIC LIBRARY THROUGH MIDCENTURY

1870: Elyria's first library, a gift from Charles Arthur Ely (the only son of Heman Ely, Elyria's founder, and his second wife, Harriett Salter Ely) opens on June 1 on the second and third floors of the Center Block on Broad Street; the first floor is rented to First National Bank. Two and a half months prior to opening, the first librarian, Nettie E. Wheeler, is appointed. She would earn twenty-five dollars a month, working six days a week, for the next thirteen years.

1873: Fire destroys the section of Broad Street between Lodi Street and Washington Avenue—the Commercial, Center, and Ely blocks—reducing to ash all but 375 of the 4,000 books in the collection.

1874: Elyria quickly rebuilds, and the library returns to its original Broad Street site, again on the second and third floors, despite a decision by its board of trustees to sell and rebuild elsewhere. Charles Arthur Ely's will, however, specifies that the library be located on Broad Street, and his wishes are upheld in court.

1876: Melvil Dewey publishes the first edition of the Dewey Decimal System.

1886: Due to the size of its growing collection, the library adopts the Dewey Decimal System to classify and catalog its holdings, hiring Mrs. J.E. Dixon of New York at fifty cents an hour to oversee the transition from Nettie Wheeler's original filing system.

1903: The Elyria Board of Education secures the library's first operating levy.

1904: The library begins school service with an additional collection of 150 books at Elyria High School and hosts the ninth annual convention of the Ohio Library Association.

1914: The library's collection grows to 26,232 volumes with an annual circulation of 58,000.

1915: The first children's librarian is hired.

1916: The Elyria Board of Education cancels its contract; the library reinstitutes membership fees.

1927: Space—and finances—are serious problems. The board of trustees petitions the court of common pleas for permission to relocate the library. The court rules in favor of the board the following year.

1928–29: Negotiations begin with Dr. Karl Reefy, son of the building's original owner, the late Dr. Philip D. Reefy, to purchase the family's Third Street mansion, including a building at the back where the doctor's medical office is located. The library sells its Broad Street building for $60,000 and purchases the Reefy property for $30,000. Architect R.W. Silsbee redesigns the mansion's interior and devises an addition of brick with stone trimmings—also at the rear of the main building—to house the stacks. A *Chronicle-Telegram* article from the era notes that "the board expects [the materials to] offer a pleasant contrast to the stone masonry of the main structure." The new library opens on February 12, 1929, with the children's department located on the second floor of the main house.

1938: School library service is reestablished, with libraries in eleven schools.

1939: A contest is held among community children to rename the library's children's room; the "Longfellow Room" is the winning entry.

1943: Elizabeth Taylor is hired as assistant school librarian. She worked at the library until 1984, when she retired as its first reader advisor.

1945: The children's department moves from the second floor to the basement of the 1929 addition designed by R.W. Silsbee.

1948: The library becomes a charter member of the first cooperative film circuit in the United States to circulate sixteen-millimeter educational films among its member libraries.

1952: The library premieres its first radio program on WEOL. Its Saturday morning programming relies on a series called *Teen Age Book Parade.*

1962: Circulation reaches the highest point in the library's history—475,072.

1963: The library sells its Third Street property to the First Methodist Church for $85,000; arrangements are made to permit the library to remain there until a new building is constructed.

1964: The board of trustees appoints an advisory committee to assist in the library's building campaign.

1965: The Elyria Kiwanis Club spearheads the building fund drive, establishing a goal of $265,000. The State Library of Ohio provides a $200,000 grant toward the new building.

1966: Donald Sager is appointed library director. Plans progress for the new building at 316 Washington Avenue. At the October 4 groundbreaking, according to a *Chronicle* article, Mrs. J. Clare George, president of the board of trustees, "turn[s] the first shovel of earth."

1967: The library closes for three weeks in September to move into its new location with assistance from the Elyria Jaycees. On October 8, the library is formally dedicated. With 28,000 square feet and a cost, including furnishings, of $601,000, this is the first time in its history that the library has a building expressly designed for library service.

1969: The library's book collection passes the 100,000 mark, double the number of books it contained in 1950. NASA awards the library a contract to administer its library of one thousand films serving seven midwestern states. The library is chosen to administrate an eight-millimeter film circuit for the seven libraries in Lorain County.

1979: The Friends of the Elyria Library is formed to maintain an association of people interested in the library and its welfare.

1981: A Nordson Foundation grant allows the library to access two hundred national online computer information databases.

1982: The King Fauver Memorial Fund makes it possible for the library to begin automating its catalog.

1984: The bookmobile program begins. The library joins an online computer cataloging and circulation system with the Cleveland Public Library and several other libraries. An adult literacy program is launched, and videocassettes are added to the collections. A front parking lot is added.

3
The Dancer and Her Dance: Betty Bishop

Like the characters in *A Chorus Line*, countless Elyria children, myself included, once trooped up a steep and very narrow stairway to learn ballet, jazz, and tap from Betty Ann Bishop. Although I don't remember her voice being like a metronome, I do remember the elegant French phrases with which she punctuated her lessons: arabesque, demi plié, port de bras. On some level, these words registered as important in learning ballet, but to my impressionable ears, their musicality suggested mystery, beauty, and fascinating lands far beyond Elyria's boundaries.

Then there was the woman herself. She was not very tall, but she could command a room with her theatrical style: a cap of short red hair, full makeup with red lipstick and turquoise eye shadow, black tights, black shoes with a small heel, and a black turtleneck leotard set off by a piece of stunning gold jewelry. One former Bishop student with whom I spoke remembered a "flow-y" jersey wraparound ballet skirt falling to about midcalf length. Another recalled a scarf tied around her waist. Regardless of her studio attire, Betty shimmered in a way that no other adult women did; her glamour and sophistication set her apart from our neighborhood mothers. Such is the measure of Betty's creative force and vivid personage that I, who took group lessons for less than a year and never studied with her privately, never forgot her. Dianne Maddock Fenbers of Carroll County, Ohio, said: "If you bring up the name 'Betty Bishop' to someone who knew her, their face lights up."

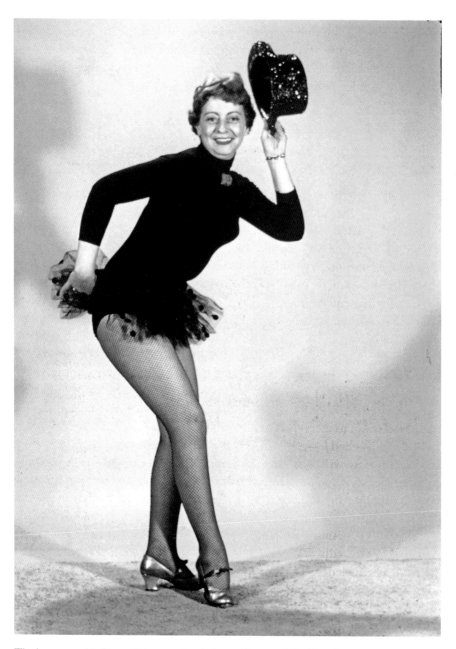

The incomparable Betty Bishop, undated photo. *Courtesy of Brad Loomis.*

Dianne had just turned three in 1963, when she and her twin sister, Dawn, started taking lessons from Betty; their older sister, Denise, also took classes. Without preamble, this is how Dianne started our conversation: "I have, to this day, a love for Betty Bishop that will never leave me."

A Born Dancer

Betty Bishop was born in Elyria on February 26, 1917, the youngest of three girls. Her sister Adelphia, known as "Budd" since infancy, was six years older. The eldest was half-sister Thelma.

In one childhood photograph, Betty is seated on a wooden table, one leg crossed over the other, jauntily holding what looks like a cane or walking stick. She wears a newsboy cap, a striped shirt, and suspender-fastened shorts complemented by knee socks and Mary Janes. The inscription reads: "Age 10. Modeling at the C.H. Merthe Co." In another photo, undated but likely taken at around the same time, she's standing on the front porch of a house on Cornell Avenue and wearing a wrinkled ballet costume with a knee-length tutu that she has fanned out to the sides with her hands. Toe shoes, ankle socks, and a headband securing what looks like a butterfly's antennae complete the ensemble. In both photographs, her hair is cut in a short bob. Even as a child, she had a dramatic flair.

Betty established her reputation as a young dance theater impresario early. A note, possibly written in her mother's hand, appears on the facing page of a book in which another Merthe's modeling photo appears [punctuation added]: "Betty Ann and her gang put her show on at the McKinley Bazaar Dec. 4, 1928, Ogo Pogo being the name of the play. Room filled twice. Receipts $14.00. All through, they did well."

The yearbook editors of the *Elyrian* for Elyria High School's midyear class of 1937 acknowledged Betty's career destiny. Epigraphs for each graduate appeared next to their senior portraits. Betty's reads like something out of Shakespeare if, say, Ophelia or Juliet had been dancers:

> *Thou takest to dancing, fair damsel; thy feet are thy fortune.*
> *Thou hast made a way for thyself in the world by teaching*
> *Others to be graceful and to make use of their feet.*

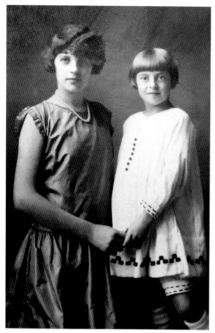

Left: Sisters Adelphia Mary "Budd" (*left*) and Betty Bishop, circa 1925. *Courtesy of Brad Loomis.*

Right: Betty Bishop's Elyria High School graduation portrait, circa 1937. *Courtesy of Brad Loomis.*

After high school, Betty continued her education at the Boston Elite Dancing Academy. As early as the 1930s, notices began appearing in the *Chronicle-Telegram* announcing dance recitals presented by the Betty Ann Bishop School of Dance. For the next three decades, her students performed at various Elyria venues. Susan Murbach Hunt of Citrus Hills, Florida, remembered "ballroom dance lessons for all" held at Ely School; she took tap and ballet—even getting up on her toes—at the Bishop school. In addition to offering private and group studio lessons, Betty also gave occasional specialized lessons to boys and girls at the Elyria YWCA's Holly Hall.

Barbara Kasper Folds of Olmsted Falls started taking ballet and tap in 1954, when she was five, and continued through 1963. "Every year, we had a recital at Ely School," she wrote in an email. "Everyone had a tap and ballet routine. To this day, I still love the ballet and classical music." Marlene DeLaVars Jacobs of Carlisle Township wrote in an email that her favorite part of recitals were the costumes, "sparkly with glitter." She took lessons between 1951 and 1953, starting when she was about eight.

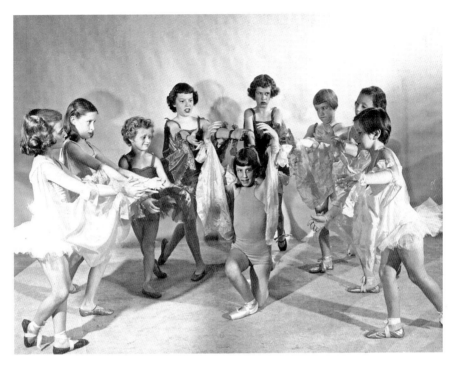

Students of dance teacher Betty Bishop, circa 1955. Barbara Kasper Folds is at the end on the far right. *Courtesy of Barbara Folds.*

She recalls Betty's studio at that time being located upstairs on the south side of Broad Street, somewhere between East Avenue and the alley next to Driscol Music.

This timing suggests that Betty continued to teach in Elyria after getting married, a fact that surprised me when I discovered her wedding announcement in the June 12, 1951 edition of the *Chronicle*. That morning, Betty wed Alfred G. Taylor of Lakewood, Ohio, at St. Andrew's Episcopal Church. Someone in the records office at the Cuyahoga County Clerk of Courts confirmed what I suspected: Betty and her husband divorced on February 4, 1955. They had been living in Lakewood. They had no children.

That is, Betty had no *biological* children. She had her students, thousands of them, throughout her decades-long career—children of various talents, abilities, and aspirations. A story told by Dianne Maddock Fenbers suggests she loved every one of them.

A BELOVED TEACHER

When Dianne was three, she and her twin, Dawn, were cast, at Betty's recommendation, in an Elyria High School production of *The King and I*. Pianist Don Green, a friend of Betty's and her frequent recital collaborator, conducted the Elyria High School orchestra for the production, which was directed by Frank Toth.

"Betty was there for every rehearsal," Dianne recalled.

> *On opening night, I fell asleep onstage. Betty and my parents were laughing so hard! The King carried me off. The next night, I wet my pants; when I turned around you could see the stain on the satin material. The audience roared. At the matinee, I fell behind in the clapping, and so I stood up and blew the audience a kiss. Betty, who was backstage, picked me up and hugged me. She loved each and every student for whatever they brought to her class.*

In the early 1960s, when I took Betty's class, her studio was located at 375 Broad Street, up that steep and very narrow stairway next to the Fay Company, a ladies' apparel shop. According to city directories from the era, Betty lived in an apartment near the studio at 385 Broad Street in the Century Block.

Dianne remembers large windows in the studio that looked out onto Broad Street, hardwood floors that creaked, and a room that smelled of wood and was so large that it echoed. I recall a mirror off to one side—with a ballet barre attached—that seemed to span the length of the room. A row of wooden chairs was set up on the opposite wall so parents could sit and watch. Phyllis Wasserman Harvey of Palm Springs, California, remembers a "big, cool-looking desk" at the front of the studio near the windows. A small, raised platform allowed Betty or her student assistants to demonstrate the five different foot positions.

Phyllis was about five when she began lessons; by the time she was fourteen, she had advanced to become Betty's teaching assistant, with her own changing room in the back of the studio, shared with Nancy Barr, who is pictured in the *Chronicle* recital ad on the facing page. Betty encouraged Phyllis and Nancy to paint their changing room and decorate it to their liking.

"Betty loved to dance," said Phyllis in a phone interview. "She built your confidence as a child. She developed our personalities. I attribute my level of confidence and self-assurance to Betty. When you went out on stage, she

Betty Ann Bishop School of Dance

Presents Their —

ANNUAL DANCE RECITAL

"SHOW TIME"

Ely School

8:00 P.M. SHARP!

Wednesday, June 14
Adults .. $1.00
Students .. 50c

Pictured At Right
Intermediate Student
Nancy Barr

A newspaper advertisement for a 1961 Betty Bishop dance recital. *Courtesy of Brad Loomis.*

taught you how to emote the dance, how to show it. I've danced my entire life because of Betty. She gave me my sense of style and my sense of dance."

Dianne Maddock Fenbers spoke about the positive influence that dance lessons can have on a child. Because of what dance had done for her, she signed her adopted daughter up for classes at the age of four while she was still in foster care. "It really healed her," she said.

"Girls are very fragile. If you can get that confidence at a young age, it can carry you through. Betty did that for my sisters and me. Betty did that for a

lot of young girls in our community. She was always so positive. She believed we could do anything we could set our minds to. 'If you can dream it, you can do it,' she would say. I lived that for a long time."

A Tragic End

The Yankee Clipper Inn, located off State Route 8 in Boston Heights, had several events on its books the weekend of November 18, 1967, including a meeting of the National Association of Dance and Affiliated Artists. Betty planned to be there, and she hoped that Phyllis Wasserman would join her. By then, Phyllis was seventeen, and although she had remained close to her teacher, high school activities and a boyfriend, whom she eventually married, kept her so busy that she had to curtail her involvement in dance.

Nevertheless, Phyllis said she was delighted when Betty invited her along for a weekend where dance would be the focus. "It was something I would have wanted to do very much," she said, so the reason must have been compelling for her to decline her teacher's invitation. Betty's sister Budd took Phyllis's place on the trip. Phyllis no longer remembers what scheduling conflict or family obligation intervened, but whatever it was, it saved her life.

Carbon monoxide gas—odorless, tasteless, and invisible—wafted through the Yankee Clipper Inn that Saturday evening. The *Chronicle-Telegram* reported that two hundred guests were evacuated, sixty were hospitalized, and three perished: a twenty-two-year-old Cleveland man on his wedding night and two sisters from Elyria, Betty and Budd Bishop. Betty was fifty years old, and Budd was fifty-six.

A graduate of the M.B. Johnson School of Nursing, Budd was as highly esteemed in her profession, working for Drs. Roy E. Hayes and Harold E. McDonald, as Betty had been in hers. She lived in the Bishop family home at 709 East River Street.

The sisters had few survivors—two aunts; a nephew (Richard Loomis of Elyria, their half-sister Thelma's son); and Richard's two little boys. One of Richard's sons, Brad Loomis of Lebanon, Ohio, contributed the photographs included in this chapter (with the exception of the group dance class photo).

According to a local history article by Mark Price, a staff writer for the *Akron Beacon Journal* and *Ohio.com,* investigators traced the poisonous gas to a swimming-pool heater in a basement laundry room; its vent, installed too

close to a fresh-air intake, gave the fumes free rein to make their deadly ramble throughout the hotel's ductwork. *Chronicle* reporters and editors included the tragedy in their list of the top ten news stories of 1967.

Jennifer Toth Moneagle of Beaufort, South Carolina, whose father, Frank Toth, directed the Elyria High School production of *The King and I*, recalled in an email that her parents were very good friends with Betty and pianist Don Green. They were, she wrote, "devastated when she died. Some said Don was never quite himself again."

The sudden and random manner of Betty's passing loomed large in our childhoods, leaving an echoing void.

Phyllis's parents, who were the owners of the Fay Company next to the dance studio, broke the news to her. "I was devastated," she said. "I honestly was freaked out and I don't like to use that word. I was so shocked to think that I would have been there, that that could have been my fate. And I was brokenhearted because Betty was someone I'd looked up to my whole life. She played such an important role in my life."

Phyllis went to the visiting hours at the Sudro-Curtis Funeral Home, but she doesn't have a vivid recollection of the experience. "I don't know if I blocked that. I have a great living image of her. I do not have a gone image of her."

Phyllis continues to dance and has taught many forms of dance as well. Whenever she checks into a hotel room, she cracks the window and leaves the heater off.

Dianne Maddock Fenbers remembered that Betty did not like saying goodbye to people. "Instead, she would say 'au revoir,' or 'à tout à l'heure,' or 'à bien tôt.' On the night before she died, I had class with her. She said goodbye to my mother. To me, she said, 'Goodbye, mon petit chou.' I asked my mom, 'Why did she say that?' and my mom said, 'I don't know.' That is something I never forgot."

Dianne and her family also went to the funeral. It was important to them—especially to Dianne—to say goodbye. But what she and her mother really said was "Au revoir, Betty."

4
Stage Doors and Footlights

Professor Harold Hill romanced Marian the Librarian—while singing and dancing—in the 1962 film of Meredith Willson's hit Broadway show *The Music Man*. Sitting in the darkened Capitol Theatre, an eight-year-old boy was transfixed. He dreamed that one day he, too, would be up on a screen or a stage making music of his own.

The boy was David Cameron Anderson, and he indeed took to the boards. He gave an exuberant performance as Sancho Panza in a 1971 production of *Man of La Mancha* at Elyria High School.

Another production of *The Music Man* took place in 1966 at Elyria Catholic High School and marked the first time on the musical theater stage for seventeen-year-old Marilyn Firment. Her piano-playing ability, as well as the singing lessons that she took with Louise Curtis, paid off: she was cast as Marian, the dubious librarian. Joseph Bonczek, not Robert Preston, was her Harold Hill.

Playing a small role as one of the River City townspeople was Chris Wilczak. The following year, Chris, known as Crissy, lit up the stage as Eliza Doolittle in the Elyria Catholic production of *My Fair Lady*.

I remember each of these electrifying productions. It came as no surprise that D.C. Anderson, Marilyn Firment, and Crissy Wilczak went on to tread the boards on New York stages.

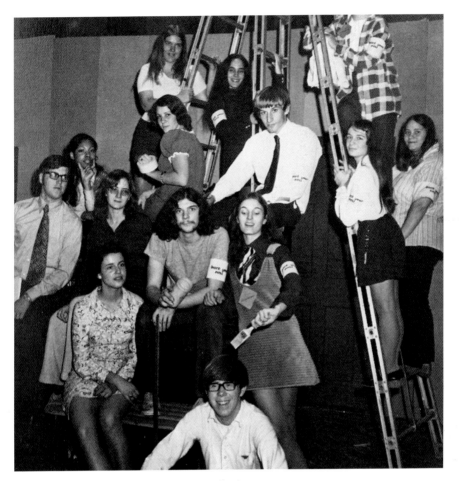

Elyria High School thespians from the 1971 production of *Man of La Mancha*. D.C. Anderson is front and center. *Courtesy of Elyria City Schools.*

THE GOLDEN AGE OF ELYRIA THEATER

D.C., Marilyn, and Crissy were fortunate—they were around for Elyria's theatrical golden age. At midcentury, the two high schools produced plays and, by 1966, musicals of phenomenal quality. The amateur theater group Black River Playhouse (and its predecessor, Elyria Playmakers) also provided an important source of entertainment, priming Elyria audiences to expect excellence in live theater. In return, Elyria audiences supported fledgling thespians and community theater, helping to ensure the ultimate success of these and other young actors.

Left: Joseph Bonczek (Professor Harold Hill) and Marilyn Firment (Marian Paroo) in the 1966 ECHS production of *The Music Man. Courtesy of Marilyn Firment Detmer.*

Below: Scenes from the 1967 ECHS production of *My Fair Lady,* starring Crissy Wilczak. The photos appeared in a class yearbook. *Courtesy of Elyria Catholic High School.*

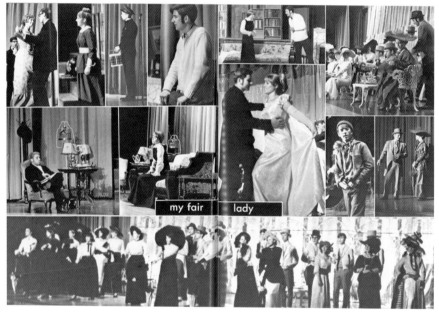

It's no wonder that amateur theater was popular at midcentury. Two wonderful organizations, the Elyria Musical Arts Society and the Elyria Community Concert Association, offered the only real competition for audiences in the lively arts. The internet did not exist. The television program listings in the newspaper covered only three Cleveland channels. Besides television, the only other entertainment outlets were the movies and radio; at one time, the newspaper even published radio program listings.

TABLE 2: AVERAGE TOP NETWORK TELEVISION SHOWS AS TRACKED BY
NIELSEN RATINGS*

<u>1950s</u>

1950–51 *Texaco Star Theater*, NBC
1951–52 *Arthur Godfrey's Talent Scouts*, CBS
1952–53 *I Love Lucy*, CBS
1953–54 *I Love Lucy*, CBS
1954–55 *I Love Lucy*, CBS
1955–56 *The $64,000 Question*, CBS
1956–57 *I Love Lucy*, CBS
1957–58 *Gunsmoke*, CBS
1958–59 *Gunsmoke*, CBS
1959–60 *Gunsmoke*, CBS

<u>1960s</u>

1960–61 *Gunsmoke*, CBS
1961–62 *Wagon Train*, NBC
1962–63 *The Beverly Hillbillies*, CBS
1963–64 *The Beverly Hillbillies*, CBS
1964–65 *Bonanza*, NBC
1965–66 *Bonanza*, NBC
1966–67 *Bonanza*, NBC
1967–68 *The Andy Griffith Show*, CBS
1968–69 *Rowan & Martin's Laugh-In*, NBC
1969–70 *Rowan & Martin's Laugh-In*, NBC

<u>1970–75</u>

1970–71 *Marcus Welby, M.D.*, ABC
1971–72 *All in the Family*, CBS
1972–73 *All in the Family*, CBS
1973–74 *All in the Family*, CBS
1974–75 *All in the Family*, CBS

*This is a listing of the average top shows ranked by total viewers.

D.C. Anderson was twelve when he made his stage debut. He was cast as Jether in a production of Paddy Chayefsky's *Gideon* produced by the Black River Playhouse. Richard Ehlke, who portrayed the Angel of the Lord, left an indelible impression. "He was the first actor I worked with," D.C. said in an interview. "I thought he was marvelous. Everyone [in the cast] was wonderful, but I was totally taken with his rich voice and commanding presence."

D.C. recounted his memorable opening night: "I had a crippling bout of stage fright, and I froze on stage. There was a curtain behind me that was part of the set; Conni had to run from the audience, go backstage, and push me through the curtain to get me going." The woman who saved the day was Conni (Mateer) Little. With her ex-husband, Jim Mateer, she helped found the Black River Playhouse and was involved in many aspects of its productions.

THE BLACK RIVER PLAYHOUSE

The Black River Playhouse roster was filled with many Elyria theatrical boldface names who contributed to its success. Besides the Mateers, there was Nelson Beller, a Playhouse board member who went on to found Elyria Summer Theatre. Richard Ehlke, he of the rich voice and commanding presence, also served on the board. In an interview, Conni said that when it came to what he did for the Black River Playhouse, "Dick Ehlke did everything."

He was, she said, instrumental in creating the Black River Playhouse Readers' Theatre. "We would travel around a variety of venues and do readings from our productions," Conni said. One of the most requested readings was *The Wonderful World of Carl Sandburg*.

The group's first home was a studio on School Street on the west side of town. The Playhouse later purchased the former Mount Zion Church at 532 West River Street, remodeling it for theatrical use. The area beneath the pulpit was gutted, and the cloak room was turned into an office. Parking was limited, and the church was small, with room for only eighty seats, but the Playhouse volunteers improved it by buying and installing theater seats from a movie house in Lorain.

"They worked so very hard," Nancy Dunkle Horvath (see bottom image on the facing page) said in an interview. Nancy performed the role of Sandra

The Black River Playhouse production of *The Glass Menagerie*, circa 1965. Connie (Mateer) Little is on the chaise. *Courtesy of Conni (Mateer) Little.*

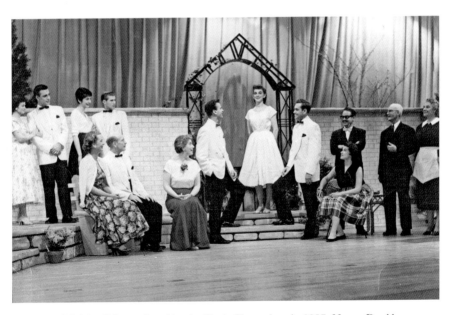

The cast of *Sabrina Fair*, produced by the Elyria Playmakers in 1957. Nancy Dunkle, as Sabrina, stands beneath the arch. *Courtesy of Nancy Dunkle Horvath.*

Markowitz, the social worker, in the Playhouse's 1964 production of *A Thousand Clowns*.

The Black River Playhouse was an innovative organization. Its leaders hosted an annual spring banquet at which they presented awards for acting, directing, and production à la the Academy Awards. They sponsored a junior theater for children ages eight to fourteen and a teen group called Backstage Inc. (I remember going to a meeting of Backstage Inc. when I was about twelve. My father drove me there, and I seemed to be the youngest kid in the group. I recall the teenagers played a game of theatrical charades; one young man fluffed out the bangs on his long hair to denote the smash-hit musical *Hair*.)

By 1967, the group had left the small church and presented one of its last shows, *The Rainmaker*, at Lorain County Community College in April 1968. Richard Ehlke called Nancy Horvath with a request: "He wanted me to take the female lead in *The Rainmaker*. But we had just moved into our new house, and there were boxes everywhere. Dick said 'Those boxes will still be there. Take the part.' But I also had to register my daughter in a new school. It just wasn't the right time. He gave the part to Joan Crawford."

No. Not *that* Joan Crawford.

Nancy, however, had already enjoyed the experience of a starring role. In what she believes was the final production staged by the Black River Playhouse's predecessor, the Elyria Playmakers, she was cast in 1957 as Sabrina in *Sabrina Fair*. The director was Richard Ehlke.

ELYRIA PLAYMAKERS

Sabrina Fair was produced in May at the Eastern Heights Junior High School auditorium. "The play was so popular," Nancy said. "After the three performances, there were so many who couldn't get a ticket that we held a repeat performance at Elyria High School."

Nancy recalled those opening moments:

> *No one was on stage when the curtain opened, but the set design—a garden—was so realistic that the audience applauded just for the scenery. Fred and Mary Lou Wilkins designed the set. They had cut bricks out of wood and covered them with a linoleum that looked like brick and constructed a brick wall that was a little more than waist high. It looked*

just like a brick wall in a garden, with greenery behind it. You really felt you were in a garden setting.

Nancy and the other cast and crew members of *Sabrina Fair* were part of an illustrious tradition.

The Elyria Playmakers was formed in the 1920s by graduates of Elyria High School. They began producing one show per season, but eventually, they were staging five or six each year. Money was tight, especially during the Depression. A founder of the Playmakers, Frank Seward, told the *Chronicle's* Connie Davis in 1978, "We probably never made more than a hundred dollars a year." However, the group offered Elyrians a relatively inexpensive form of entertainment.

According to Davis's 1978 article:

Sets and costumes were made or borrowed from many sources. The Graystone Hotel loaned tables and chairs for Outward Bound. *Costume mistress for many plays was Ella Foley Smith, assisted by some women of First Congregational Church....Productions were presented at EHS and the old Rialto Theatre on Second Street....Sometimes they were given in a hall above* [what was once Bride's World, at] *114 Middle Avenue. Also used for rehearsals, the hall seated 105 persons.*

One 1939 Playmakers production is significant—its actress had been a Hollywood star.

RUDOLPH VALENTINO'S LEADING LADY

Silent-film star Lila Lee was born in New Jersey in 1901. Her obituary in the *New York Times* reported that a vaudevillian discovered her after spotting her at her father's hotel; he promptly put her on the circuit with the childhood stage name "Cuddles." Lila toured the country and, when she was thirteen, was discovered again. A producer gave her a screen test, and a star was born.

In 1919, Cecil B. DeMille cast her in *Male and Female*, starring Gloria Swanson. A few years later, Lila appeared opposite Rudolph Valentino in one of his most storied movies, *Blood and Sand*. She also performed in many plays in New York and in summer stock—and, of course, in one play in Elyria.

But why Elyria? What was the connection?

Cue the family.

Lila's sister Pauline, called Peg, was married to Leonard "Leo" Tufford of Elyria. They had two children; Peg named her daughter Lila Lee in honor of her sister.

Lila often visited Elyria. After her divorce from her first husband, James "Jimmy" Kirkwood, their son, James Jr., lived with his aunt Peg and uncle Leo. Young Jimmy went to Elyria High School, graduating in 1942. He would go on to achieve great theatrical acclaim—but we'll get to that later.

In 1939, while in Elyria, Lila joined the cast of a Playmakers production of *Night of January 16th*, a courtroom drama written by Ayn Rand. (The 1941 film version of Rand's play starred Robert Preston, who would later become known as "the music man.")

The nineteen-member cast of the Elyria production was directed by Frank Seward. Ed Champion, a Playmakers founder, played the part of the district attorney. But Lila was the star of the show. She portrayed Karen Andre, a woman on trial for murder. The production was staged at the Lorain County Courthouse. *Chronicle* writer Connie Davis set the scene for her 1978 readers:

> *Seating was limited in the courtroom, so windowsills were sold too. They were only eighteen inches wide, but two small skinny persons could be squeezed in. The play's jury was filled by audience volunteers; "we could then re-sell their seats," explains Ed.*

Rand's script was written with two alternate endings—guilty or not guilty. Based on evidence given during the trial, the latter was the typical conclusion. To change things up a bit, the jury in the Playmakers production was asked ahead of time to announce a guilty verdict during one performance. Wearing a costume provided by the Style Center, defendant Lila Lee was reported to have gracefully fainted upon the announcement of the verdict.

"Lila was a joy to work with," Frank Seward told Connie Davis, and she accepted his direction like a professional, although she did admit to being scared before each performance.

The Elyria Playmakers flourished until World War II, when twenty-seven of its members went into the armed services. The group's first postwar offering was *The Man Who Came to Dinner* in 1946. Among its many productions were *Blithe Spirit*, *Laura*, *Harvey*, and *A Doll's House*.

By the time of *Sabrina Fair*, however, the Playmakers were, sadly, played out.

"Like any other organization, there's a nucleus of people who do all the sets, all the directing, all the acting, and they were getting older, and they couldn't do it anymore," Nancy Horvath said. The group disbanded, but a new theatrical troupe emerged to fill the void: the Black River Playhouse.

THE ELYRIA–*CHORUS LINE* CONNECTION

Lila Lee died in 1973, so she did not live to see the phenomenal success of her son, Jimmy. A novelist and former actor, James Kirkwood Jr. wrote, with Nicholas Dante, the book for one of the most successful musicals of all time: *A Chorus Line*. The playwrights received the 1976 Pulitzer Prize for Drama, and the show won nine Tony Awards, including one for Kirkwood and Dante for Best Book of a Musical.

An apocryphal story went around Elyria in the 1970s about the *Chorus Line* auditions. A bright young actress auditioning for the musical addressed the principal decision-makers at New York's Public Theatre by purportedly introducing herself from the stage as "Crissy Wilzak from Elyria, Ohio."

"God bless you for not saying Cleveland!" James Kirkwood shouted from the clutch seated in the audience. "I'm from Elyria, and I'm going to give you another chance."

"That's not how it happened," Crissy told me. Kirkwood likely wasn't even there at the time, although, with the other creators of the show, he did attend rehearsals.

FROM *MY FAIR LADY* TO NYC

After her star turn as Eliza in EC's production of *My Fair Lady*, directed by Sister Mary Joanmarie, Crissy attended Lorain County Community College. She performed in *You're a Good Man, Charlie Brown*, among other shows, all under the direction of Roy Berko.

The drama professor was instrumental in Crissy's professional development. "He organized a New York City trip for a group of us," she said in an interview. "And he made sure I got a front-row seat to *Hair*." His machinations worked.

From LCCC, Crissy went to Kent State University and majored in theater. She moved to New York in the early 1970s and, after a few New Jersey dinner theater productions, caught her first big break, winning an audition to appear in the original Broadway cast of the musical *Seesaw*. It was her first Equity production; she was billed as Christine Wilzak, having dropped the "c" from her last name.

The book for *Seesaw* was written by Michael Bennett. During previews, the producers changed directors and the lead actress, bringing in Bennett to direct and actress Michele Lee to star. "Michael brought in all of his own dancers and fired just about everybody in the show except for me," Crissy said. She was with the show for its entire run, and when it went on tour with Lucie Arnaz as the lead, Crissy went with it as her understudy.

Michael Bennett had taken a liking to Crissy. "He thought I could move, even though I wasn't a 'dancer-dancer.'" She had never taken formal lessons. Her teacher, she said, was Dick Clark, and his television show *American Bandstand* was her studio.

Bennett's assistant, Baayork Lee, called to let Crissy know about a new show that his team was putting on. "You have to audition for it, but we want you to be in it," Lee told her. For the audition, she sang a bluesy song from *Girl Crazy*, "Boy! What Love Has Done to Me!"

"I remember seeing Michael and all his people sitting there in the audience smiling and laughing," she said. "I could just tell they were enjoying me so much."

She got the part of Vicki, one of the many dancers ultimately cut from the audition during the opening number, "Gee, I Hope I Get It." The song established how high the stakes are for those in a chorus line.

Crissy also understudied for several parts in *A Chorus Line*, including that of Val, who sang "Dance Ten, Looks Three." She performed with the cast on the Tony Awards broadcast and was with the show for three years.

Other successes followed, including the role of Ginger Brooks in Broadway's *The 1940's Radio Hour*. "There were casting directors from Hollywood at the show one night," said Crissy. "The next thing you know, I had a contract with ABC."

And just like that, Crissy landed in another cultural touchstone: ABC's hit comedy *Mork & Mindy*. She joined the show for its third season as Mindy's friend Glenda Faye Comstock, a young widow.

With a five-year marriage coming to an end, she finally felt ready to get back to New York; she missed Broadway. But by then, musical theater had changed—the hot tickets were shows such as *Cats* and *The Phantom of the*

Crissy Wilzak (*center*), an original cast member of *A Chorus Line*, in rehearsal, circa 1975. She dropped the "c" from her last name during her career. Photograph by Martha Swope. *Courtesy of Crissy Wilczak.*

Opera. "They were looking for more operatic voices," said Crissy. "I didn't have a voice like that. I was a 'belter.'"

It was time to move on. She moved back to Elyria in 1999 to be close to her family. "I have always loved my family," she said.

A MUSIC MAN

Despite D.C. Anderson's inauspicious debut, when he had to be pushed from behind onto the stage at the Black River Playhouse, he was hooked on theater. At EHS, following his success in *Man of La Mancha*, he performed the role of Tevye in *Fiddler on the Roof*; both shows were directed by Gene Dulmage. D.C. graduated from Baldwin-Wallace College in 1976, and he was soon making the rounds of auditions and callbacks so typical in an actor's life.

In 1998 came the call that would change his life. Not only does he remember the date he made his Broadway debut, he remembers the time: a 2:00 p.m. matinee on August 8, 1998, in a show that helped usher in a new

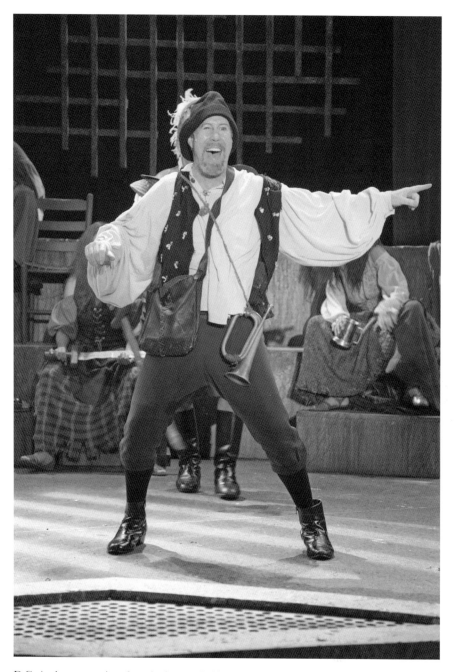

D.C. Anderson reprises the role that made him a local star—Sancho Panza—in an Equity production of *Man of La Mancha*. Photograph by Michael Feldser. *Courtesy of Gretna Theatre.*

style of musical theater: an Andrew Lloyd Webber juggernaut called *The Phantom of the Opera.*

D.C. was already associated with the show. He first auditioned for it ten years earlier and was cast as Monsieur Reyer, debuting at the Ahmanson Theatre in Los Angeles with the original Phantom, Michael Crawford. D.C. remained with the L.A. production until it closed in 1993.

In all, D.C. was employed by *Phantom* for eighteen years, a tenure that included numerous swing assignments—filling in whenever a performer is unable to go on stage—for the second and third national touring companies. Three years after his Broadway debut, he joined the show's third national tour as André and was on stage for the closing night of that tour, October 31, 2010.

He still lives the life of a working, traveling actor based in New York City. When interviewed in 2017, he was in Mount Gretna, Pennsylvania, to perform the role that made his name in Elyria: Sancho Panza.

What Became of Marian Paroo?

In 1966, Elyria High School and Elyria Catholic High School embarked on something daring: for the first time, both schools staged world-class musical theater productions. EHS presented *Brigadoon*, and Elyria Catholic produced *The Music Man.* The occasion prompted a *Chronicle* editorial on May 24, 1966, applauding both schools.

In her *Chronicle* review of *The Music Man*, directed by Sister Mary Louise with music direction by Sister Mary Joanmarie, Grace Tulk wrote:

> *The standing ovation with great spontaneous applause given the entire cast of Willson's* The Music Man *at Elyria District Catholic High School last night spoke louder than words the deserved tribute for the school's first musical. If the school was ever to present this show, this was the year to do it because available for the lead role was Joseph Bonczek, senior, a young man with the right type voice and plenty of personality to carry the part off well....In her first major role, Marilyn [Firment] did an excellent job and her lovely soprano voice was a joy to hear....*The Music Man *provided an evening of top entertainment for the opening night audience which filled the auditorium.*

Joe Bonczek died in 2009; I tried to reach his wife but did not succeed. I did speak with Marilyn Firment Detmer, and she updated me on her career since her remarkable stage debut.

After graduating from EC, Marilyn studied at Baldwin Wallace College for two years as a music major, intending to minor in music education. "I was spending too much time in the theater, though," she said. "I needed to think about what I really wanted to do."

The oldest girl in a family of eight children, Marilyn returned home to live with her family on West Eleventh Street and got a summer job at the Fisher Body plant. She began formulating her plans and decided that her best path to pursuing her dreams was to major in musical theater at the Boston Conservatory.

"To pay my way, I was a singing waitress," she said.

In 1974, she moved with her college sweetheart to New York City and was cast in a national touring production of *No, No Nanette*. She understudied Nanette (playing the role in Texas) and was in the chorus. The tour included two Ohio stops, Akron and Toledo.

Marilyn Firment Detmer as Emma Bovary in *Three* at the Harold Clurman Theatre in New York, circa 1990s. *Courtesy of Marilyn Firment Detmer.*

Her small-town values nearly got in the way of her career, however. "I almost turned down an off-Broadway show, *The Gilded Cage*, because rehearsals would interfere with my going home for Christmas," she wrote in an email. "Luckily, the choreographer talked some sense into me, and it was one of my favorite theatrical experiences."

Marilyn lived in Manhattan for thirty-five years, working off-Broadway, off-off-Broadway, in commercials and movies, and doing countless odd jobs—"mostly as a caterer or as an administrative or personal assistant. Because of my piano lessons and Elyria Catholic typing class, I was a wiz."

She met her current husband on a theater tour in 1976, and they live north of Saratoga Springs not far from Yaddo, the artists' retreat. She volunteers and occasionally acts for local community theaters. "The last musical role I sang was Aunt March in *Little Women*," which was produced by the NSC ("Not So Common") Players in Clifton Park, New York.

D.C. Anderson, Marilyn Firment Detmer, and Crissy Wilczak (she returned the *c* to its rightful place in her last name) all followed their dreams, and their dreaming began in Elyria.

"I'm proud of myself and of what I accomplished," said Crissy. "My dad gave me two hundred dollars to help me move to New York. If I really knew what was ahead of me, I might have gotten scared and turned around. But I'm so glad I didn't."

TABLE 3: A LIST OF POPULAR BROADWAY SHOWS BY OPENING YEAR

1950	*Guys and Dolls*
1951	*The King and I*
1952	*The Seven Year Itch*
1953	*The Teahouse of the August Moon*
1954	*The Pajama Game*
1955	*Damn Yankees*
1956	*My Fair Lady*
1957	*The Music Man*
1958	*Flower Drum Song*
1959	*The Sound of Music*
1960	*Camelot*
1961	*How to Succeed in Business Without Really Trying*
1962	*A Funny Thing Happened on the Way to the Forum*
1963	*Barefoot in the Park*

1964　*Fiddler on the Roof**
　　　　*Funny Girl**
　　　　*Hello, Dolly!**
1965　*Cactus Flower*
1966　*Cabaret*
1967　*Rosencrantz and Guildenstern Are Dead*
1968　*Hair*
1969　*1776*
1970　*Sleuth*
1971　*Jesus Christ Superstar*
1972　*Grease*
1973　*A Little Night Music*
1974　*Equus*
1975　*A Chorus Line*

*So many enduring and popular musicals were produced in 1964 that I couldn't choose just one—so I didn't.

— Part II —

LIVING

"Operator, Could You Help Me Place This Call?"

In 1876, when Alexander Graham Bell uttered his famous phrase, "Mr. Watson, come here; I want to see you," the words heralded a revolution. On January 9, 2007, we experienced a revolution of our own: on that date, Apple CEO Steve Jobs introduced the iPhone to the world.

"Apple is going to reinvent the phone," Jobs told the gathering at the MacWorld Conference in San Francisco. With a tongue-in-cheek flourish, he announced, "Here it is," and an image appeared on the projector behind him: a white rotary telephone with a small iPod screen at the top, the hybrid's rectangular shape hinting at the grand reveal to come.

It was a wonderful joke, and the crowd roared. Thanks to YouTube, where you can watch the video, the revolution was televised.

In the years following Bell's invention, technological advancements kept the industry in flux, and several twentieth-century businesses in Elyria contributed to the evolution. At the hub of the city's communications web was the Elyria Telephone Company.

PLEASE HANG UP

When the Elyria Telephone Company was incorporated in 1897, it operated with "a small magneto board, located in the back of a small business establishment, [and] served a maximum of 100 subscribers," according to a 1957 article in the *Chronicle-Telegram*. This was typical in the industry's

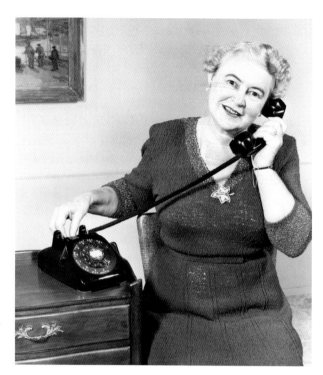

A woman uses a "volume control" telephone in this undated promotional photo. *Courtesy of the* Chronicle-Telegram *archives.*

fledgling days. John Kosto directs the Buckeye Telephone Museum in Marion, Ohio. According to him, a community's original phone system could be found in a variety of businesses from general stores to livery stables to funeral homes.

By 1899, the cover of the Elyria Telephone Directory noted that 525 subscribers had telephone service. It also admonished those subscribers to "Please Hang Up," a reminder that an open line in one's home prevented someone else from placing a call. Today, we take for granted the luxury of an immediate connection when using the phone, but well into the twentieth century, party lines were standard issue. Paulette Tomasheski Baglyos of Cleveland grew up on Grafton Road in the 1950s as one of seven children. Her family had a ten-party line shared with others in the neighborhood.

"People did listen in," Paulette said. She remembers a young couple that "swooned with each other" over the phone.

"It used to aggravate my mother so much. The boy's last name was Campbell. I don't know who his girlfriend was, but everyone knew about them. People would pick up their phones and listen to their conversations. My mother would pick up and say, 'Oh, it's Mr. and Mrs. Campbell on the phone, just goo-goo-ing over each other.' And if she had an important call

TREAT YOUR PHONE KINDLY

Your telephone, while a sturdy instrument, has delicate adjustments, so you should use it with care. The cord should be kept free from kinks. Any damage to the telephone is repaired at the subscriber's expense.

It is not advisable to attach unauthorized devices or instruments to your telephone or to lines serving it. The company's regulations prohibits this practice, and if persisted, it reserves the right to remove the attachments and cancel the contract of the offending subscriber.

NO NAUGHTY LANGUAGE PLEASE

Subscribers should not make use of foul or profane language, impersonate any other individual with fraudulent intent over the wires of the Company or use the facilities for any unlawful purposes. "Listening in" on a party line excepting to ascertain if the line is "Open" or "Busy" is prohibited.

BE A GOOD NEIGHBOR

When several persons are sharing the use of a telephone line, consideration and courtesy are important to all. Every person gets better service if they will observe these three simple rules: Be brief as possible, space your calls so the other party can place his calls and give up the line for emergencies. A new state law provides fines and jail sentences for persons who refuse to yield the lines in emergencies involving life and property or who pretend emergencies in order to obtain a line.

Public service messaging from the 1955 Elyria telephone book. *Author's collection.*

to make, she would ask them to 'wrap it up.' She would keep lifting up the receiver to make sure they were gone; once she heard the dial tone, she knew she could use the phone."

In those days, said Paulette, people didn't call each other just to chat; the phone was used for a purpose. But teenagers will be teenagers, even in the 1950s.

PHONES FOR AN INDUSTRIAL CENTER

Mike Fenik worked for the Elyria Telephone Company from 1973 until his retirement in 2013 and has amassed a collection of forty antique phones and other memorabilia. Hanging on the wall of his Wellington home is an early magneto phone produced by Elyria's Dean Electric.

Dean Electric began manufacturing in 1903 in a factory on the corner of Olive and Taylor Streets and was said to be, according to Bill Bird, director emeritus of the Lorain County Historical Society, "the largest independent manufacturer of complete telephone systems in the country."

Through time and changes of ownership, Dean Electric became Garford Manufacturing, which became the General Phonograph Company and, ultimately, General Industries. The product line of this major concern was diverse, according to Bird, and included "a vast array of things made of plastic, including phone casings."

By 1905, Elyria had become a center of industry. The telephone company needed to address the city's many manufacturing concerns and did so by embarking on a modernization program that included a battery system installed with a switchboard that could accommodate 1,200 trunk lines, which allowed for long-distance calls. They also provided intercommunication systems in the various large factory buildings that were being erected. The phone company secured larger quarters and built new lines to expand the improved system's territory.

Magneto phones such as the one owned by Mike Fenik required someone to turn a crank on the side to engage an operator. The dial telephone, introduced in 1891, allowed for a faster and easier way of placing calls, but according to John Kosto of the telephone museum, these newer phones were scarce: "Equipment supporting dial telephones was not readily available for widespread use until the 1920s." By then, one could finally swap out their old crank wall phone for a sleek new desktop model; Elyria's automatic dial system was installed in 1919. At the Buckeye Telephone Museum, a display of old dial telephones includes what Kosto refers to as a "banjo" phone, likely dating from 1907 or 1909; although Mike's collection doesn't include a banjo phone, it does feature a variation of an early dial phone.

Other early twentieth-century industry improvements brought about the pioneering move of installing underground cables, thus replacing the thicket of wires above Elyria's streets. As a cable splicer, Mike Fenik was well acquainted with what was above and below ground.

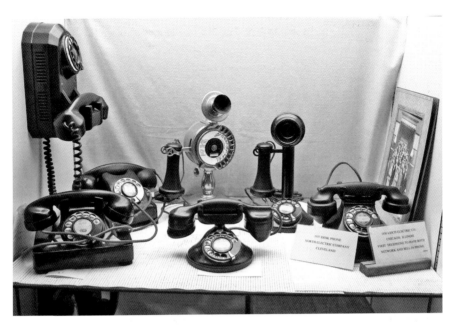

An exhibit at the Buckeye Telephone Museum in Marion, Ohio. *Courtesy of the Marion Area Convention & Visitors Bureau.*

An early rotary telephone from the private collection of Mike Fenik. Note the absence of letters on the dial. *Author's collection.*

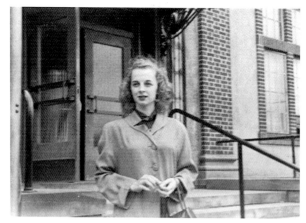

Left: Telephone operator Nancy Dunkle outside the Elyria Telephone Company on Second Street, circa 1950. *Courtesy of Nancy Dunkle Horvath.*

Below: Telephone operators on strike in 1953 at the Elyria Telephone Company on Second Street. *Courtesy of the* Chronicle-Telegram *archives.*

The Elyria Telephone Company was determined to make the Elyria exchange a model for other cities. In 1918, it moved into an elegant new building on Second Street that would serve its subscribers for the next thirty-eight years. Nancy Dunkle Horvath of Elyria worked there.

Operators Are Standing By...

Nancy Dunkle Horvath became a full-time telephone operator after graduating from Elyria High School in 1947. In an interview, she said she always loved her job.

Operators were required to work every other weekend. There were three shifts: the all-night shift, the night-relief shift (from 6:30 a.m. until 3:30 p.m.), and the day shift, from 8:00 a.m. to 5:00 p.m., during business hours. This was, understandably, the busiest shift, and the one that Nancy normally worked.

Nancy's tenure at the phone company lasted until 1953, putting her squarely at the heart of fast-paced communications. "Elyria had at least thirty industries," she said. "I could name most of them today. If you sat at the incoming board, you got to know those telephone numbers by heart, because other companies were calling Bendix, Invacare, Worthington Ball, Colson. Some business calls would come in four and five at a time. It kept me extremely busy."

This incoming board—the largest board in what was called the toll room—was dedicated to businesses placing calls to Elyria from other cities, and they came in at a furious pace. "We took them as fast as we could," Nancy said, "but it wasn't fast enough."

Also in the room were twelve long-distance boards, or toll boards, with ten circuits assigned to each. These were for anyone in Elyria—business owner or homeowner—who wished to call long distance, and to do so, they dialed zero for an operator. "We could have ten calls going at our boards," said Nancy. "After those calls were completed and we closed our key, ten people were talking long distance."

A key was one of several black switches that an operator could push forward to allow a call to drop into her board, at which point she identified herself by saying "Long distance." "If I had to talk to my supervisor without the caller hearing, I would pull the black key all the way toward me until it was in the monitor position," Nancy said.

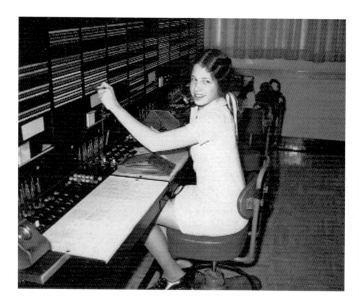

Nancy Dunkle Horvath's daughter at an operator's board during a phone company open house, circa 1969. *Courtesy of Nancy Dunkle Horvath.*

The room also included two delayed boards. Nancy explained how they worked:

> *An Elyria businessman might call the long-distance board and say "I want to talk person-to-person to So-and-So at So-and-So Company in Chicago." If it's a busy circuit, or the person is unavailable, I can keep trying. I place a red ring around the key with the call ticket propped up in front of me so I don't forget. But after a few tries, and it looks like it's going to take longer, I tell the caller that his call will have to be delayed. I alert my supervisor by placing a red card on a clip at the top of my board. She comes by, picks up the ticket with the caller's information, and takes it to the delayed board.*

Imagine needing someone to act as a go-between today, nudging our calls along by pressing buttons and flagging tickets.

Nancy ultimately became a supervisor, walking up and down the floor to offer operators any needed assistance. In 1950, she married Gene Horvath; three years later, she was expecting their first child. She was about eight months along when the chief operator, Minnie Laming, took her aside and said, "Nancy, I really think it's time for you to leave."

Wartime Communications

Mary Harrison Neuman worked as a telephone operator at the Elyria Telephone Company for forty-five years, from when she graduated from Elyria High School in 1934 until her retirement in 1979. She died in 2015. Her niece, Carol Edwards Greentree of Elyria, found an intriguing item in her aunt's belongings.

In an unassuming brown folder, typewritten orders issued by James Lawrence Fly, chairman of the Board of War Communications under President Franklin D. Roosevelt in 1942, outlined the protocols for "Urgent Telephone Toll Calls Essential to the War Effort or Public Safety." Preferred callers on the list included, among others, the president of the United States, members of Congress, the army and the navy, and civilian defense organizations. Three levels of priority were identified, with the first given to calls requiring immediate completion for war purposes—to safeguard life or property or to arrange for the movement of armed forces during combat operations.

If someone on the preferred callers list was attempting to place a priority one call, the operator had to interrupt any conversation already in progress that would get in the way. All telephone carriers were required to keep records of these priority calls, including the priority level given and whether a call had been interrupted. Within thirty days after the end of each month, the American Telephone and Telegraph Company was required to file a report for the Bell System Companies with the Board of War Communications.

The typed directives in Mary's brown folder were lightly annotated in pink colored pencil, although whether this was in her hand or someone else's, I do not know. I can only imagine what her reaction was upon receiving such an official and sobering dossier, and I wish she were alive for me to ask her about it.

Out of the Twilight Zone

The Elyria Telephone Company held the ribbon-cutting ceremony for its modern building in 1957, the same year that Madeline Whited's husband took a job at the National Tube Division of U.S. Steel in Lorain, prompting their move to Elyria from West Virginia. Madeline was in the first class of telephone operators trained to work at the phone company's gleaming new

headquarters, earning one dollar and ten cents an hour. "At the end of ninety days, we got a three-cent raise," she said in an interview. "You talk about a bunch of happy girls!"

Madeline worked for the phone company until 1983. She explained that the type of switchboard she used had twenty-five positions, making room for twenty-five operators at once, and each operator had ten sets of paired cords. When a light blinked, indicating that a caller needed operator assistance, Madeline plugged a cord into the hole below the blinking light to engage the caller, then plugged its mate into another hole to finish the call. At the bottom of her board—separate from typical, day-to-day operations—was a special section with a specific purpose: the reporting of UFO sightings. Yes, you read that correctly: UFO, as in unidentified flying object.

Seated at her switchboard, Madeline would see a light come on at the bottom. Unlike the other lights, however, this one didn't blink. It remained brightly lit, indicating that a special call required immediate attention. Madeline would have no way of knowing where in Elyria the call was coming from. She would quickly plug one of her pair of cords into the hole below the light, plug the cord's mate into an outgoing circuit, and key in a number that she can no longer recall. She was never actually on the line, and she never talked to anyone. She merely kept the call moving— managing that transfer by plugging into her circuit. She would then go about her other tasks.

"We got UFO calls all the time in the 1950s," she said. "It was very rare that you did not get one [during a shift]. When that light would come on, whoever saw it first better grab it."

"LONG-DISTANCE, PLEASE"

For those who have only ever used a cell phone, this information, gleaned from the 1955 Elyria telephone book, might help explain the concept of long distance, for which you first had to dial zero for an operator:

- *Rates were generally for three minutes.*
- *Rates differed depending upon the time of day and the day of the week; it was usually less expensive to call at night or on a Sunday, but not always. The station-to-station rate from Elyria to Akron was thirty-five cents for three minutes during the weekday, at night, and on Sunday.*

- *If you absolutely had to reach Aunt Helen in Akron and no one else, you made that call person-to-person, but you paid for the privilege: a thirty-five-cent station-to-station call to Akron jumped to sixty cents for person-to-person.*

With her parents, Paulette Tomasheski Baglyos devised a clever way to circumvent expensive pay phone calls if she was out and needed a ride home—that is, as long as her parents knew where she was going to be. Their system, arranged in advance, required Paulette to call the Tomasheski house person-to-person and ask for "Paulette" when she was ready to be picked up.

"It cost ten cents to call at a pay phone," Paulette said, "but you didn't have to put any money in when you picked up the receiver and dialed zero for an operator." She would call the operator, saying that she wished to make a long-distance telephone call, person-to-person, for Paulette, and provided her home telephone number. She would then hear her mother answer, followed by the operator saying, "I have a long-distance phone call for Paulette." "I'm sorry," her mother would reply. "She's not here."

"It didn't cost me one penny to call, and my mother knew to come pick me up."

A BUILDING FOR THE MODERN AGE

In September 1955, the *Chronicle-Telegram* published a photograph of the ground-breaking ceremony for the telephone company's sleek, modern new building. It would house all the newfangled equipment required to keep communications humming at the century's midpoint. The project, slated to cost $5 million, was located one street south of the old 1918 building at 363 Third Street on the corner of West Avenue. Roy Ammel was CEO, but within a year, he would be gone. Weldon Case of Hudson, Ohio, led the company's revitalization.

"We believe the customer is the ultimate boss and we wish to please and serve him," Case said two years later, when the *Chronicle* covered the building's grand opening. "We…will bring every improvement in the art of telephony that we can; we'll bring the kind of service people are interested in having."

Other power brokers attending the ribbon-cutting ceremony included Mayor J. Grant Keys and Otto B. Schoepfle, president of the Lorain County Publishing Company and publisher of the *Chronicle-Telegram.*

The new Elyria Telephone Company on Third Street, circa 1957. *Courtesy of the* Chronicle-Telegram *archives.*

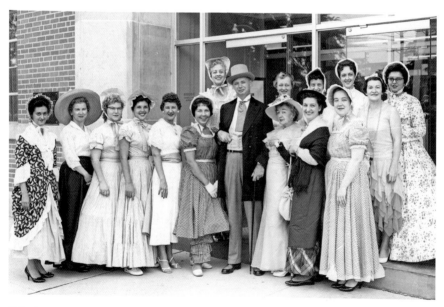

Telephone company employees celebrate Elyria's quasquicentennial in 1958. At center is President Weldon Case; Connie Conry is at far right. *Courtesy of Connie Conry Brent.*

Connie Conry Brent, now of North Ridgeville, began working at the phone company in 1955 after graduating from Elyria Catholic High School. At the time, she earned ninety-three cents an hour as a long-distance operator. "I was only going to work there for a year; then I was going to go to college," she said in a phone interview. Thirty-eight years later, she hadn't left; by the time she retired in August 1993, she worked in sales and marketing at the company's home office in Hudson and made considerably more than her initial hourly wage.

"We didn't make a lot of money, but we had good benefits, and it was a loyal company," she said. "They took care of you, and you wanted to take care of them. We were like one big happy family. I loved my job and couldn't wait to get to work."

Connie remembers the move from the old building on Second Street to the new facility on Third Street and has fond memories of Weldon Case, as well. "He was fantastic," she said. "We had sixty operators; he would visit us and call each of us by name. I was getting contact lenses; he asked me how my eyes were doing. It amazed me that he remembered me personally."

The telephone company's float in Elyria's quasquicentennial parade, August 1958. Telephone operator Connie Conry is on the swing near the back of the float. This photograph also appears on the front cover. *Courtesy of Connie Conry Brent.*

By 1958, the year of Elyria's 125th anniversary, the utility had settled nicely into its new home and placed an ad in the *Chronicle* proudly proclaiming—with capital letters for emphasis:

> *The telephone has played an ever-increasing role in the economic and social life of the community. As a public utility, we are conscious of our obligation, and, in this anniversary year, renew our pledge: THE QUALITY AND QUANTITY OF TELEPHONE SERVICE YOU WANT WHEN AND WHERE YOU WANT IT.*

Another vintage slogan, featured on the frontispiece of an Elyria City Directory, echoed the economic boom of the era: "Elyria's Prosperity is Your Security."

THE TWO-FIVE OPERATION

In 1956, the year I was born, the Elyria telephone system instituted a sweeping change: every subscriber received a new telephone number. Gone were the four-digit business numbers and the five-digit numbers for residences. Areas in the city were sectioned into exchanges—the first two being Fairfax and Emerson. The new plan, called the "TWO-FIVE operation," designated that telephone numbers would now include letters—the first two letters of a person's exchange—plus five numerals.

Before 1956, the telephone number for my father's hardware store was 2675. With the new system, the number for the store, which was located in the Fairfax exchange, became FA2-5824. In time, the phone company would add two more exchanges to Elyria: Endicott and Glendale.

Paulette Tomasheski Baglyos still remembers her family's five-digit telephone number from when they lived on Grafton Road: 84729. After the new exchanges were added, their number became GL8-4729 to indicate they were in the Glendale exchange area.

A full-page announcement in the 1955 Elyria telephone directory stated that this new system would allow the phone company to conform to the standard being used throughout the United States; it also provided greater telephone numbering flexibility for future growth and expansion.

But something else had to be taken care of: telephone dials only had numerals. No letters? No problem. The telephone company provided subscribers with new telephone dials.

REAL
WIFE-SAVER . . .
A
KITCHEN
WALL EXTENSION

● The real wife-saver in every household is a kitchen wall extension. When the telephone rings she merely reaches. No running all over the house to answer while the pie burns or the stew runs over. This wife-saver is a step-saver.

Extension telephones in other locations are wife-savers, too . . . in the living room, an upstairs bedroom, the den, the laundry or the recreation room. And the telephone which goes well everywhere is the beautiful little Princess in its array of pastel decorator colors.

The cost is less than you think . . . the convenience is more than you hoped for.

Order a wife-saver today!

 THE ELYRIA TELEPHONE COMPANY

An advertisement from the 1963 Elyria City Directory. *Author's collection.*

This significant development affected everyone in town, but there was an upside. With the new prefixes, Elyrians could now dial direct, without an operator, when calling local numbers. Businesses placed ads in the *Chronicle* congratulating the Elyria Telephone Company on this "major improvement." Botamer Florist's ad invited people to call their "NEW" telephone number: FAirfax 2-6626.

"Everything was so exciting before direct dial, because we felt so necessary to getting things to happen," said Connie Conry Brent. Operators did remain essential, however; they were still needed to call long distance and to place collect, emergency, person-to-person, and international calls.

DIRECT DISTANCE DIALING

According to an article about New Jersey firsts that appeared in the July 22, 1979 edition of the *New York Times*, the city of Englewood entered the annals of telephone history on November 10, 1951. That was the date its mayor, M. Leslie Denning, telephoned Frank Osborne, the mayor of Alameda, California, without the help of an operator. Thus did Englewood, New Jersey, become the first city in the United States to offer its residents coast-to-coast direct-dial service. It would be eight years before this technology reached Elyria.

To prepare subscribers for this latest communications marvel, the phone company touted the coming change in a full-page announcement in its 1958 directory.

"Direct Distance Dialing," or DDD, meant that someone in Elyria could call a number in New York City entirely on her own without the aid of an operator. If the TWO-FIVE system meant that someone could call locally without an operator, DDD meant that callers could now use area codes—the three-digit prefixes assigned to specific locations in the United States by the North American Numbering Plan. This was rather like being given the secret code to a locked safe; until this time, only operators had access to area codes. Elyria residents will remember being part of the Cleveland 216 area code until 1997, when a new area code, 440, was assigned to the region.

STILL FASTER SERVICE ON THE WAY

By midsummer 1959 Elyrians from their own telephones will be able to dial numbers in all parts of continental United States just as easily as they call a neighbor on the next street. This will be made possible by DIRECT DISTANCE DIALING—D D D—the latest communications marvel.

The first step was taken for D D D when Elyria's TWO-FIVE dial system was placed in service last August. Then Elyria was tied in with the nation-wide uniform numbering system setup to speed long distance calls.

D D D will put millions of telephones at Elyria's fingertips.

The announcement of a revolutionary dialing development in the 1958 Elyria telephone book. *Author's collection.*

MERGERS AND ACQUISITIONS

In 1960, Weldon Case combined the Elyria Telephone Company with four other small Ohio telephone companies to form a family-owned enterprise called Mid-Continent Telephone. A new sign went up on the building, and Weldon's brother Baxter was appointed president and general manager of the Elyria operation. At the time of Baxter's untimely death in 1976, at the age of fifty, he was manager of Mid-Continent's Western Division. Another Case brother, Nelson, was the regional manager for Ohio.

In 1983, the signage on the building changed again when Mid-Continent merged with the Allied Telephone Company of Little Rock, Arkansas, forming an entity called Alltel. Eighty-six years after the incorporation of the Elyria Telephone Company, with its one hundred subscribers, its new iteration, Alltel, had 842,000 customer lines and was the nation's fifth-largest local telephone company. Weldon Case served as Alltel's chairman and chief

executive until he retired in 1991. After his death, on September 30, 1999, Saul Hansell of the *New York Times* wrote that by then Alltel had a million customers in nineteen states.

The year 2006 saw another major corporate change. Alltel—by now involved in wireless as well as hardwire communications—spun off its landline business and merged it with VALOR Communications Group, forming the Windstream Corporation. Mike Fenik worked at the phone company throughout all these iterations, beginning with the Mid-Continent days and through his retirement from Windstream in 2013; his collection of phone memorabilia includes Mid-Continent and Alltel signs.

The building that opened on the corner of West Avenue and Third Street with such fanfare in 1957 still stands, but it sports a Windstream logo. The company uses it as an operational base for some of its hardwire systems.

As a child, I would go with my mother to the Elyria Telephone Company when she paid the phone bill. I remember looking at the display cases in the lobby, artfully arranged with telephone directories from past years, and the different models of telephones featured like so many new cars in a dealer's showroom. These were not phones that you bought. These were phones that you rented through the phone company, and your bill included a fee for the company's technician to do the installation. Another line item on your bill indicated the monthly charge to rent your princess phone, your sturdy black rotary dial phone, or your sleek, space-age Ericofon. My father had a red Ericofon in his hardware store.

The lobby sits unused and empty now, but the past hangs in the air like a remembered phone conversation. Outside, two brass plaques flank the locked doors at the Third Street entrance. They announce, simply: "TELEPHONE COMPANY."

To Market, to Market: The Corner Grocery Store

On the south side of Elyria, where I grew up in the 1950s and 1960s, I never had to walk very far to get my Popsicles. Bounded by ten blocks between Seventeenth Street to the south and Seventh Street to the north, no fewer than eight small grocery stores dotted Middle, West, and East Avenues.

We lived on East Fifteenth Street. Following the closure of my grandparents' store one block south, our primary shopping destination was the South End Market on the corner at 1415 Middle Avenue. That's not what we called it, though. My mother sent me to "Dombrowski's Market," adding an "m" where there was none. It was only when I interviewed Jack Golski, a grandson of the store's founders, that my childhood error was corrected.

To get there, I had to be old enough to cross Middle Avenue. I figure this would put me at around age five or so, a seasoned graduate of Safety Town, which I had attended at Hamilton School. With my mother's list in hand, and giddy at the prospect of being allowed to buy something for myself, I reached the corner and looked south, waiting for a lull in the traffic. At the concrete and grass oval separating the opposing lanes, I paused again, this time looking north.

The squat, wood-framed building beckoned, its large, plate-glass windows flanking two center doors, and I stepped up the riser to enter. The air inside smelled vegetal and fruity, with an underlying note of Pine-Sol. My purchases (Wonder Bread, bologna, and—encased in blue and clear cellophane—celery and a head of iceberg lettuce) filled the paper bag, which I juggled on

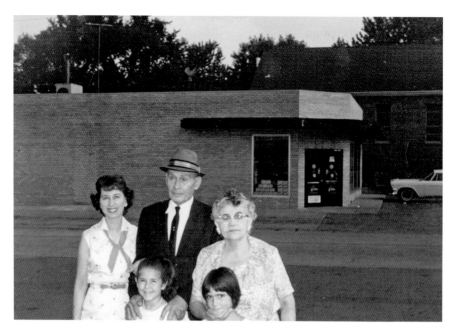

Standing outside the Abookire store around 1961 are the author, Marci Abookire Rich *(front row, left)*; her cousin, Sharon Sofra Kessler *(front row, right)*; the author's mother, Angela Abookire *(back row, left)*; and the author's grandparents, Anthony *(back row, center)* and Marie *(back row, right)* Abookire, the store's original owners. *Author's collection.*

the walk home with the Popsicle I'd chosen from the freezer case at the front of the store. The confection melted down my fingers, staining them a sticky orange—a satisfying reward.

As difficult as it is to imagine today, in 1963, some thirty-eight family-owned grocery stores were situated throughout Elyria. Back then, people could walk up the street to buy fixings for breakfast, lunch, or dinner. Customers short on cash could charge their groceries and pay when they were able. The South End Market and Hales Finer Foods even delivered.

The families who owned these stores, including their children, worked long hours every week to provide food and a gathering place for their neighborhoods. Jack and Katherine Jacoby, owners of the Evergreen Food Store on East Avenue, never took a vacation in the forty years that they managed their market.

The grocers were immigrants and first-generation Americans. My grandparents, who founded Abookire's Grocery and Meats, emigrated from Beirut, Lebanon. John and Josephine Dobrowski, of the South End Market, were Polish immigrants. Albert and Ethel Hales, who started Hales Finer

Foods, crossed the pond from England. And the Jacobys of the Evergreen arrived from Austria-Hungary and West Prussia. Although he was born in Girard, Ohio, Philip Gerdine, owner of Frank's Foodway Market, was a first-generation American; his parents came from Italy, but his wife, co-owner Ann (née Polimene), was born there, in Reggio-Calabria.

It is a sad irony that among these family-owned stores, the last to remain open was the first to disappear from the streetscape. Hales closed in 2005 but was torn down in 2017. The other buildings remain, but they are shadows of their former selves, recognizable only to those who shopped there decades ago and remember the food, flavors, and stories contained within as important markers in their lives. Dobrowski's store is vacant. The Evergreen is now home to the East Avenue Market, a catering enterprise that also serves carryout sandwiches, salads, and chicken wings. There appears to be a market in the old Frank's Foodway, but when I was last in the neighborhood, a sign on the door stated that it was closed for remodeling. The Abookire market is now a food pantry organized by the Asbury United Methodist Church next door, open on the first and third Saturday of each month, according to Kim Jones-Beal, treasurer of the church.

It is heartening that at least a couple of these places are still providing nourishment to the south side, but there is nothing in Elyria today like the variety and convenience offered by its old corner grocery stores.

ABOOKIRE'S GROCERY & MEATS

My grandparents Anthony and Marie Abookire emigrated from Beirut, Lebanon, and in 1919 they settled in Elyria. The following year, my grandfather established the city's first army surplus store on West Broad Street, but his true calling was the grocery business. He and my grandmother opened their market at 1621 Middle Avenue in 1923, managing it until 1948, when their son, my uncle Norman, and his first wife, Mary, took over.

In what becomes a recurring theme throughout this chapter, the Abookires—like other market-owning families— lived close to one another and to the business: my grandparents initially lived across the street from the store, then purchased a home next to what is now the Asbury United Methodist Church. Norman and his family lived across the street on Middle

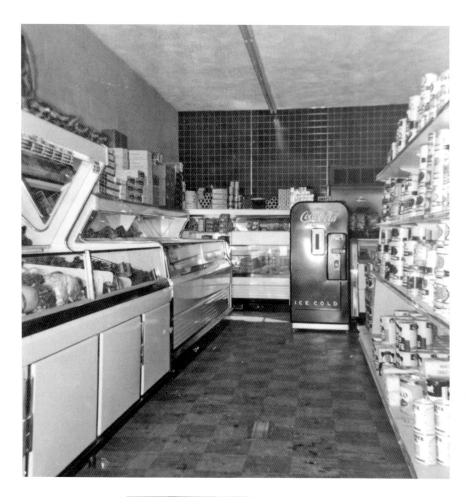

Above: Inside Abookire's Grocery & Meats, circa 1955. *Courtesy of Norma Abookire.*

Right: Mary Abookire, Norman's first wife, at the register of Abookire's Grocery & Meats, circa 1955. *Courtesy of Norma Abookire.*

Avenue before moving to East Fifteenth, and my parents and I lived next door to his family. My aunt Gloria and her family lived across the street from the grocery; she also worked there for a time. No matter which way I turned, aunts, uncles, and cousins were close at hand.

Photographs in my collection and those shared by my cousin Norma reveal that the original Abookire grocery was a small brick building set close to Middle Avenue. At some point in the late 1950s, the first store was torn down to make way for the new store, which was set farther back from the street to provide for parking in the front. I asked Norma, whom everyone calls Nuny, to share her memories. She graduated from Elyria High School in 1961 and now lives in Cleveland.

"I remember Luke Easter visiting the store," Nuny wrote in an email. (Easter was once a first baseman for the Cleveland Indians.) "I was sitting on the ice cream cooler, and there he was! Too bad I didn't get a signature."

Both of our fathers served in the U.S. Army during the Second World War. Norman, wrote my cousin, "was so enamored with his stint in the service that he had a sign designed for the store with the Third Armored Division logo."

In one of the letters that my father wrote home to his parents when he was in the service, he alludes to the hardships endured by many grocery owners: "Try and not work too hard Ma as I don't want you to. I'd like to see you & Pa on a vacation this year."

The store closed in 1963.

Evergreen Food Store

"My father was lucky to get out of Europe when he did," said Sharlet Jacoby Berman of Mayfield Heights. "So was my mother."

Sharlet's parents were Jewish. Jack Jacoby, born in Austria-Hungary in 1909, was one of five sons whose father made the voyage to the United States, became a citizen, and settled into a job—first in Cleveland, then in Lorain—before making five trips back to Europe in the early 1920s to bring over his wife and sons. With each return to Europe, said Sharlet, her grandfather had to sneak back in. "If he'd been caught, he would have been conscripted, as well as the young boys."

The story was similar for Sharlet's mother, Katherine. Her father had served in the Prussian army during the First World War and was aware of

the political climate in postwar Europe. When Katherine was ten, her father gathered her up with the rest of the family, took them to the cemetery so they could say goodbye to their ancestors, and brought them to America. Katherine met and married Jack in Lorain; they moved to Elyria and opened the Evergreen, at 1115 East Avenue, in 1935.

In addition to Sharlet, who graduated from Elyria High School in 1957, Jack and Katherine had a son, Dovid, called "Danny," who now lives in Israel.

Food was scarce during the Second World War and tightly controlled by the government through ration books and tokens. Sharlet wrote in an email, "Holiday times really saw short supplies."

She worked in the market as a child, clerking, stocking shelves, and doing whatever was needed at any given moment. She often accompanied Jack when he drove to the Cleveland Food Terminal or to local farms to stock up on fresh fruits and vegetables.

She remembers children bringing in empty soda-pop bottles for the two-cent deposit. "Funny, these glass bottles never got broken, but milk bottles often did!"

The store was small, just forty feet long and eighteen feet wide, but the vast array of merchandise Sharlet recounted suggests an emporium: cleansers and clothespins and Mason jars; flypaper and moth balls; bananas in a container called a "banana boat"; cigars in mahogany wood boxes and Bond Street pipe tobacco; cigarettes; Barbasol and Burma-Shave creams; Ipana and Pepsodent toothpowder in cans; Log Cabin syrup in a metal container shaped, well, like a log cabin; flour and canned fruits and vegetables and yeast and much more.

I have vivid memories of this store. My mother and Katherine Jacoby were friends, and I often walked with my mother when she visited "Katie" in the Jacobys' upstairs apartment next door to the store. Before heading home, we stopped in to purchase some needed item or other. I was particularly fascinated by the long wooden stick with tongs and a hook at the end that Jack would use to grab a roll of toilet paper from the top shelf behind the counter.

Jack and Katherine, who was fondly known as "Missus Jack," were respected fixtures on East Avenue. On December 18, 1984, a few days after Jack died, the *Chronicle-Telegram* honored him with an encomium. It read, in part:

He could have become rich, a friend told us, but Jack never cared much about material things. He preferred to be among his friends, where he could help people. Jack was particularly fond of the young people who hung

Three schoolgirls at the Evergreen Food Store on East Avenue, circa 1971. Store owner Jack Jacoby is at rear. *Courtesy of Sharlet Jacoby Berman.*

around his store. He was patient with them, gave them the benefit of his wisdom, and kept track of them when they left town to go to school and start careers of their own.

Katherine began writing her reminiscences of the store in 1970 and had one bound copy of the book, complete with photographs, privately published. *And Yet It Stands* recounts the Evergreen's Depression days, the shortages and rationing of World War II, and stories about the beloved neighborhood children.

A passage from Katherine's preface was prophetic:

The neighborhood store is gradually disappearing from sight, good only for the record in years to come, when Grandma and Grandpa may tell their darling grandchildren the way they remember it; when one ran to Jack's the friendly neighborhood grocer, for emergency items in time of need, or perhaps for a loaf of bread or a quart of milk, late in the evening…

The Jacobys closed their store in 1975.

Frank's Foodway Market

Sometime in the early 1960s, after Ohio repealed its "blue law" prohibiting stores from being open on Sundays, my mother and I often stopped at Frank's Foodway Market after Mass at Holy Cross before walking home. We typically bought natural-casing hot dogs, which she boiled in water and served for lunch on hot-dog buns with mustard or ketchup. To this day, whenever I think of hot dogs for lunch on Sundays, I think of the Cleveland-based television programs that aired around noon on that day, *The Gene Carroll Show* and *Polka Varieties*, which my mother enjoyed watching while we ate.

Philip and Ann Gerdine opened Frank's Foodway Market at 1412 West Avenue in 1942 and operated it until 1985, when they sold it to new owners. Their daughter, Fran Gerdine Zimmerman of Westlake, recalls that on a typical day, every Monday through Saturday, her father woke up around 5:00 a.m., had a cup of instant coffee, and went down to the store, working from 6:00 a.m. until 7:00 p.m. After the blue law was repealed, his Sundays began with early Mass at St. Mary's followed by work at the store, which he kept open until noon.

The fact that everyone we knew seemed to know or be related to everyone else reinforced the sense that ours was a close-knit neighborhood. Ann Gerdine's parents, Francesca and Stefano Polimene, lived on our street and were family friends; my mother often sent me to pick fresh mint from their garden. Ann and Phil Gerdine had purchased their store from the Sharps, a family related to Ethel Hales of Hales Finer Foods. Ann Gerdine's sister Mary was married to George "Bucky" Ross, who owned the White Horse Custard Stand on West Avenue, where we went in the summer for cones. In Elyria, there always seemed to be fewer than six degrees of separation.

Fran remembers the lively neighborhood as providing everything a person could ever want or need, with businesses including Herb's Laundrymat, Sito's Polish Village, Gigi's Barber Shop, Mitchell's BBQ, the custard stand, and Halliburton's Dry Cleaners. On Fridays, people walked to the Polish Club for carryout fish fry. (So did we.) "Everyone looked out for everyone else," said Fran.

The Gerdines lived above the store, and Fran's parents first settled in the largest of the three upstairs apartments. Her aunt and uncle, Angelina and John DeTillio, lived in the next-largest apartment. Before Fran's grandparents, the Polimenes, moved to East Fifteenth Street, they lived in the smallest one. Fran's family eventually moved to Miami Avenue in 1956,

Phil Gerdine, owner of Frank's Foodway Market on West Avenue, circa 1974. *Courtesy of Fran Gerdine Zimmerman.*

when she was three, but the vacant apartment was soon inhabited by another aunt and uncle, Edith "Toodie" and Frank Polimene.

Why wasn't Frank's Foodway Market called Phil's Foodway Market, after its owner? According to Fran, the most likely reason was because Elyria already had a grocery store with Phil in its name—Phil and Harve's on Lake Avenue. "Grandma Polimene suggested the name of Frank's for Uncle Frank.

"Bread was delivered every weekday except Wednesday by drivers from bakeries like Wonder, Nickles, and Laub," notes Fran, who also remembers their drivers. "There were chip deliveries and pop and beer and wine

deliveries. The back of the store was the full-service meat counter. My dad was a wonderful butcher, and people came from all over to buy the steaks and roasts. I remember having head cheese, tongue, chitterlings, pigs' ears and feet and all the delicacies of the era."

Phil Gerdine allowed people to charge their groceries and make payments when they could or pay their bill in full on payday. "A lot of families in the neighborhood had store credit," Fran said. Many people over the years have told her, upon finding out who she was, "what a blessing it was to be able to charge items and to pay later."

Fran said that her older brother Sam played football in a field next to the store in the late 1940s before a parking lot curtailed that activity. The store was originally heated by coal, which was delivered and dumped down a coal chute next to the back door on Fifteenth Street; she recalls Sam's memory of taking a big round bucket and carrying the coal to the furnace, which was eventually replaced by a boiler.

Fran and Sam worked in the store, with Fran typically at the cash register: "To this day, I would rather bag my own groceries. Gotta use every square inch of the bag!" She said her favorite store memory dates from the early 1960s, when Henri Mae Ogle taught her how to dance the twist in the cereal aisle.

HALES FINER FOODS

Albert and Ethel Hales established their Middle Avenue market in 1919 after originally opening on West Avenue in 1912. Through the years, the store was an Elyria institution no matter what it was called—Hales Finer Foods, Hales Superette, Hales Grocery, or Hales Market.

During an interview, their grandson, Richard Hales, got up from an ottoman in his living room to retrieve something. "This was my daughter Angie's idea," he said, handing me a large, spiral-bound book. Notes of gratitude filled its pages, written by customers who came in to make final purchases and say goodbye in 2005, during the store's waning days. The building was demolished twelve years later.

Richard said that he and his brother Gary "basically grew up in the store. I was on the books by the age of nine." They stocked shelves, bagged groceries, and, when they were old enough to drive, made deliveries. I remember Richard and his brother bringing groceries in a cardboard box

Hales Superette (aka Hales Finer Foods), 715 Middle Avenue, 1960s. *Courtesy of Richard Hales.*

to our side door many times after my father died in 1969, when my mother decided, after trying to learn, that driving wasn't for her.

John Hales, Richard's father, and John's brother Ellsworth joined the family business after World War II and purchased the store from their parents in 1948. Albert died in 1963, but Ethel, also known as "Grandma Hales," continued working at the counter until the age of eighty-nine, according to a 1995 *Chronicle* article by Connie Davis. Hales was the quintessential family business, and Richard and Gary took over in 1975. They guided it through to the end.

"When we were younger, my father and my uncle would go in on Friday nights after supper and stock the shelves, and Uncle Ells would process the meat for the next day," said Richard. He explained that deliveries would arrive from vendors such as Seaway Foods toward the end of the week, and they were first stored in a back room. Then, on Friday night, the Hales crew would carry all of those boxes into the store, set them in their appropriate aisles, and begin stocking the shelves. "When we got home, Mom [John's wife, Flossie] would make us a root beer float, so that kind of incentive helped."

Richard Hales with the notebook of gratitude signed by store customers. Photograph taken by the author on March 11, 2018. *Author's collection.*

Working together as a family was a tradition established when Albert and Ethel arrived from England with only $500 and a positive attitude. The couple lived above the small store that they had taken over on West Avenue in 1912, the first iteration of a Hales store.

They were still living there when their first three children, Lawrence, Irene, and Ellsworth, were born; John came along after the family had moved to a new home farther north on West Avenue.

"Grandma Hales" was as famous for her devotion to the business as she was for the pies she baked and sold to help the family survive the Depression. She was also highly praised for her ham loaf.

Her recipe, like the formula for Coca-Cola or the eleven herbs and spices in Colonel Sanders's Kentucky Fried Chicken, remains highly classified. No amount of prodding could convince Richard to share it with me. He once put up 170 pounds of the meaty delicacy for a church banquet, and, as reported by Connie Davis, declined to give the recipe to a visiting missionary from New Zealand who wanted to take it back with him.

One day, Richard suggested to his father that they make the ham loaves as an oven-ready freezer product. The idea "took off like crazy," he said. "We still have people who ask for that ham loaf."

The brothers remodeled the rear of the store to accommodate a production facility, passed state inspections, and sold loaves to a handful of other Ohio stores for several years. "We were also able to ship one or two loaves at a time to residents in fifteen other states," said Richard. When they closed the store, they took orders from Hales' customers for one thousand pounds of ham loaf. And although Richard still prepares them for family today, he has no plans to make them widely available again. (In the name of full disclosure, after our interview, Richard gave one to me. It was delicious!)

Hales was also famous for its prime meats and homemade sausage. "I miss them so much," lamented one of Richard's cousins, Sharron Vanek of Elyria. "They had the best hamburger!" Sharron's mother, Bessie, was married to Lawrence Hales, John and Ellsworth's brother. Bessie also worked in the store.

Irene, Albert and Ethel's only daughter, moved with her own daughter, Carol Gerber Czarnecki, to the downstairs Hales apartment after separating from her husband. She also went to work in the store. "I was very close to my grandparents," said Carol, of Elyria. "Every Sunday, my mother and I ate dinner with them—roast beef and Yorkshire pudding, a typical English dinner."

In 2005, when word began to get out that the store was going to close, people stopped in to reminisce while they shopped. All of the memories and everything that happened on that corner for nearly ninety years filled Richard's mind. "These people were more than customers," he said. "They became your friends."

He still has a letter from a third-generation customer who came in one day in tears after learning the store would soon be gone. She was so upset that she spent a sleepless night writing a five-page letter. "I just had to get this out," she said, handing it to him. "I didn't read it until later," he said, and when he finally did, he was also in tears.

The day they closed, Richard remembers, as they were about to turn the key for the last time, Jean Bowen came in. "What," she asked him, "am I supposed to do now?"

THE SOUTH END MARKET

Easter is when Jack Golski's memories of the South End Market are the sharpest. The store, at 1415 Middle Avenue, is the one I walked to most frequently as a child. His grandparents, John and Josephine Dobrowski, Polish immigrants who arrived in Elyria as children, founded their store in 1915. John had a smokehouse in the back, where he smoked Easter kielbasa and hams. Norma Conaway, writing for the *Chronicle-Telegram* in 1963, asked him what it took to make good Polish sausage. "Good pork, good veal, and good beef and just the right spices," he carefully replied. "Of course, you have to know exactly what spices to use and how much."

Like the Hales family's ham loaf, Dobrowski's kielbasa recipe was a closely guarded secret. It helped that it was stored in his grandfather's head, said Jack.

"Life for my grandparents centered around two blocks in Elyria," remembers Golski, who lives in Amherst. "Work at the store, church and school at Holy Cross, and socializing at the Polish Club."

This was an exceedingly full life. John and Josephine raised eleven children while maintaining the grueling hours demanded by their market, yet John found time to become the first president of the Elyria United Polish Club, a president of the Holy Name Society, and president of the Cleveland Food Dealers Association. The 1963 *Chronicle* article noted that in the early days, Josephine "clerked, cut meat, and now and then took time off to raise her family."

John Dobrowski was a huge fan of the Cleveland Indians; Jack remembers the store radio tuned to their games.

He also remembers proximity to extended family, with everyone working at the market at one time or another. John and Josephine lived on the corner of Middle Avenue and East Sixteenth Street, one block from the store. Jack and his parents, Dan and Sophie, lived nearby on Sixteenth Street. Another Dobrowski daughter, Mary Rybarcyk, lived on the corner of Middle Avenue and East Fifteenth Street, directly across from the store.

Like Jack Jacoby, John Dobrowski drove to Cleveland each week to buy his produce and delivered groceries in Elyria in his panel truck. He regularly visited the stockyards in Creston for livestock and owned two large farms in Oberlin, where he had a slaughtering house. He was still butchering his own meat at the age of seventy-five. Letting anyone else do it was not an

John Dobrowski, owner of the South End Market, near his store's self-serve cooler, circa 1938. *Courtesy of Jack Golski.*

option; he simply would not have been satisfied. He did, however, pay others to raise wheat, corn, oats, and hay on 262 acres of land that he owned off Diagonal Road.

Josephine Dobrowski died in March 1971. Three months later, John shuttered the store. Thirteen months after that, at the age of eighty-four, he, too, was gone, and a neighborhood landmark passed into memory.

ELYRIA'S FAMILY-OWNED GROCERY STORES IN 1963*

B & B Food Market, 327 Lake Avenue
Bilow's Variety, 515 Clark Street
Block's Grocery, 830 West Avenue
C & J Superette, 125 Hilliard Road
Cascade Grocery, 969 West River Road
Dodsley's Cash Market, 432 Cleveland Street
Don's Food Market, 2002 Lake Avenue
East Side Food Store, 300 East River Road
Eastgate Variety Store, 616 Prospect Street
Elyria Dairies, 123 Lake Avenue
Evergreen Food Store, 1115 East Avenue
Fell's Market, 1501 Grafton Road
Frank's Foodway Market, 1412 West Avenue
Griswold Road Meat Market, 1627 West Griswold Road
Hales Finer Foods, 715 Middle Avenue
Isaly's Cleveland Street Store, 360 Cleveland Street
Isaly's Dairy Store, 346 Broad Street
Lindale Food Market, 2110 South Middle Avenue
Lindway Market, 913 Lake Avenue
Madara Creamery, 901 East Avenue
Maiher's Groceries & Meats, 98 Courtland Street
McDonald's Grocery, 1217 West Avenue
Molosky's Grocery, 1401 East Avenue
Norris Groceries & Meats, 1701 Lake Avenue
O'Brien's Food Fair, 208 Cleveland Street
Packinghouse Market, 565 Broad Street
Pallas Dairy, 800 West River Road North
Pete's Foodtowne, 104 Oak Street
Phil & Harve's Foodway Market, 422 Lake Avenue
Rolings Food Market, 320 East Broad Street
Ross Grocery, 309 Eighteenth Street
Salyi's Market, 387 Furnace Street
Schmidt's Food Market, 821 East River Street
G.A. Smith Grocery, 108 Irondale Street
South End Food Market, 1415 Middle Avenue
Vargo's Market, 900 Lake Avenue
Wooden's Food Market, 442 Cleveland Street
Wycosky's Fine Foods, 602 Lodi Street

Former Elyrian Bob Bailie captured this detail of Capt. E-Z's on Middle Avenue in the 1970s, when he was an art student. *Courtesy of Bob Bailie.*

*Missing from this list are the corporate chains: the A&P, of which there were four; the two Second Street stores, Fisher Foods and Kroger; Pick-N-Pay in North Ridgeville; and Lawson's Milk Stores, of which there were also four—on Middle Avenue, Cleveland Street, Lake Avenue, and East Broad. Neither the Abookire Grocery and Meat store, which had closed, nor the legendary Captain E-Z's, which opened on Middle Avenue sometime after 1963 and was popular with Elyria High School students for the proximity it offered them to candy, soda pop, and comic books, were listed in the city directory that year.

Cascade Park: An Urban Oasis

T he east and west branches of the Black River cut through Elyria like an unclasped, upside-down necklace, converging in a serpentine pendant in the heart of Cascade Park, then flowing northward toward Lake Erie. The area's indigenous people—most likely the Wyandots, who, by 1655, had vanquished the powerful Erie tribe—gave the river a musical name: Canesadooharie (kah-NESS-ah-DOO-hah-REE), which meant "stream of fresh water pearls" according to Frank Wilford's 1936 book, *Cascade Park: Elyria's Beautiful Natureland*.

Sometime after the first Europeans arrived in 1755, the park's trademark feature lost its poetic nomenclature to become the more prosaic Black River. But the 135-acre urban oasis we know as Cascade Park—which has been called a miniature Yellowstone and Elyria's Central Park—remains, without question, a pearl of great price.

I knew nothing of these wonders when I was growing up. My obsessions were the swings and slides on the playground, the sand trickling into my canvas sneakers while I ran to keep up with the merry-go-round before jumping onto its wooden platform, the thrill of riding in my father's car while he drove us across the auto ford. What kept our car from sinking into the river? From my sledding hill perch on a hot summer night, I shuddered at the thundering cannons of Fourth of July fireworks, which lit up the inkwell sky with dazzling hues and cascading arcs, then sizzled out in a haze of smoke.

That's my childhood history. But Cascade Park was here ages before 1962.

Above: The Black River in Cascade Park, undated photo. *Courtesy of the Elyria Public Library.*

Left: Visitors to Cascade Park could once cross the Black River by driving across a shallow ford. This photograph was taken around 1935. *Courtesy of the Elyria Public Library.*

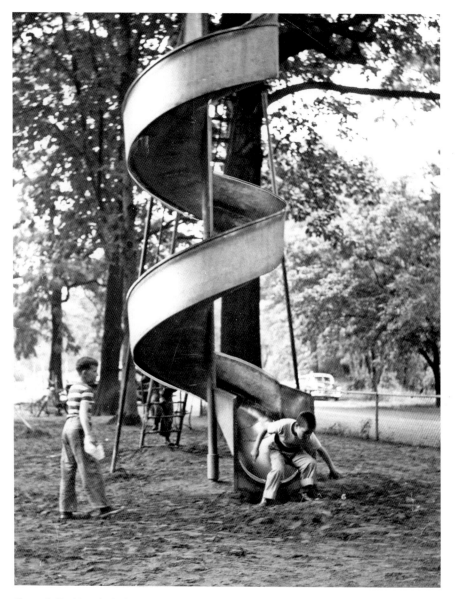

Cascade Park's spiral slide, June 1955. Photograph from the *Cleveland Press*. *Courtesy of the Lorain County Historical Society.*

EARLY HISTORY

Frank Wilford described his book as "a detailed record of the gorges of the Canesadooharie as gleaned from available historical data, from the rocks and caves, and from the memory of man, together with touches of Indian tradition and mystic lore."

The park's earliest inhabitants found much to sustain them. The area was considered one of the greatest game countries on the continent, with elk, deer, bear, buffalo, wolves, wild cats, and turkeys roaming in abundance.

The nucleus of Cascade Park was created in 1894 when, just before his death, Heman Ely II, the oldest son of Elyria's founder, along with his son George Henry and nephew William A. Ely, deeded a fifteen-acre tract to the city that included land on both branches of the Black River and their junction.

As an aside, Elywood Park is technically part of Cascade Park, according to Jeff Sigsworth, a board member of the Lorain County Historical Society. The land on the east side of the Black River north of the junction where the two branches merge, bordering Washington Avenue, was first donated to the city by members of the Ely family in 1925.

In 1900, the Ely cousins donated a second parcel of land—the rocks and caves of the Black River's west bank on the west branch. That included the Old Stone Quarry, Shelter Cave, the Ancient Waterfall, Oyster Shell Rock...and the Bear's Den.

The bear cave in Cascade Park, 1949. Photograph by Perry Frank Johnson. *Courtesy of Lorain County Metro Parks.*

MINKS AND ROBBERS...

At one time, there existed something called Mink Run—a small cavern directly west of what was known as the Big Cave, an impressive rock opening adjunct to the West Falls. Mink Run, wrote Frank Wilford, led from the rear of the waterfall back into the rocks for some distance and could only be reached when the water was low.

"Standing back of the fall," he wrote, "it is plainly seen as an ideal animal retreat, for, as its name indicates, it was long the abode of the elusive mink. The last pair of mink were spotted during the summer of 1925."

Fur of a different sort looms large in Cascade Park lore.

Blinky Morgan and his gang, famous desperadoes who terrorized the area in the late nineteenth century, purportedly stashed furs they had stolen from a downtown Cleveland department store in a Cascade Park cavern. The Robbers' Den—so called because a counterfeiting operation had once used it as a rendezvous—was the perfect hideout for Blinky and Co.

On the night of January 26, 1887, according to the *Encyclopedia of Cleveland History* and a *Chronicle* account by Connie Davis, the gang robbed the Benedict and Ruedy store of a large number of valuable furs. On the run after the heist, and with police alerted in two states, they boarded an eastbound train in Bedford, stashing the furs in two trunks. On February

309:—Entrance To Big Cave, Cascade Park, Elyria, Ohio.

Postcard of the entrance to the Big Cave, circa 1930. *Courtesy of Lorain County Metro Parks.*

10, 1887, while trying to rescue a gang member who was taken prisoner, the outlaws shot and mortally wounded a Cleveland detective on a train returning from Allegheny, Pennsylvania. It is a breathless story of cops and robbers worthy of a film treatment.

Whether the furs remained on the train or ended up in the Robbers' Den is a mystery. In 1913, Wilford wrote, a flood destroyed every vestige of the main entrance to the den—"rock and earth slides have concealed its former vastness." By 1936, what remained of the cave could only be reached by a small and dangerous side crevice.

...AND BEARS—OH MY!

Once upon a time, there were four black bears. They lived in a wood called Cascade Park in a cage tucked into a grotto once used as a Native American campfire site (see image on page 121).

If you grew up in Elyria in midcentury, you already know their names: Grandma, the Mama Bear; Pete, the Papa Bear; Sophie, given to the park by a man from New London; and Gracie, the Baby Bear.

Cascade Park employee Richard "Dick" Gibbons, circa 1957, with Gracie the bear cub. *Courtesy of Dick Gibbons.*

Like Sophie, Gracie was born in the mid-1950s. Unlike Sophie, Gracie was one of three cubs born to Grandma and Pete. Cubs born in captivity are, at times, at risk of being killed by a parent, and that's what happened—Pete killed two of the cubs. Park warden John Machock took the survivor into his home to protect her and named her Gracie.

The warden lived with his wife, Bernadine, and their five children in a red house on West River Road near the park entrance and the sledding hill. They cared for Gracie, feeding her from a bottle like a baby and playing with her the way they played with their cocker spaniels.

When Gracie was nearly full-grown, however, John Machock knew she had to return to life in the den.

PLEASE FEED THE BEARS

"Johnny Machock saved Gracie's life," said retired city employee Gary Siwierka of Elyria in a phone interview. After experiencing life among humans, the bear was as gentle as a dog. "She would bump you with her head until you petted her in the back of the neck."

Gary worked at Cascade Park for thirty years beginning in 1972; feeding the bears was one of his duties. He recounted a legendary story that has been passed on since the warden died in 1965: While Gracie was still a liberated cub living with the Machock family, she reportedly made the rounds of Elyria's taverns.

According to an archival *Chronicle* article by Connie Davis, Gracie was occasionally taken bar-hopping in Elyria, during which she cultivated a taste for beer. Richard "Dick" Gibbons, who began working at the park when he was eighteen and remained there for more than forty-five years, helped care for the bears. He told Davis—and coyly reiterated to me during an interview at his Elyria home—that he really couldn't say who was in the driver's seat during Gracie's pub crawls.

Having graduated from the, um, beer bottle, Gracie eventually indulged in a slightly more traditional bear diet, at least for Elyria bears: a mixture of skim milk, sardines, and stale bread from Link's Bakery. Park officials ultimately acquired a diet recommendation from the Cleveland Zoo: Dad's Dog Food— three tons per year were required to satisfy the four bears' appetites.

Papa Bear Pete had to be put down in the mid-1960s, and Mama Bear Grandma was euthanized sometime after 1969. Survivors Sophie and Gracie

remained to charm Elyrians into the 1970s. At nearly twenty-five years of age, in 1979, Gracie had to be put to sleep. Sophie, who was nicknamed Mona because of her grousing, lived for another six to eight months. But before shuffling off their mortal coils, Grandma, Sophie, and Gracie would have one last great adventure.

WATER, WATER EVERYWHERE

With its two waterfalls—the highest natural falls in northern Ohio—the Black River has historically been a boon to Elyria. The *Chronicle's* Connie Davis wrote in 1978:

> *Just downstream from the Washington Avenue bridge is the crescent of a dam which once impounded water for mills, later for a power plant that supplied electricity to the city. A short distance beyond the dam the river plunges in a 40-foot cascade over the East Falls into a gorge carved by glaciers during the Ice Age.* [See image on page 128.] *Soon thereafter,* [the river] *junctions with the waters of the…West Branch, which tumble over another 40-foot falls beside the Lake Avenue bridge.*

At intervals throughout Elyria's history, however, the water has not always been so kind.

The first major flood in Elyria's recorded annals occurred in 1832, and it destroyed dams and mills along the river. A 1992 book compiled by the Elyria Historic Book Committee on the occasion of the 175th anniversary of the city's settlement points out that the river's highest recorded level occurred during a flood in February 1883. But it was the flood of 1832 that was used as a benchmark, a point of comparison for what would come to be called the Great Flood of March 1913—the one that wrecked the Robbers' Den.

In January 1959 there was another devastating flood, and Ron Nagy of Elyria remembers it. Ron's parents lived on Louisiana Avenue near Cascade Park's sledding hill. That's the vantage point from which his father Steve took photographs that depict a submerged concession stand, bathhouse, and restroom after the torrential rains.

As noted in a paper published by the U.S. Department of the Interior, *Floods of 1959 in the United States*, "the Black River flooded the center of Elyria. Small streams in the area swept cars from roads and caused a night

The January 1959 flood was just as destructive as the one that would hit ten years later. *Courtesy of Ron Nagy.*

of terror." According to a *Chronicle* article published on September 16, 1959, the flood that January reportedly caused damages in the Black River basin in excess of $500,000.

Ten years later, in 1969, on the Fourth of July, it happened again. This time, the storm spawned tornadoes. A *Chronicle* headline the day after captured the citizens' mood: "Even for the unharmed…a night of fear."

I will certainly never forget that night. I was thirteen, and my father had died just eight days before the holiday. My mother and I were invited to my godparents' home in Elyria Township for a big Fourth of July bash they were hosting, complete with a roasted pig. Someone, although I no longer remember who it was, drove us there, and after the first claps of thunder and lightning, that someone sped through the country roads to get us back

The Cascade Park bathhouse after the January 1959 flood. *Courtesy of Ron Nagy.*

home, where my mother and I took shelter in our basement. The storm, in its violent, raging chaos, felt like some kind of a test—we were on our own now. We had to find ways to be brave.

Although Elyria suffered no deaths or serious injuries, a retrospective article in the *Plain Dealer* reported that dozens throughout northeast Ohio were killed. The July Fourth fireworks at Cascade Park were already underway when they were brought to an abrupt halt; the *Chronicle* reported that an estimated 1,500 to 1,800 people had to be evacuated from the park.

By 1969, Ron Nagy was working full time for the parks department. As a member of the crew that July, he played a supporting role in saving the bears, who nearly drowned in the rising waters.

THE GREAT BEAR RESCUE OF 1969

The Fourth of July deluge flooded the golf courses at Spring Valley Country Club and the Cherry Ridge Golf Club and the wastewater treatment plant on Gulf Road. The entirety of Cascade Park was devastated. Everything was underwater: the tennis courts were destroyed, the pool and its mechanicals ruined, most of the playground equipment mangled, and trees throughout the area uprooted. "The pavement," said Dick Gibbons, "rolled up like a rug."

The bears—Grandma, Sophie, and Gracie—were in danger. Water had risen to a dangerous level in their den; the park crew's first priority was to save their lives. In an interview at his home near the entrance to Elywood Park, Dick recounted the saga:

> *On the day of the flood, we couldn't drive to the bear cage....Ronnie Nagy, who couldn't swim, stayed* [above the bear cage]*...while Greg Lesher and I come down through a big opening in the two big rocks, like a narrow walkway to the front of the cage....The water was that high* [he gestures with his hand]*...they were standing in water shoulder-deep...the bears*

The Fourth of July flood in 1969 wreaked havoc at Cascade Park and nearly drowned the bears. *Courtesy of the Lorain County Historical Society.*

only had about a foot-and-a-half space before the whole cage would have been covered with water.

Me and Lesher took 120 feet of blue strand manila rope and from the top of the cliff overhanging the bear cage proceeded to put planking in the cage and wire it up to the fencing, so the bears would at least have a place to hang on, and enough air room to breathe.

After the crew positioned the boards, Gracie and Sophie climbed up on the planking.

Ron Nagy recalled that Old Grandma had remained in her den seated on a wooden pallet that had floated on the rising water. "It floated her right up, and she had enough of an air pocket to survive, so she was safe," he said. Gracie and Sophie hung onto the planking for dear life.

AFTERMATH

The tennis courts never reopened. A vintage fire pumper truck, donated by the fire department to the parks department in 1956 at the suggestion of John Machock and long a favorite playground attraction, was also ruined in the flood. At some point, it was finally removed.

The iconic round pool, built in 1926 through the inventive and vigorous fundraising efforts of the Elyria Kiwanis Club, was ultimately repaired and restored. But the city's four neighborhood recreational parks, each with their own pool, had rendered superfluous the pool at Cascade. Vulnerable as it was to flooding, as well as being a strain on the city's coffers, the pool that *Chronicle* sports writer Jerry Rombach, a founder of Friends of Cascade Park, once lauded as "more impressive than anything Lorain or any community our size in northern Ohio had," had reached the end of its usefulness. It closed in 1985. For several years after, deserted and surrounded by overgrown weeds, it looked, Rombach wrote, "like a ruin of Ancient Rome."

On March 29, 1989, the city filled in the pool, and just like that, a treasured recreational era ended.

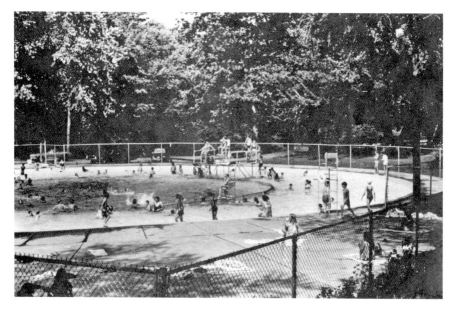

Cascade Park's iconic round pool, circa 1971. *Courtesy of Ben Mancine.*

MR. ELYRIA PARKS

In 1983, Bob Choate wrote in the *Chronicle*: "If any one man could claim responsibility for the beauty of [Elyria's parks], it was John [Machock]. He loved and knew nature as do few men."

From his hilltop home, John Machock watched over Cascade Park like a hawk—an apt cliché, given the setting. One news account reported that after a heavy rain, with the river swollen, he walked the banks and pulled children to safety. John and Bernadine are gone now, as are their five children. Patty Machock McBain, of Cleveland Heights, died as this book was going to press. When speaking with me in the summer of 2018, she expressed how wonderful it had been to grow up overlooking a park in a household that, for a time, included a bear cub.

Cascade Park "was our whole playground," she said. "Every summer, swimming in the pool…and every winter, sliding and skating." One of her favorite memories was the city's annual Christmas tree collection, after which, on the twelfth day of Christmas, the trees were lit on the Cascade Park baseball diamond in a huge bonfire, a ritual that is no longer practiced. Of her father, McBain said: "The park was his life."

Today, if you visit the park, which has been revitalized thanks to a

Right: Cascade Park warden John Machock. *Courtesy of the collection of Dick Gibbons.*

Below: The plaque honoring John Machock in Cascade Park; his daughter Patty wrote the inscription. This picture was taken by the author on July 29, 2018. *Author's collection.*

partnership between the city of Elyria, Lorain County Metro Parks, and the continuing philanthropic efforts of the Elyria Rotary Club, you'll see a plaque affixed to a rock. You'll find it slightly south of the new, all-inclusive playground that the Rotarians donated. The plaque honors John Machock, a man called Mr. Elyria Parks and the Patron Saint of Cascade Park.

Patty Machock McBain wrote the inscription on her father's plaque:

The story of his 42 years with Elyria's Park System is written in the trees, the flowers and the birds around you. We who have reaped the harvest of his labors, and those to come after us dedicate this hillside to his memory.

AT GLACIAL SPEED: A PARK MILLENNIA IN THE MAKING

Why is a place where it is?

Oberlin College emeritus professor of biology Thomas Fairchild Sherman asks that question in his book *A Place on the Glacial Till.* The book's primary focus is the terrain surrounding Oberlin, thus, it is not concerned with Cascade Park; nevertheless, it is a useful field guide to the ecological, archaeological, and geological history of north central Ohio, which happens to include the roughly 1,240 stream miles of the Black River watershed.

The professor, who now lives in Hillsdale, Michigan, kept small journals in which he recorded field trips that he took in Lorain County. I emailed to ask him about his memories of Cascade Park, and he wrote me the following:

> *I was in Cascade Park on 3 October 1977, with my* [family], *scouting out the place in preparation for a nature walk to be conducted the next day for the Elyria YWCA....It is a remarkable place for contemplating the glacial ice that deposited the granite rocks on the Knob, and the post-glacial erosion that has in the past 10,000 years cut the gorges of the river and left the Knob as an uncut gem between the old and new paths of the West Branch. The red oaks atop the Knob were in scarlet foliage the day we were there, and the bur-marigolds, New England asters, white snakeroot, and wreath goldenrod were in bloom.*

"The Knob" is a bluff at the confluence of the west and east branches of the Black River, standing, he wrote, "about seventy-five feet above the river level on the west bank. It is interesting because it has been cut away on its back side, forming a hillock of about thirty feet above a saddle that separates it on the west from the rest of the high ground on which Elyria is built...geologists believed, at least in my time, that the saddle represents the bed of the west branch at an earlier time in the formation of the present gorges."

Park historian Jim Smith of Elyria, vice president of the Friends of

Cascade Park, has taught U.S. history at Lorain County Community College and would take his students to the park for a unit on ancient geology. He told me that the saddle Sherman mentioned is known as the Natural Bridge, described in Frank Wilford's 1936 book as a connecting neck of land between the bank of the gorge and the little hill to the east known as the Camel's Back.

I sent Professor Sherman a few photographs and a map of the park, asking him to point out the Knob. He settled on the area known as Oyster Shell Rock, noting that the presence of granite stones there is especially interesting. "[It] must have been deposited by the glacier coming down from Ontario…but the absence of these rocks in the valley of the Black River suggest strongly that the river valley was cut after the glacier receded—so that the gorges of the Black River were formed in post-glacial times."

Put simply, Cascade Park is where it is because it formed as a result of the Ice Age. But were the glaciers that were responsible for the formation of the Great Lakes the same ones responsible for the gorge at Cascade Park? The Lorain County Metro Parks information office forwarded me this answer from senior naturalist Grant Thompson, who is now retired:

> The glaciers extended far south of the Black River watershed. As the glaciers melted, the runoff flowed north toward Lake Erie. Runoff got concentrated into rivers and as the rivers eroded deeper into the ground they exposed ancient bedrock like we see in Cascade Park. The more resistant sandstone erodes slower than the soft underlying shale stone resulting in waterfalls, again like we see at Cascade Park.
>
> So yes, the glaciers that are responsible for the formation of the Great Lakes are the same ones responsible for the gorge at Cascade Park. But the gorge was not carved by the glaciers, but rather, first carved by the melting water from the glaciers and then subsequently by the more mature river.

According to the website for the Black River Watershed Project, nearly five hundred miles of the Black River drains northward into Lake Erie's Central Basin. The gently rolling terrain of this area formed during the retreat of the Wisconsin glacier some 10,000 years ago, give or take a millennium.

Berea sandstone, common throughout northern Ohio, forms the crest over which Elyria's two large waterfalls cascade. After the glaciers receded more than 13,000 years ago, the massive rock eroded, froze, cracked, split, and weathered into the narrow gorges.

Bedrock (composed of Bedford shale and Cleveland shale) is the backbone

The forty-foot-high West Falls in winter. The Lake Avenue bridge is visible in the background of this undated photo. *Courtesy of the Elyria Public Library.*

of Cascade Park, according to the Lorain County Metro Parks website. The bedrock formed 320 to 345 million years ago, during the Mississippian period, when much of Ohio was covered by a shallow inland tropical sea.

Those of you who escaped Ohio's harsh winters for warmer climes might find it ironic that if only you had lived 345 million years ago, you could have been swimming in January in your own backyard.

4
At the Movies

The buttery aroma of popcorn fills the air in the Capitol Theatre. The lights dim, the movie is about to start, and the children begin to settle down, clutching their boxes of Jujyfruits and Good & Plenty. With others in the audience, including teenagers and young adults in the bloom of new romance, they gaze up, anticipating the wonders about to burst across the screen: a Disney film, a Western, or an epic complete with swordfights.

This was a typical Saturday in Elyria around 1946, and these were among the 90 million people, on average, who went to the movies each week in America. Maybe you were one of them.

The aforementioned year—1946—was Hollywood's best year ever, according to Thomas Schatz, author of *Boom and Bust: American Cinema in the 1940s* and a professor at the University of Texas at Austin. In an email to me, he explained why: the influx of returning servicemen and women after the war caused a surge in dating.

Among the statistics included in his book is the number of indoor movie theaters in the United States. In 1946, there were 18,719, and Herman Frankel, new to Elyria, had just purchased four of them.

A Shaker Heights native, Herman walked away from a job as a time-study engineer with RCA, which was, ironically, an industry leader in television, the medium soon to have a deleterious effect on film attendance. With his brother Marvin, Herman started the Elyria Theatre Circuit with movie houses they purchased from Seymour Amster.

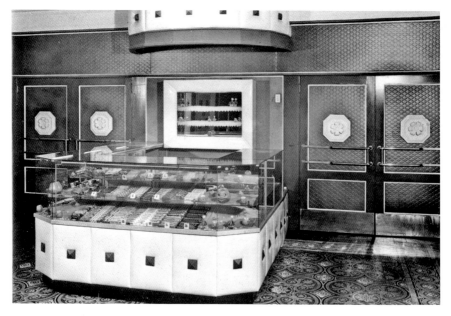

Undated photo of the Capitol Theatre's concession stand. *Courtesy of the Lorain County Historical Society.*

They hoped to renovate the most historic of them—the Rialto on Second Street, which was gutted by fire in 1945 and had sat vacant for several years. Built in 1904 as the Elyria Theatre and also briefly called the Opera House, the Rialto had a rich theatrical past and showcased such legendary vaudevillians as George M. Cohan, Al Jolson, and Will Rogers.

The Rialto renovation never happened. The increasing popularity of television killed the idea, Herman's son, Ken, explained. Although radio still reigned in American living rooms, the fledgling television industry, interrupted by the war, was picking up steam. In *The History of Television, 1942 to 2000*, Albert Abramson wrote that Americans were "enchanted with the new medium. It was the novelty of the experience that made television grow."

The Rialto was razed in 1952. The Frankel brothers decided to focus their attention on their other theaters, all of which were on Broad Street: the Capitol, the Rivoli, and the Lincoln, which later became the Lake Theatre.

The trio of Elyria movie houses contributed to the hustle and bustle of downtown at midcentury, luring—at least, for a time—entertainment seekers away from television's siren call. The Frankels showed five hundred movies per year during the time they owned the theaters, from 1946 to 1968.

The boom would not last.

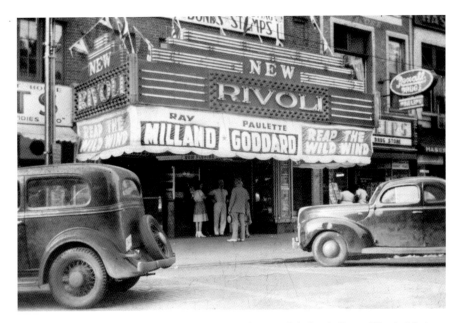

The Rivoli Theatre on Broad Street, circa 1942. *Courtesy of the Lorain County Historical Society.*

Undated photo of the Capitol Theatre entrance, although the advertised film, *Rope of Sand*, was released in 1949. *Courtesy of the Lorain County Historical Society.*

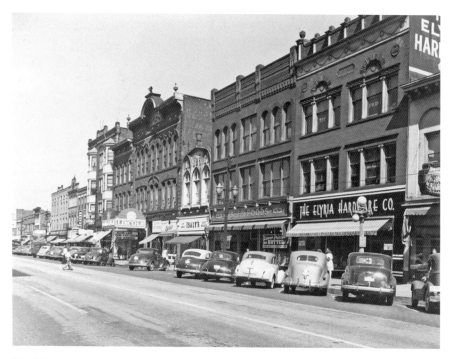

The Lincoln Theatre on Broad Street, circa 1945, the year that *Trail of Kit Carson* was released. *Courtesy of the Lorain County Historical Society.*

FILM IN THE FAMILY

Ken Frankel, an only child born in 1950, still lives in Elyria. He grew up at the movies, doing "everything but run a projector," he told me. He sold tickets in the box office, worked behind the candy counter, and called parents who had dropped off their children to let them know that the film had ended. He also contributed to a little-known tradition of "bicycling the print."

A film typically opened in Cleveland, he explained, and an orderly system existed to give secondary cities such as Elyria and Lorain a print to run the following week. For some reason, the studio distributing a popular Jerry Lewis film ran out of prints, presenting Herman with a problem: although he had already booked the film at the Rivoli, the distributors sent the only available print to Lorain. The cities had to share the movie until another print was found.

"In those days, there were twenty minutes on a reel of film, and movies would start at different times," said Ken. So, for three days, he drove back

and forth from Lorain to Elyria with one reel of Jerry Lewis at a time, allowing his father to show the movie in Elyria as advertised.

It wasn't all work, though. Ken recalled "a very pleasant childhood, being able to see all these movies any time of the day or night. I saw between 1,500 and 2,000 movies, but…a lot more movies were being made than now." His estimate does not include films he saw more than once. "My mother told me I saw *Lady and the Tramp* about a dozen times."

Anything by Walt Disney was a surefire hit, he said. Also popular were movies starring Elvis Presley or Jerry Lewis. To promote Presley's films, the Frankels displayed a standup cutout of Elvis Presley—until it was stolen.

Being the son of a movie-theater owner had other perks—an autograph from Walt Disney, for example, obtained when his parents attended a theater convention. Ken also had a front-row seat when Elyria's homegrown film star, actor Keefe Brasselle, came back to visit.

The actor, who grew up on West Bridge Street, had achieved a degree of success in Hollywood. At the peak of his fame, the 1940 Elyria High School graduate starred in *The Eddie Cantor Story*, which was released in 1954 and screened at the Capitol.

"My father made a big deal about the movie when it came out," said Ken, who was three at the time. "My parents told me that Brasselle had a police escort and that I was thrilled to ride in the police car with sirens blaring. Too bad I don't remember any of it."

THE CAPITOL

With a thousand seats and a balcony, the Capitol, at 360 Broad Street, was the largest of the three theaters. Decorated in a faux Spanish motif, it had "much nicer chandeliers, a more attractive lobby, and more style" than the Rivoli or the Lincoln, Ken said. A *Chronicle* article described a 1960 remodel as having gold as the accent color in the new décor, with black and shades of green and gray. Herman Frankel ordered black, gold, and green hotel/theater-type carpeting at the Furniture Market Show in Chicago, and the new green leatherette seats sported floral upholstered backs.

Because the size of the theaters determined where films would run, the Capitol typically booked more adult-oriented fare and the hugely popular Disney films.

In 1959, Disney released its first live-action feature comedy, *The Shaggy Dog*. It sold more tickets than any other film at any of the Frankel theaters. "More people saw that film in Elyria than any other movie that we showed in all three theaters the entire time we owned them," Ken said.

A profile of Herman Frankel from the May 8, 1959 edition of the *Chronicle* reported that for *The Shaggy Dog*'s ten-day run at the Capitol, children were lined up four-deep for blocks. Attendance totaled 17,000—equal to about half the population of Elyria at the time.

"THE STUFF DREAMS WERE MADE OF"

Mary Poppins, Disney's candy-colored song-and-dance confection combining live action and animation, was released in 1964, when I was eight. I saw it at the Capitol and played the soundtrack album on our phonograph until I nearly wore it out. Such was my fandom that I even carried a *Mary Poppins* lunchbox to school at St. Mary's.

The film was the biggest Disney blockbuster at the Capitol and held the Frankel record for the longest-running show. It was also the top-grossing movie of 1964, according to the Internet Movie Database. "We rarely played a movie more than a few days or a week, but *Mary Poppins* ran for seventeen days," Ken said.

I saw other landmark films downtown—*A Hard Day's Night* at the Rivoli and, at the Capitol, the Beatles' second film, *Help!* Ken Frankel was about fourteen, working while *A Hard Day's Night* was screened. "As soon as the picture began, there was screaming," he said. "I couldn't hear the movie and asked the projectionist to turn up the sound. He told me if he made the sound system any louder it would probably blow [it] out along with my eardrums."

By the mid-1960s, ticket prices at the Frankel theaters had increased from $0.95 for adults to $1.25, although children under the age of twelve could still see a picture for $0.35. Ken explained that a studio such as Buena Vista/ Walt Disney, however, set firm prices. "For a movie like *Mary Poppins*, the prices were $1.50 for adults and $0.75 for children. For most movies, the film company received 35 percent of the ticket price."

Herman Frankel's employees enjoyed a nice perk: they could see movies for free and received passes for their friends and family.

Edna Larkin was the Frankel's head cashier—she mostly worked at the Rivoli but spent some time at the Capitol, where she remained until her

retirement in 1968. Because she didn't drive, she walked to work from her home on Blaine Street. Her granddaughter, Joan Larkin Villarreal of Elyria, remembers Edna receiving two movie passes every payday with her paycheck and sharing them with her and her siblings; they, in turn, shared them with their friends. The pass allowed its holder to see a movie for only fifteen cents.

Joan's mother did not drive, either, so on Saturdays, she would walk her four children downtown and drop them off at the theater, where Edna could keep an eye on them. "Grandma would situate us near the back, and Mom would run her errands," Joan said.

Joan recalled that *West Side Story* was her first "adult" movie, and in addition to all of the Disney and Elvis pictures, she saw *A Hard Day's Night* and a Beatles-film clone, *Ferry Cross the Mersey*, featuring Gerry and the Pacemakers. She also remembered that "Mr. Frankel was adamant that the theater full of teenagers remain well-behaved."

Jerry Spike lived on West Ninth Street. His father's family owned Spike's Market and later bought the Jackson Hotel and several Elyria bars. When Jerry was a sophomore in high school, his parents moved to Cleveland Heights. "I ran back to Elyria almost every weekend," he wrote in an email. He now lives in Valencia, California, and shared a movie memory of his first date, in 1946, with a girl named Pat Lowe. He was in the seventh grade at Franklin School:

> *The movie was* Duel in the Sun *with Gregory Peck and Jennifer Jones. I remember nervously putting my arm around her on top of her seat but* [I was] *too nervous to touch her. After ten or fifteen minutes, my fingers finally touched her shoulder, but by then my arm fell asleep, and I pulled my hand back, afraid that she would tell her parents.*

Jerry added that Saturdays in Elyria—with Westerns, Humphrey Bogart, and the Bob Hope and Bing Crosby road movies—"were the stuff dreams were made of."

MOVIES FOR ALL

Herman Frankel created a weekend program for area parent-teacher associations in which children and their parents could see movies such as *My Friend Flicka* and *Davy Crockett, Indian Scout*, at a discount. He also

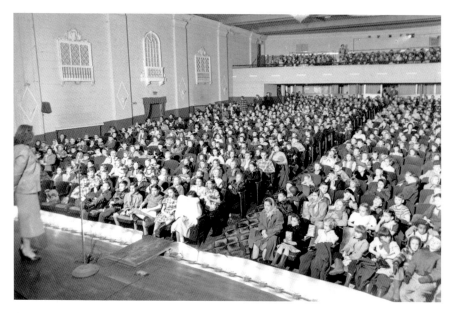

A school program at the Capitol Theatre organized by Herman Frankel, undated photo. *Courtesy of the Lorain County Historical Society.*

invited juveniles from the Lorain County Detention Home to attend viewings of wholesome Disney films like *Mary Poppins*, and he booked religious-themed "road show" movies, such as *The Lawton Story of "The Prince of Peace."*

Frankel forged a relationship with the Elyria branch of the American Association of University Women in the early 1960s, supporting their sponsorship of an art film series that brought films to Elyria that might not otherwise have been seen—selections from the Cannes Film Festival, for example, and those by auteur directors such as Ingmar Bergman.

Unlike the Capitol, which had an inner lobby, one walked immediately into the auditorium at the Rivoli, which sat seven hundred and typically screened children's pictures or films geared to teenagers. Herman had been leasing the building at 511 Broad Street that housed the Rivoli, and it was showing signs of wear. He wanted to remodel, but the landlord, said Ken, was uncooperative. Herman let the Rivoli lease expire and put his money into the Lincoln, remodeling it and renaming it the Lake. Herman closed the Rivoli after screening its final picture, *Cat Ballou*. The Spitzer Plaza stands in that location today.

Marvin Frankel (the Easter Bunny) and Herman Frankel (wearing glasses) in the Capitol lobby, circa 1958. *Courtesy of the Lorain County Historical Society.*

In 1965, Herman Frankel closed and remodeled the Lincoln Theatre, renaming it the Lake and opening the new theater in August of that year. *Courtesy of the Lorain County Historical Society.*

Following a $35,000 renovation, the newly branded Lake Theatre, at 537 West Broad Street, opened on August 18, 1965, with a film starring Rock Hudson and Leslie Caron. According to the U.S. Inflation Calculator, the cost of that renovation is equivalent to $280,862 in today's dollars. A *Chronicle* article stated that the upgrades included new air conditioning, fully remodeled restrooms, and a new refreshment bar. With inch-thick carpet and a décor of aqua and gold trim, the Lake could accommodate 650 patrons. The *Chronicle* article noted:

> *Frankel has directed that the projectionist's booth be rebuilt and enlarged to accommodate new projectors with cinemascope lenses. The 18-by-30-foot screen is of material treated to hold reflective glare to a minimum while providing a maximum of image reproduction. The sound system… is completely new.*

The *Chronicle* praised the venture in an opinion piece: "Its bright lights will be a welcome addition to downtown Elyria's nightlife.…The opening of this new theater is an impressive vote of confidence by Mr. Frankel in the future of downtown Elyria."

A Sea Change

In September 1966, just thirteen months later, the Midway Mall, a regional shopping center at State Route 57 and Ohio Turnpike Exit 8, held its grand opening, and Elyrians were breathless with excitement. The multimillion-dollar project created jobs for some two thousand people and provided parking for more than four thousand automobiles. Higbee's was one of three anchors at the mall and one of the latest among the elegant and storied Cleveland department store's suburban outposts. The other two anchors, Sears and J.C. Penney, abandoned their downtown Elyria locations for the shiny new venture; Sears would open the following year. On opening day, September 29, 1966, more than thirty establishments, including the F.W. Woolworth Company, opened their doors in the mall.

Included among these exciting new stores was the Midway Cinema, with a mammoth screen, stereophonic sound, and one thousand rocking chair seats. The premiere attraction that evening was *Fantastic Voyage*,

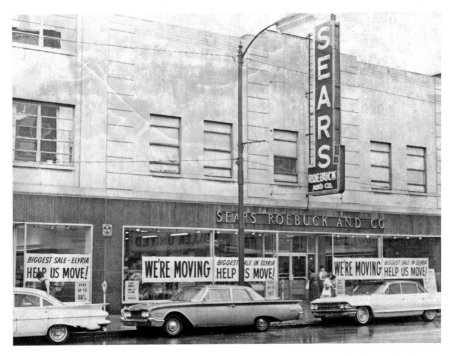

The downtown Sears store on September 9, 1967. The grand opening for its new Midway Mall location took place eleven days later. *Courtesy of the Lorain County Historical Society.*

"linking the imagination of man and the magic of the camera as never before," as its trailer put it, and starring Stephen Boyd, Raquel Welch, and Edmond O'Brien.

Two years later, in 1968, Herman Frankel left the theater business, closing the doors at both of his downtown movie houses.

"Because of the Midway Mall, it just wasn't as profitable," Ken said. "There were only a few pictures every year where you could make your money. The newer theater at the mall was getting the moneymaking pictures; you hoped you'd break even for the other films."

FIRE!

The Wild, Wild World of Jayne Mansfield was playing for an audience of about twenty patrons at the Lake Theatre on May 5, 1969, when manager John C. Miller, seated near the ceiling in the projection room, smelled smoke.

According to coverage by the *Chronicle*, twenty-two-year-old Lilly Ruhl was living with her infant son, Jason, and newlyweds Agnes and David Baldwin above the theater in apartment number seven on the third floor. There were nine apartments above the Lake. Agnes, Lilly's sister, was finishing her senior year at Elyria High, and David worked at American Standard; the couple, waiting to occupy a home they had purchased, was helping Lilly care for Jason.

Like John C. Miller, Agnes smelled smoke, too, but she also saw flames coming from a second-floor trash closet. She now lives in Oberlin, and I spoke with her by phone. I also talked with Lilly, who still lives in Elyria and whose last name now is Rosa.

Lilly had been doing laundry, and Agnes entered the laundry room to hand her more clothes to wash. "I told her I smelled smoke," said Agnes. "When I noticed the fire, Lilly ran down to wake people up, knocking on their doors. All I knew was to go in and get the baby. I didn't think about anything else but get the baby."

Lilly saved a lot of lives that night.

"One woman didn't speak any English," Lilly told me. "I just grabbed her arm, pulled her out of the apartment, and pointed to where the fire was on her floor. She ran inside, grabbed some stuff, and ran out of the building."

Another man yelled at Lilly for bothering him. "I probably woke him up. I yelled back, 'The trash closet is on fire!' Guys out back of the building said

later that he climbed out a window in his underwear and people at a bar gave him some clothes."

The call to the fire department went in at 8:48 p.m. According to the *Chronicle's* coverage, every available piece of equipment and seventy-one of the Elyria Fire Department's seventy-four men were engaged in battling the blaze. Flames shot out from at least four windows on the building's third floor, as depicted in a front-page photo. Miraculously, no one perished or was injured. Two neighboring businesses, Lorain County Vacuum Cleaners and Seghy's Nut Shop, received water and smoke damage. The cost of the fire, which was brought under control two hours after the initial call, was estimated, conservatively, at $100,000.

Agnes carried Jason outside to safety; they were among the thirty-five people to flee for their lives. Like the other apartment dwellers, they were left homeless by the inferno. All of the wedding presents that Agnes and her husband had received, and which were stored in the apartment, were reduced to smoldering ashes. So was the theater that had been so lovingly restored by Herman Frankel.

Standing outside holding her nephew and watching everything go up in smoke, Agnes felt overwhelmingly depressed, she recalled. But the experience taught her not to place importance on material things. "As long as you have your life, you've made it. Something like this makes you stronger. It's a lesson you learn."

At the time of the fire, my father was a member of the Lorain County Sheriff's Auxiliary Department. He drove my mother and me up West Avenue, as close to Broad Street as we could safely get, to watch the firemen battle the blaze in the night. I still remember the fire trucks and how the surface of Broad Street, covered with the uncoiled snakes of fire hoses, glistened with water.

The Last Picture Show

Movies booked at the Lake Theatre by manager John C. Miller were shifted to the Capitol, which he also managed. The Capitol, which had been in business under various ownership since 1918, was now the last remaining indoor movie theater downtown. Softcore X-rated films were advertised on the screens where religious-themed road show movies once played.

John Miller, featured in an April 7, 1972 *Chronicle* article, noted that an X-rated film called *The Voluptuary* drew a week's attendance of 1,127 during its Elyria run. By contrast, the G-rated *My Side of the Mountain* had a paid attendance of only 152 people in a week. One could still see the occasional Disney movie at the Capitol, but *Lady and the Tramp*, which Ken Frankel had seen twelve times in 1955, attracted only 171 adults and 432 children during the week it was rereleased.

The reels at the Capitol were winding down. The Midway Cinema was showing *The Godfather* in April 1972; the Capitol held *Teenage Tramp* over for at least two weeks. The last ad I could find for the Capitol appeared in the *Chronicle* on May 2, 1972; a search through the *Chronicle's* archives to determine the last film shown there was not definitive, although the lack of ads for any films at the Capitol after May 3, 1972, suggests that *The Carey Treatment*, starring James Coburn and Jennifer O'Neill, was its last picture show.

The Capitol was torn down in 1976. In its place now? A parking lot. The location where the old Rivoli once stood is now home to the Spitzer Plaza. The gutted Lake Theatre, in the building owned by William Seghy, was razed after it burned; occupying the space today is an empty McDonald's and its equally empty parking lot. Herman Frankel died in 2010.

At the Drive-In

Film historian Thomas Schatz wrote to me that while television was indeed a factor in film's decline, other issues—suburban migration and a 1948 antitrust suit that forced the biggest studios to sell their theater chains— were also to blame. "The one bright spot was the boom in drive-in theaters, which obviously fit in nicely with the family/baby boom and suburban migration. The U.S. went from just a few dozen drive-in theaters in 1945 to about 6,000 by 1960."

In 1951, the year after the Tower Drive-In opened on Lake Avenue, the installation of a curved screen—said to be the largest in Ohio, at eighty feet wide by forty-one feet high—made it the first theater in Greater Cleveland to offer Cinemascope, according to a *Chronicle* article from the era. The Tower closed in 1985.

Of the other drive-ins in Lorain County—North Ridgeville's Auto-Rama, the Carlisle on Oberlin-Elyria Road, and the Lorain Twin Drive-in on West Erie Avenue—only the Auto-Rama remains.

TABLE 4: U.S. TOP-GROSSING FEATURE FILMS RELEASED FROM 1950 THROUGH 1975

1950 *Cinderella*
1951 *Quo Vadis*
1952 *The Greatest Show on Earth*
1953 *Peter Pan*
1954 *Rear Window*
1955 *Lady and the Tramp*
1956 *The Ten Commandments*
1957 *The Bridge on the River Kwai*
1958 *Auntie Mame*
1959 *Ben-Hur*
1960 *Swiss Family Robinson*
1961 *101 Dalmatians*
1962 *How the West Was Won*
1963 *Cleopatra*
1964 *Mary Poppins*
1965 *The Sound of Music*
1966 *The Bible: In the Beginning*
1967 *The Jungle Book*
1968 *2001: A Space Odyssey*
1969 *Butch Cassidy and the Sundance Kid*
1970 *Love Story*
1971 *Billy Jack*
1972 *The Godfather*
1973 *The Exorcist*
1974 *Blazing Saddles*
1975 *Jaws*

— Part III —
LOSS

I

Downtown

Shopping with My Mother

Note to the reader: Some of these things happened. Some of them could have.

It's a beautiful spring Saturday in 1963. I am not quite seven, and I'm going shopping downtown with my mother. Because she doesn't know how to drive, we walk to the corner of Middle Avenue and our street, East Fifteenth, to catch the city bus. We get off near the town square with its famous fountain. At night, lit by red and blue and green lights, the fountain sprays brightly colored water into the dark sky. Because it is morning, the color of the water is water.

Our first stop is Berson's, the ladies' shop, at 114 Middle Avenue, so that my mother can look for a new dress. She asks the owner, Ivy Terrell, to please hold a pale blue shirtwaist for her; if there is time after our shopping, she'll come back to try it on. If not, she'll take it home on approval.

We turn the corner, heading east on Broad, and walk into the Central Book Store. My mother buys some greeting cards, which the clerk puts in a small white paper bag decorated with violets, the name of the store printed on it in black. While my mother waits for her transaction to be concluded, she spots a new book on the counter display by someone named Betty Friedan. Years later, it will occur to me that my mother's life would have been somehow better had she bought and read *The Feminine Mystique*.

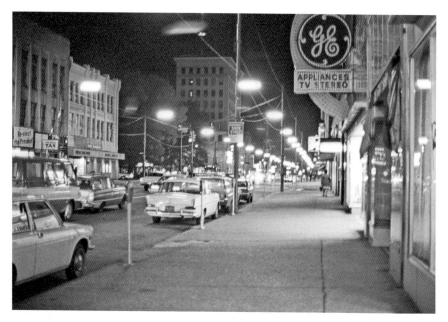

Above: Broad Street at night, circa 1972. *Photograph by and courtesy of Kim Tonry.*

Opposite, top: The Ely Square fountain, mid-1950s. *Courtesy of the Lorain County Historical Society.*

Opposite, bottom: Brandau Jewelers, 336 Broad Street, 1960s. *Courtesy of the* Chronicle-Telegram *archives.*

We stop at the Hotel Graystone, because there's a beauty shop there, and my mother hopes to make an after-lunch appointment. The owner, Mary Guastella, apologizes, saying that they are completely booked. My mother schedules an appointment for the following week, and on the way out, she runs into the salon's other beautician, Betty Kowalski, who has just returned from running an errand. In seven years, I will begin high school at Elyria Catholic, where I will become friends with Susie and Cindi, the daughters of these women.

We walk toward the Style Center, and my mother pulls me in so she can look at skirts—she favors tailored blouses and skirts—but there are so many of them that she can't make up her mind. We leave and walk farther east up Broad Street toward Brandau's, her favorite jewelry store. Because my birthday is just weeks away, I'm thinking that perhaps it's not too early to drop a hint. I point to a necklace with my birthstone—an emerald—set in a pendant on a delicate silver chain.

"This is pretty," I say, trying to convey interest and detachment at the same time. It's never a good idea to get one's hopes up.

We are about to leave the store when the strap on my shoe, which I've been worrying all morning, breaks off. Next door is Walter's Shoe Store; we stop in to see if they can repair my Buster Browns. I'm hoping they'll say the strap is beyond fixing, so that I can get a pair of Red Goose shoes. They come with a golden egg with a prize inside!

They fix the strap on my shoe.

We take the crosswalk to the other side of Broad Street and head toward Wagner's Music and Appliance store. My mother loves classical music and Broadway show tunes and buys the Broadway cast album of *The Sound of Music*, featuring Mary Martin, who appears on the front of the album holding an acoustic guitar, which she is apparently playing while singing to the von Trapp children, who are all decked out in sailor blouses. While my mother pays for her album, I look at the 45 singles in the rack. Because the Beatles will not be introduced to America on *The Ed Sullivan Show* until the following year, none of the 45s really interest me. This will not always be the case.

We're heading west now, past Neisner's, the five-and-dime store. I beg my mother to let me go in and look through the bins for things I didn't know I needed but must have as soon as I see them. She tells me I have ten minutes, so I speed up my search. I find a wooden paddle with an elastic band stapled to it, and at the other end of the elastic is a small rubber ball. I walk with my mother down Broad Street, striking the ball against the paddle until it breaks away from the staple.

I'm starting to get hungry, but there are things we must do before we can have lunch. We cross the street at Washington Avenue, past the Fay Company, where my grandmother likes to buy her hats. We enter the big, blue Robinson Building so my mother can pay the electric bill at Ohio Edison. We continue on past Loomis Camera, with its giant-sized camera on the sign. I stop and pose so it can take my picture. My mother laughs. I will someday learn that the camera never did have the capability to take pictures.

We stop in at Harry's Men's Wear, where my mother looks at ties for my father. Soon, he will no longer own the hardware store on the south end of town, where he doesn't need to wear a tie. Instead, he will have to drive to Lorain every workday to sell cars and will need to wear a tie most of the time.

Wagner's Music & Appliance store, 309 Broad Street—a popular place to buy LPs and 45s. *Courtesy of the Al and Evelyn Wagner family.*

Dick Wagner in the record department at Wagner's Music & Appliance store, 1962. *Courtesy of the Al and Evelyn Wagner family.*

The iconic Loomis Camera sign, pictured here around 2004, once loomed large on the downtown streetscape. *Photograph by and courtesy of Kim Tonry.*

Harry's Men's Wear and Loomis Camera, left of the Robinson Building, in 1963. *Courtesy of the Lorain County Historical Society.*

My mother and I go into Merthe's department store so that she can buy a pair of stockings. I watch, fascinated, as the whooshing tube takes her money and sends it off to some mysterious location, returning moments later with her change. Years from now, when I am in high school in the early 1970s, I will shop at Merthe's for shoes and Yardley Pot O' Gloss.

We finally reach Al and Lu Sterner's restaurant, which used to be an Isaly's Dairy Store. We enter, find a booth, and I order a cheeseburger, French fries, and a chocolate soda. My mother orders a tuna salad sandwich, cole slaw, and a cup of coffee. Not that I have any change, as I spent all of my money at Neisner's, but I flip through the metal pages of song listings on the small jukebox attached to the wall at our booth just for something to do until our food arrives.

At lunch, I manage to convince my mother that a stop at Rigbee's Bargain Town across the street is necessary; they sell toys, and my Barbie doll needs a new outfit. She agrees that this is something we can do. Except for not getting a new pair of shoes and breaking my paddleball, this is turning out to be a pretty good day for me.

It's almost time to head for the bus depot a few doors down from Elyria Savings & Trust National Bank on Court Street to catch the bus home. But first, my mother and I dart across the square so she can run in to Berson's and pick up her dress on approval.

We're moving quickly now. We rush back across the square. Finding that the bus hasn't arrived yet, we stop in at Gartman's Bakery next to the Sederis Hotel, where my mother buys a loaf of bread and some Napoleons, her favorite pastry. I longingly gaze at their chocolate cupcakes with chocolate frosting. When I become an adult, I will learn to call this kind of frosting ganache. My mother says that we can buy a half-dozen. The woman in the white uniform behind the counter packages our order in white boxes, tying each with white string while I study the bride-and-groom figurines in the display case on the opposite wall. I wonder if someday I will have something like that on my own wedding cake.

Instead of a bride and groom, the topmost layer of the tiered wedding cake at my first wedding will feature a pair of artificial white doves poised in flight amidst an arrangement of tulle, as though the air beneath them had been made visible.

The wedding cake served at the dinner celebrating my second marriage will be chocolate, with a chocolate mousse filling and chocolate ganache frosting.

The bus has arrived. We board, make our way, with our packages, to a seat, and ride past the churches and the courthouse toward home.

TABLE 4: NUMBER ONE SONG OF THE YEAR FROM 1950 THROUGH 1975 AS CHARTED BY *BILLBOARD MAGAZINE*

1950 "Goodnight, Irene," Gordon Jenkins and the Weavers
1951 "Too Young," Nat King Cole
1952 "Blue Tango," Leroy Anderson
1953 "Song from Moulin Rouge," Percy Faith
1954 "Little Things Mean a Lot," Kitty Kallen
1955 "Cherry Pink and Apple Blossom White," Perez Prado
1956 "Heartbreak Hotel," Elvis Presley
1957 "All Shook Up," Elvis Presley
1958 "Nel Blu Dipinto Di Blu (Volare)," Domenico Modugno
1959 "The Battle of New Orleans," Johnny Horton
1960 "Theme from *A Summer Place*," Percy Faith
1961 "Tossin' and Turnin'," Bobby Lewis
1962 "Stranger on the Shore," Mr. Acker Bilk
1963 "Sugar Shack," Jimmy Gilmer and the Fireballs
1964 "I Want to Hold Your Hand," The Beatles
1965 "Wooly Bully," Sam the Sham and the Pharaohs
1966 "The Ballad of the Green Berets," Staff Sergeant Barry Sadler
1967 "To Sir With Love," Lulu
1968 "Hey Jude," The Beatles
1969 "Sugar, Sugar," Archies
1970 "Bridge over Troubled Water," Simon and Garfunkel
1971 "Joy to the World," Three Dog Night
1972 "The First Time Ever I Saw Your Face," Roberta Flack
1973 "Tie a Yellow Ribbon 'Round the Old Oak Tree," Tony Orlando
 and Dawn
1974 "The Way We Were," Barbra Streisand
1975 "Love Will Keep Us Together," Captain and Tennille

THE C.H. MERTHE COMPANY

Before Amazon Prime, with its siren song of free delivery, there was Elyria's C.H. Merthe Company at the corner of Broad and Lodi Streets (Lodi Street was later renamed Lake Avenue). If you were too rushed during the Christmas season to wait for the complimentary gift-wrapping in the store's

basement, Merthe's would wrap your gifts and deliver them to your home or office at no extra charge. On Fridays, the store would make deliveries—for free—anywhere in Lorain County.

Today, family-owned department stores like Merthe's, Gimbel's in New York City, Wanamaker's in Philadelphia, and Halle Bros. in Cleveland are gone, relics of a time when you could find almost anything your heart desired under one roof and likely say "Good morning!" to the store's owner at the same time. Couldn't decide which dress or coat to buy? If you had good credit, you could obtain a coveted Merthe's charge account that allowed you to take that dress or coat home "on approval" without putting down a dime. To keep track of your items, everything was handwritten in receipt books.

There were no cash registers at Merthe's. In the days before debit cards, this is how sales were transacted: Customers stood at the counter while a sales clerk wrote out the order in a receipt book, took the customer's cash, inserted both into a brass cylinder, and sent it whooshing through an intricate network of pneumatic tubes to its destination in Merthe's office on the second floor.

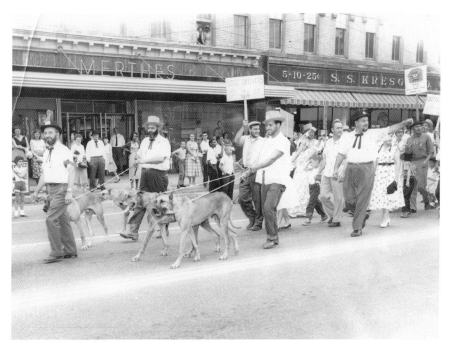

Merthe's is in the background of this 1958 parade. The author's father is second from left, holding the leash on one of his Great Danes. *Author's collection.*

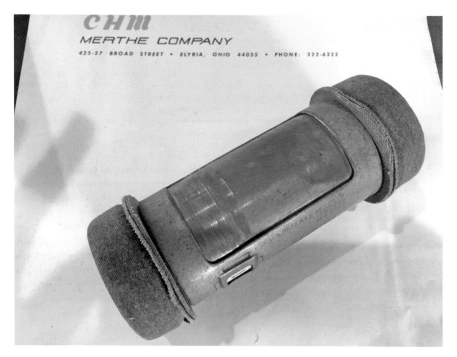

A capsule from Merthe's pneumatic tubing system. This picture was taken by the author on July 11, 2017. *Author's collection.*

This means of communication between floor clerks and operations was fascinating. Once the office had completed its part of the deal—*whoosh-thunk*—the brass cylindrical container arrived in the brass receptacle near the sales counter bearing the shopper's change and receipt.

Michele Ross of Medina County grew up in Elyria. She remembers that when she was a child and wanted to buy her mother a gift, she saved all of her change to buy her a linen handkerchief at Merthe's. "They had to tape the tube shut because of the weight of the change."

By the time Michele was sixteen, she was working the other end of the tube; she got a Christmas job in the Merthe office, taking care of the cylindrical tubes as they wound their way up (or down) to the second floor. When a tube came through, it would contain a little handwritten receipt with the money. Michele would make the change from the sale and send the tube back down with the receipt.

Whoosh. Thunk.

She made $1.91 an hour.

A Brief History

For our purposes, we're marking the start of Merthe's as 1917, when the store's name was changed to C.H. Merthe & Company. Before that time, several different owners had enjoyed successful runs at the store's prime location on Broad Street; the first was established in 1879, when the Kupfer brothers opened a four-thousand-square-foot dry goods store. C.H. Merthe reported for work at D.H. Lewis and Company, the store's latest, larger incarnation—by then measuring sixteen thousand square feet—in 1897. In 1914, David Lewis retired, and Merthe became the sole owner, conducting business under the Lewis company name for three years. In 1916, he added five thousand square feet, and in April of the following year, he renamed the business after himself. By that time, C.H. had been associated with the store for twenty years.

An undated portrait of Charles H. Merthe, founder of the department store that bore his name. *Courtesy of the Gary Merthe Taylor archives.*

A *Chronicle* article dated October 3, 1971, dodged the question about the store's origin date by quoting its twentieth-anniversary brochure, which was produced in 1917: "This store is as old as it feels—as old as the new born day." A bit coy, but charming, like a lady being asked her age.

Gary Merthe Taylor of Vermilion is the grandson of founder C.H. Merthe, the only child of an only child (his mother was Marion Merthe Taylor). Gary's father, William "Bud" Taylor, took over the business from his father-in-law in 1948, and Gary grew up in the store. The Christmas shopping seasons were the source of some of his favorite memories.

"I always loved gift-wrapping in the store at Christmastime," he said. "When I was ten, the girls who did the gift-wrapping taught me how."

He first started working at the family store when he was eight, sweeping the basement and carting boxes and bags to the sales clerks, earning all of ninety-eight cents an hour.

When Gary was older and living with his parents on Washington Avenue, he would take his grandfather to the store:

I'd pick him up from his house on West Avenue and take him to the store in his wheelchair. We had just installed new carpeting on the third floor, and the tires of his chair left tracks in the carpet. "That carpeting won't last more than eight years," he said. And he was right.

C.H. Merthe died in 1963 at the age of eighty-nine.

A Good Business Foundation

Merthe's was a mom-and-pop operation in every sense. Gary Taylor's father, Bud, became president after C.H. retired, and Gary's mother, Marion, served as vice president. She worked in the store, held an ownership interest, and ran things behind the scenes, having "the word" over both C.H. and Bud, said Gary.

Gary became a store manager in 1970, five years after graduating from Elyria High School. In 1974, following the death of his mother, he became a co-owner, with Bud serving as the board's treasurer and director. Titles didn't matter, though. In a family-run business, it was all hands on deck. In fact, this Taylor became quite the tailor.

Merthe employees, circa 1927. *Courtesy of the Gary Merthe Taylor archives.*

"I could pin, hem, and sew," he said, relating a story—with no small amount of pride—about a time when he was kneeling on the floor in front of a customer to pin a dress for hemming.

"Can he do this?" the incredulous customer asked.

"Oh yes," replied the sales clerk. "He can sew and use the mangle iron, too."

The sewing, Gary admits, did take some skill; he practiced on different types of fabric when the store wasn't busy. "In a family business, you had to do a variety of different things."

In 1973, he redesigned the second floor, the housedress area, and the drapery department. He was also charged with a delicate duty in an area mysteriously called "foundations." Here, torso mannequins— dressed by Gary—modeled the latest word in brassieres and girdles. I still remember shopping in this department with my grandmother, fascinated by the dismembered mannequins who, like sentries, guarded the racks of undergarments upon which they rested.

The Ladies' Paradise

When I first read *The Ladies' Paradise*, Émile Zola's novel about a Paris department store, I immediately thought of Merthe's. In Elyria's version, a uniformed attendant, most likely Myra Thompson or Lelia Cruise, operated its only elevator, which took shoppers all the way up to the "Third Floor of Fashion"; all the way down to the basement, where one could find bargains galore; or to the floors in between. Here's an overview of what you could buy and see, floor-by-floor, at Merthe's:

BASEMENT: *Bargain items, gift-wrapping, shipment, delivery.*

MAIN FLOOR: *Cosmetics; fabric, yarn and sewing notions; medium-end and costume jewelry; bedding and table linens; ladies' hosiery and shoes; men's shirts, ties, and wallets; luggage and umbrellas.*

SECOND FLOOR: *Infants and children's clothes (boys, once they reached the age of twelve, had to shop elsewhere); robes and the aforementioned foundations (now known as lingerie); the office—command central for the pneumatic tubes.*

THIRD FLOOR: *Ladies' hats, coats, sportswear, dresses, and housedresses; handbags; draperies; rugs; the gift department; alterations.*

A brief survey of old Merthe ads in the *Chronicle-Telegram* reveals that in 1946, a lady could "swing into summer" with a $4.00 hat. In 1953, she could add a figure-slimming denim wraparound skirt, available in coral, denim blue, navy, and grey, to her "sunshine diet" for $3.95.

In 1966, Merthe's beloved shoe department offered FANFARES shoes by Petite Debs in "Ballyhoo Colors," "Swedish Blondes" by TEMPOS and Natural Poise in "smart stacked heels." These brands proudly joined Merthe's "family of fine foot wear" and ranged in price from $11.00 to $16.00.

Moms could outfit their daughters in 1971 in "plaid power," with a vest or tunic for $2.75, a shirt for $2.75, and pants for—you guessed it—$2.75, available in sizes three to six and seven to fourteen. Pantyhose—sizes A or B for a sure fit—were available in navy, pecan, light brown, or coffee stretch mesh, and were on sale for $0.89 a pair. If you think that was a bargain, it was; the regular price per pair was $4.00.

Chamber of Commerce

A particular code of altruism existed among store owners in those days. Because downtown Elyria boasted several fine, high-end jewelry stores, including Brandau's, Hart's, and Moss's, Merthe's did not trade in those items; they instead confined their ornamental accessories to costume jewelry and what Gary Taylor called "medium-end jewelry." The same reason held true for why Merthe's lacked a complete menswear department. Although the store sold men's shirts, ties, and wallets, the clerks encouraged male shoppers to patronize neighboring shops such as the Bell Company, the Men's Shop, or Harry's Men's Wear.

"I bought most of my suits and sports jackets at the Bell Company," said Gary. "At one point, I had twenty suits and fifteen sports jackets in my closet."

The 1950s through the 1970s were Merthe's peak years. The store typically employed fifty-five women and five men, not including Gary and his father. The busiest seasons, understandably, were Christmas and inventory, which lasted from mid-November through January. By the time Gary sold the store in 1978 to Orrin Heller, a manager from Higbee's, Gary said that his official records, maintained by store office manager Margaret Sullivan, showed that Merthe's employed one hundred people.

The store's tenure under Heller's ownership was brief. Although Merthe's held on much longer than most after the Midway Mall opened

in 1966, it finally closed its doors in 1982. For a short time afterward, a delightful Italian grocery called Alesci's operated on the building's main floor, but it did not last very long. Sometime around 1984, John E. Dixon Sr. purchased the property, turning it into Dixon's Party Center, with a restaurant/bar on one side and a banquet hall on the other. His son, John E. Dixon Jr., owns the building today, and it is now home to the PowerHouse Gym.

Merthe's, that "ladies' paradise," is now an artifact, albeit a glamorous one, of history. That Elyria benefited, economically and socially, from such a family-owned store for as long as it did is no small thing. The Merthe-Taylor family created a lifetime of memories for many Elyrians.

THE FAY COMPANY AND NEW HORIZONS EAST

The Fay Company, which specialized in women's apparel, was known as the place "Where Style, Quality, and Price Meet." Its mirrored vanity tables, where I remember my grandmother trying on hats in the haberdashery department, contributed to its ambience of glamor and elegance.

A *Chronicle* article from March 1939 announced the season's new spring styles:

> [They] *present an opportunity for women to make the best of their claims to good looks if the gowns, suits, and coats displayed today at the Fay Company can be taken as a criterion—and they can.... The soft monastic drapes, the swing skirts, and the lovely colors are alluring to the eye and most complimentary to any woman.*

Some of those "lovely colors" taking center stage were dresses in isle green, Juliette blue, grenadine, chartreuse, and Plaza rose. I cannot fathom what shade of rose might qualify as "Plaza," but it does sound posh, as does this: "Blue and red fox jackets also make their luxurious appearance among the lovely merchandise at the Fay Company store with lovely silver fox scarves already [*sic*] to be draped about the shoulders of one of the new coats or suits."

The Fay Company would retain this sense of sophistication and style throughout the 1950s and into the 1960s.

The Fay Company, with its distinctive awnings, is to the right of the Robinson Building in this postcard of Broad Street from the 1960s. *Author's collection.*

A Brief History

Philip Schultz founded the original Fay Company store in 1916 at a location just a few doors east of its ultimate iteration at 383 Broad Street (at the corner of Washington Avenue). His granddaughter Phyllis Wasserman Harvey of Palm Springs, California, was named for him. She was born in 1950, just two months after he died.

"My grandfather had the store for forty to fifty years—his whole married life," she said.

Through the years, as Philip and Libby Schultz's family grew, so did the store. Their son, Erwin, and their daughter Marjorie Schultz Wasserman became co-owners upon Philip's death; Marjorie's husband, Leonard (called Len), joined the family business after his discharge from the army. In 1960, Erwin left the business, and Len became president of the company. The following year, the Fay Company expanded west to the location that I remember, having taken over what had been the old Woolworth building, and increased its floor area to 16,000 square feet to make room for a preteen department.

Although its specialty was women's apparel, and it featured a bridal and fur department, the Fay Company also sold children's clothes. All of the merchandise was displayed on one level, but inventory was done in the

Left: Fay Company founder Philip Schultz and his wife, Libby, late 1940s. *Courtesy of Judy Kuperman.*

Right: Ultimate owners of the Fay Company, Leonard and Marjorie Wasserman (née Schultz), circa 1988. *Courtesy of Judy Kuperman.*

basement, where, Phyllis remembers, an employee named Chappy Chapman worked. "There might have been a little room upstairs, above the store, but it was only for alterations," she said.

Of Buying Trips and Wayne Newton

Phyllis has a rich trove of Fay Company stories, from working the summer sidewalk sales in the 1960s with her sisters, Judy and Loryn, to traveling with her father to New York City for buying trips, a highlight of which was seeing singer Wayne Newton at the Copacabana when she was fourteen. When buyers came to the store to show samples to Len, petite Phyllis got to keep the clothes. Not everyone is small enough to fit into sample sizes.

One of Phyllis's memories illustrated her father's generosity:

When I was in high school, my friends and I would go to the Pit, the Paradise Soda Grille, after school. We'd have a cherry Coke and French

fries with gravy. If it was Friday, we'd go to the store to get new outfits to wear to the football game. I'd ask my dad: "Can I have a pair of wool Bermuda shorts and a V-neck sweater?" "Yeah," he'd say. "It's okay." "Can they—her friends Red O'Dell and Dee Lloyd—have them, too?" "Yeah, V-neck sweaters and Bermuda shorts for them, too." So, we'd all have new outfits of wool Bermuda shorts with V-neck sweaters and knee socks to wear to the game.

Phyllis's most vivid memory comes from the day President John F. Kennedy was assassinated, November 22, 1963.

We all left school and went down to the store. There were three big picture windows and a corner window. Dad had emptied all the displays from the windows and hung black velvet material in the background of all of them. Then, in the corner window, in front of the black velvet, he placed a big portrait of Kennedy with a spotlight on it, and a sign that read "Lest We Forget." My sisters and brother and I helped him fix these windows. It was Dad's way of mourning the president. He had such respect for the presidency.

New Horizons East

With the Midway Mall's grand opening in 1966, downtown merchants were feeling the effects of their customers' shifting tastes and purchasing desires. Business was falling off for everyone, and many store owners were getting ready to leave. Indeed, the J.C. Penney Co. and Sears were already abandoning their downtown locations to move to sleek, modern stores at the mall. Phyllis remembers that Leonard was asked to move the Fay Company to the mall, too.

"No. I'm not going to leave downtown," Phyllis recalled him saying. "Maybe we'll try one more thing—freshen it up, make it more youthful,'" And so, in March 1967, the Fay Company shook off its 1950s white-glove-and-millinery fustiness, reduced its footprint by five thousand square feet to make room for the Boston Drug Store on its west side, and became New Horizons East.

"My father was very forward-thinking," said Phyllis. An editorial in the *Chronicle* agreed:

Leonard Wasserman, longtime owner of the Fay Company, with daughter Judy at the 1967 grand opening of New Horizons East. *Courtesy of Loryn Wasserman Hutchins.*

We congratulate the Fay Co. and especially its president, Leonard Wasserman, on the opening of the New Horizons East store on Broad Street. Its imaginative name is indicative of the creative thinking and planning that have gone into making this new enterprise a reality. It is an impressive vote of confidence in the future of downtown Elyria. That is a heartening development. Mr. Wasserman has had experience in the operation of women's wear stores both in the downtown area and in a shopping center [Len opened a second Fay store, at the O'Neill Shopping Center in Sheffield, some years earlier]....*Modern suburban shopping centers obviously present a challenge to downtown merchants. Mr. Wasserman knows that, and he is facing the challenge squarely and taking positive action to respond to it.*

Elyrians turned out to celebrate the grand opening of New Horizons East in 1967. *Courtesy of Loryn Wasserman Hutchins.*

A Bit Like Carnaby Street

New Horizons East was hip and trendy; the word I probably used at the time was "groovy." I couldn't help but think that Wasserman had managed to capture for Elyria some of the spirit of London's Carnaby Street. There were beaded curtains, a jukebox, and incredibly cute clothes. This *Chronicle* article, written the day before the store's opening, described the swingin' sixties vibe provided by Cleveland designer Ramon Elias:

> *The décor features bright colors and pop art arrangements hung from the ceiling. A quintet of bright colors provided the motif for the store. The colors run in wide stripes on the deep pile carpet and are carried up the walls in vertical panels....Royal blue, emerald green, red, gold, and moss green...form the principal motif. The wall panels are overlaid with fashion sketches (painted by New York artist Samuel Scot) intended to give the effect of charcoal drawing. In the "Junior Joint" [Scot] has sketched on*

With the grand opening of New Horizons East in 1967, the old Fay Company got a mod makeover. *Courtesy of Loryn Wasserman Hutchins.*

Mannequins sport groovy fashions at New Horizons East. *Courtesy of Loryn Wasserman Hutchins.*

a light yellow wall fashion poses of Twiggy, the popular seventeen-year-old English model....Milk cans painted in various colors add to the pop art theme in the "Junior Joint" room, a nook containing a player piano, telephone, and jukebox set aside for use by the store's teen customers. The walls are hung with art work from various junior high and high schools in the area.

Of course Twiggy would be portrayed on the wall. She was the most popular model of the day, and had she crossed the pond, she would have been right at home in New Horizons East. As the *Chronicle* noted in another article, the store was for teenagers, young women, and the young at heart.

Loretta Sederis was the store manager. "Loretta worked with my dad forever, going back to 1945," said Phyllis. A *Chronicle* article reported that she "selected up-to-the-minute California fashions" for the store, which she purchased on a ten-day buying trip. "Buying trips to New York, which Mrs. Sederis makes monthly, keep the store stocked with the latest fashions from both coasts."

Len Wasserman bought all the sportswear for New Horizons East, which also featured "all types of dresses, rainwear, jewelry, handbags and accessories as well as formals."

Out of Business

Inventive merchandising, fashion-forward clothes, and an optimistic outlook weren't enough to stop the exodus of shoppers to the Midway Mall. In a little more than a year, sometime after Phyllis graduated from Elyria High School in 1968, Len Wasserman closed New Horizons East. His family's downtown store was relegated to the pages of history.

He had been president of the Fay Company for twenty-five years.

After retiring, he and Marjorie moved from their Denison Avenue home to Southern California, and their children eventually followed them there. Phyllis lives in Palm Springs, as does her younger sister, Loryn Wasserman Hutchins. Phyllis's older sister, Judy Wasserman Kuperman, lives in Redondo Beach. A brother, Richard (Ricky), died in Los Angeles in 1975.

Even though I was only eleven years old, a tad young for the New Horizons East target demographic, the memory of that place has never left me. Perhaps that's because it captured the mood and spirit of being young and alive in the mid-1960s.

2

Paradise Lost

There was no more beloved teen hangout in Elyria than the Paradise Soda Grille. Located across from Ely Square, at 521 Broad Street, it was, in its earliest days before World War II, "a first-class restaurant—very classy—with white linen tablecloths and napkins and little butter dishes," remembers Patricia Keefer of Elyria.

Patricia, who graduated from Elyria High School in 1948, said things changed because of the war effort. But the restaurant had "the best chefs," and she would know: she worked there from 1944 to 1948 and recounted with pride owner Harry Zahars telling her that she was the best soda jerk he ever had. She thought of him and his wife, Geraldine, known as Gerry, as family.

The youthful denizens of the Paradise christened it "the Pit" during its heyday in the 1950s and 1960s, and it looms large and mythic in their memories.

For proof of the fondness with which the Pit is recalled, look no further than Facebook. In 2017, more than two hundred current and former Elyrians, members of the Facebook group "You Know You're From Elyria If …" (it has since been renamed "Vintage Elyria"), reacted with enthusiastic nostalgia to posted photographs and queries about the Paradise. They loved the French fries with gravy; the cherry Cokes, chocolate Cokes, lemon Cokes, and vanilla Cokes; the banana splits and the hot fudge sundaes, with the hot fudge served in a little metal cup on the side. They loved the ribbon candy that someone named Sammy made in a big brass kettle in the

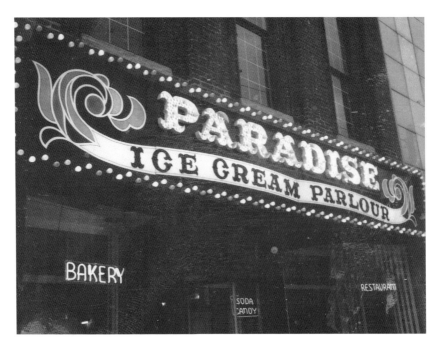

The Paradise during its post–Harry Zahars incarnation as an ice cream parlor in the 1970s. *Photograph by Dennis Camp; courtesy of the Dennis Camp family.*

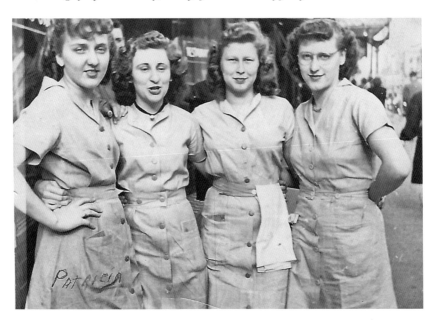

Patricia Keefer (*far left*) in a 1946 photo taken in front of the Paradise Restaurant, where she worked as a waitress. *Courtesy of Patricia Keefer.*

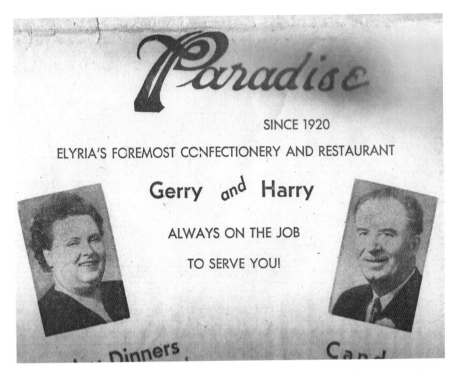

This Paradise ad featuring owner Harry Zahars and his first wife, Geraldine, appeared in the *Chronicle-Telegram* in 1951. *Author's collection.*

Paradise basement and which was sold at Christmastime. And they loved Harry Zahars. With Gerry and—later, after Gerry died—his second wife, Dorothy, Harry had given them a place to call their own.

Here, gently edited, are some of their recollections culled from Facebook threads, private Facebook messages, and phone interviews from 2017:

> "Saved [my] lunch money for fries and vanilla coke."
> —Amy Shaffstall Stafford (EHS '69), Alliance

> "I loved the Pit. They made the best thirty-cent waffles with real maple syrup. What was the name of the owner who stood up on the table and rang his bell when we teenagers got too loud?" (Author's note: That would be Harry Zahars, Rick.)
> —Rick O'Donnell Sr. (EHS '70), Oberlin

"I loved the Pit. Harry would ring his bell, stand on one of the tables and tell us to let our parents know they make great candy. He would also tell us to behave—no fighting! Great memories of cherry vanilla phosphates and French fries with gravy."

—Sandie Toth Hamby (EHS '69), Elyria

"Harry spoke with a thick Greek accent but his somewhat younger wife was born in this country. He always wore white, open-collared shirts. He and his wife were both wonderful people who truly loved their restaurant and their customers. Best ham sandwiches and cherry Cokes in town."

—Eric H. Zagrans (EHS '71), Elyria

"Boy, did we almost run after school to go there."

—Constance Thomas (EHS '69), Amherst

"We had to race down there after school because Harry would lock the door after so many were inside. You had to eat and drink slow because when you were done he would kick you out. So much fun."

—Pamela Justin Hooper (ECHS '65), Hudson, Florida

"Harry would give the impression that he was a tyrant but he was really a teddy bear!"

—Sue Maiden (EHS '64), Cornville, Arizona

"My fondest memory was the day JFK spoke at George Daniel Field in Lorain, and then a motorcade came through Elyria. Someone yelled 'JFK is coming down Broad Street!' We all jumped out and ran out the front door just to get a glimpse of him! Poor Harry almost had a heart attack thinking we were skipping out on not paying the bill! We went back inside to our booth and finished eating and then paid. Harry was up on the table telling us never to do that to him again."

—Sharon Filak (EHS '62), Lorain

"That was the place in the sixties. Harry kept things in line. I remember him counting cigarette butts in the ashtray and then saying, 'You've been here too long. Go home.'"
—JoAnn Doan Wenrick (EHS '65), Covington

"Most every night after school. A sarsaparilla and a cigarette."
—Nancy McBennett (EHS '58), Cleveland

"I was sure my mother was going to walk in and find me smoking...."
—Joan Crow (EHS '65), Vermilion

"Uncle Harry. He put up with a lot, but I think he loved the kids and the energy coming into the store."
—Sam Pronesti (ECHS '71), Elyria

"Harry had a birthday cake at the big table for me on my eighteenth."
—Terry Kayden (EHS '61), Birmingham

"Little did we realize what a treasure Mr. Harry was. The Paradise was our version of *Happy Days*."
—Shirley Mowery (EHS '61), Christiana, Tennessee

"What a fun place to go to after school and hang out. Harry spoke at one of our 1969 senior assemblies in the auditorium, but I don't remember what he talked about."
—Roseanna Cake (EHS '69), Elyria

"It was when the underclassmen did a play about the seniors for Distinction Day, making fun—nothing bad or ugly—of the things seniors did all year long. It was something they looked forward to seeing. But instead of an underclassman being made up as Harry, he came out himself and spoke—probably about our futures! I remember being so overwhelmed; I couldn't believe he actually came to address us! He signed my senior yearbook."
—Dana Bowser Elek (EHS '69), Elyria

"I took my mom and dad to share the experience. Harry got on top of a table and introduced them to everyone. They really got a kick out of it!"
 —Patricia L. Abel-Johnson (EHS '69), Riverside, California

"I had to sneak there after school. My parents wouldn't let me go."
 —Diane Toth (ECHS '67), Bainbridge Island, Washington

"Me too! I went to EC so that should explain it!"
 —Kathy Kovacs Iwert (ECHS '69), Aiken, South Carolina

"Hahaha me too, Diane! I grew up on Columbia Avenue and walked to school all the time. I almost always went to the Pit after school. I remember the sea-foam green booths and bead-board walls and tin ceiling in the restaurant part, the beautiful calligraphy on white paper listing the menu of candy and sweets up front. A lot of glass cases, cake-stands, so shiny. I remember sitting in a booth with girlfriends in 1962 as we all held our breaths over the Cuban Missile Crisis."
—Donna Stith Slocomb (EHS '63—and author of the 1963 Distinction Day skit spoofing Harry Zahars), Grayslake, Illinois

"Don't forget some of the brouhaha that went on when EHS played Admiral King or EC played Lorain Catholic. Harry lived on those tables, keeping the peace and everyone in line!"
 —Becky Warriner Finnegan (EHS '71), Elyria

"Elyria High on the right, Elyria Catholic on the left, booths in the middle. First come, first serve!"
 —Ginger Flickinger Beane (ECHS '63), North Ridgeville

"My dad worked at Harshaw. My friends and I would leave the Pit around four and meet my dad coming down the alley for a ride home to the west side."
—Katherine Frasher Schmitt (EHS '67), Wakeman and Naples, Florida

Loss

"My dad used to pick us up on the corner by the Men's Store and Merthe's across the street. Every day we went to Paradise Restaurant and I always had a lemon Coke and French fries with gravy."

—Barbara Kasper Folds (EHS '67), Olmsted Falls

"I remember watching the clock while in the Pit after school and running across the street to the square to catch the city bus to home on Gulf Road."

—Susan Twining (EHS '66), Cape Coral, Florida

"My mom worked there."

—Nancy Chapman (EHS '75), Shiloh

"Nancy Chapman, my mom worked there also!"

—Dorma Baker (EHS '75), Chesapeake, Virginia

"My aunt worked there for years."

—Georgia Gallion Klipstein (EHS '70), Wellington

"My sister worked there while she was in high school in the mid-1960s."

—Douglas Rust (EHS '61), Elyria

"It was a special treat for a little kid…to be able to go to the Pit and get a cherry Coke with an older brother or sister."

—Katie Keys (EHS '78), Elyria

"My momma went there in the '50s and I went in the late 1960s, early 1970s maybe. Lots of great memories."

—Carolyn Spence-Dobbins (EHS '80), Elyria

"First date! :) <3"

—Mindy Beller (EHS '80), Asheville, North Carolina

"Loved Paradise…."

—Peggy Paterchak (Amherst Central High School '57), Lorain

PARADISE LOST

"Loss of Paradise Deplored," read an editorial headline in the *Chronicle-Telegram* on March 23, 1968 (with apologies to poet John Milton for alluding to his masterpiece). The opinion piece followed Harry Zahars's announcement that he had decided to close his restaurant after forty-seven years of ownership. He explained that new owners who bought the restaurant in the summer of 1967 had failed to manage it profitably.

> *We can say…with complete accuracy, that many Greater Elyrians feel a loss. There has been a restaurant in this Broad Street location for more than fifty years, and…the Paradise has been a popular gathering place for teenagers.…They felt welcome there, as long as they conducted themselves properly, and they felt that Mr. Zahars was really interested in them.…The teenagers and their parents owe thanks to Mr. Zahars for providing a place like the Paradise. We are sorry he feels he can no longer carry on active operation of the business.*

Perhaps due to the sincerity of the newspaper's lament, Paradise was regained—briefly—the following month, and Zahars reversed his decision. With the start of school that September, the paper profiled the beloved restauranteur on its "Teen-age Page," and he explained that the need of Elyria's youth for a place to socialize drew him out of retirement. One of his waitresses told reporter Connie Davis: "He wouldn't be happy any place else but here with the kids."

A photograph of him, in his trademark perch atop a table, shows him exclaiming "Happy days are here again!" to welcome the returning students. Decades later, that popular television show would be invoked in Shirley Mowery's reverie.

During peak hours after school, crowds at the Paradise could total from four to six hundred teens within a two-hour span, so Harry outlined the rules: four to six at a table or in a booth, and students had to leave after twenty minutes to make room for those lined up at the door. The crowd on that September day included graduates from the class of 1968 who were about to leave for college or serve in the armed forces either in Vietnam or elsewhere.

Harry gave two speeches that day, one for the early crowd at 3:00 p.m. and another about thirty minutes later: "It thrills me to see all your young smiling faces," said the man who never had children of his own. "I love you. We welcome you…we always have and we always will," he added.

Sadly, Harry was unable to keep that promise.

A three-word headline in the June 9, 1970 edition of the *Chronicle-Telegram* no doubt broke the heart of every Elyria teen reading it: "'The Pit' Closes"

The news item reported that for the second time in two years, business operations would be suspended for Elyria's teenage haven, and it included an announcement by Harry that the restaurant's present managers were being "released of their obligations." Although Harry had hoped to find someone interested in running the Paradise, that was not to be.

Ironically, 1970 was the year Joni Mitchell released her album *Ladies of the Canyon*, which included the song "Big Yellow Taxi," with its prescient lyrics about paving paradise and putting up a parking lot.

Paradise Regained, Part II

The restaurant remained closed until Harry Zahars sold the building to real estate developer Robert Glover in the summer of 1974. According to Glover's daughter Nancy Oates of Elyria, her father hoped to spark a downtown renaissance.

"My dad purchased the restaurant and renamed it Paradise Ice Cream Parlor," she said. "Dad was a real estate developer, and the plans were to revitalize downtown."

I was too young to have frequented the Paradise during its heyday, but I do recall Glover's version as a charming place to have lunch when I worked downtown after graduating from high school in 1974. Others remember it as the site of memorable first dates. But that Paradise was not around for very long.

According to a January 29, 1984 *Chronicle* article, the Paradise had run through a number of management and motif changes; it was even a Chinese restaurant for a time. In November 1977, it closed as a restaurant and became a game room called the Double Feature. The following year, Glover sold the property to Johnny Dixon, yet another developer with dreams of revitalization, who named the place after himself and turned it into a restaurant and bar.

In a telephone interview, his son, John Dixon Jr., told me that his father ultimately retained the concept of Johnny Dixon's but rebranded it as the Hi Brows Lounge. the *Chronicle* reported that Dixon spent about $25,000 remodeling the place.

A Suspicious Fire

Sometime during the early morning hours of Sunday, January 8, 1984, a general alarm fire at the property—reported by the *Chronicle* as "one of the most difficult blazes to fight in Elyria's history"—injured twenty firefighters and caused nearly $1 million in damages to four buildings. Firefighters from Lorain and North Ridgeville joined the crew from Elyria—there were fifty-seven men in all—and it took them six hours to extinguish the stubborn inferno. What had been hallowed ground for thousands of Elyria teenagers was now the gutted wreck of the Hi Brows Lounge, which is where the fire reportedly started. Also destroyed was the Parkview Building next door, which was home to an art gallery. The nearby Frank's Army-Navy store sustained heavy fire, smoke, and water damage, as did the Spitzer Plaza, which occupied the spot where the Rivoli Theatre had once stood.

"It was a total loss," John Dixon Jr. said during a phone interview. "There was nothing left."

When the fire started, his father was out of town on vacation in Florida, according to the *Chronicle's* coverage. The lounge had been closed since the New Year. On Saturday morning, the day before the fire, Elyria realtor Les Drage discovered that someone had entered the property through a skylight window. "Drage said repairs were made Saturday and everything was fine when he left about 3:30 p.m.," the paper reported.

"They've broken into there two or three times," the realtor was quoted as saying. "I suspect the fellas that broke in the night before (Friday) probably came back." Arson was suspected.

On January 20, 1984, the paper reported that the Ohio Blue Ribbon Arson Committee was offering a $10,000 reward for information leading to the identification of those responsible for the Hi Brows Lounge fire. Another reward, in the same amount, was offered for a different fire that took place the previous October at Harry P's Lounge, also on West Broad Street. The city had formed an arson task force after that fire.

Searching the digitals archives of the *Chronicle* with the keywords "arson, fire, and Hi Brows" provided no answers about whether the case was ever solved; I could find no news reports with those keywords past 1985.

Assistant Fire Chief Joe Pronesti, of the Elyria Fire Department, was fourteen at the time of the Hi Brows fire. His late father, also named Joe, had been a lieutenant with the department and was retired by that time. The younger Pronesti had always been fascinated by what his father had done for a living.

"Back then, I used to chase fires," said Joe. He had left his police scanner on before going to bed and heard the chatter. "I woke my dad up and said, 'Let's go—there's a big fire downtown.'

"I remember it was cold," he said. "My dad went to the store to get the guys coffee and cigarettes. I remember where each truck was placed and I remember the flashover which occurred in the art gallery that [some firefighters] narrowly escaped."

A flashover, said Joe, is when everything ignites all at once. The *Chronicle* coverage from the day after the fire reported on it:

> *A number of firefighters narrowly escaped when the roof of the Parkview Building collapsed. "At one point, there was a flashover at the Gallery and we almost lost a couple of men," said Chief Novak. "It was a matter of seconds or so getting them out. They just made it out."*

Despite the $10,000 reward offered by the Ohio Blue Ribbon Arson Committee, no suspects were ever apprehended, and the case went cold.

"The fire was listed as suspicious, and it was left at that," Joe said. The structures had sustained too much damage for a definitive determination of arson, and scientific technology in the 1980s was not advanced enough to provide any answers. "It will forever be a suspicious fire."

Today, if you do a Google Maps search for 521 Broad Street, the street-view photo shows a gap-toothed space between what was once the Rivoli Theatre to the east and the Old Fortress Block, which became home to Whitey's Army-Navy store after Frank's Army-Navy burned, with the Hi Brows Lounge to the west.

The empty space is now a parking lot—the future eerily foretold by "Big Yellow Taxi" in 1970.

THE ZAHARS LEGACY

Despite the heartbreak of losing the Paradise to time, ashes, and history, its story does have a happy ending. Before Harry Zahars died on August 4, 1992, at the age of ninety-four, he saw to it that the young men and women who once prompted him to jump up on tables ringing a bell and issuing admonishments for their general rowdiness had more to remember him by than ice cream, candy, and French fries with gravy. Indeed, Harry left an

enduring legacy that would affect the lives of numerous young men and women he would never meet.

With his late wife, Gerry, and his second wife and widow, Dorothy, both of whom worked with him in the restaurant, Harry formed two scholarship funds: the Harry T. and Dorothy Zahars Memorial Scholarship Fund for Boys, and the Geraldine Elsasser Zahars Memorial Scholarship Fund, which supports female Elyria graduates who wish to pursue a nursing career. Gerry had been a registered nurse. This is the fund that allowed Karen Donovan Cohagan to attend the M.B. Johnson School of Nursing.

At the old Paradise, an aisle once separated tables of Elyria High students from those who went to Elyria Catholic, but with his scholarships, Zahars made no such distinction: both are intended for qualifying graduates of *any* Elyria high school.

3
Vietnam: Days of War and Protest

The Vietnam War formed the backdrop for a generation of childhoods, including mine. American involvement began the year I was born, in 1956. Each evening, the network television news programs broadcast horrific images directly into our living rooms.

The last remaining Americans were evacuated from Vietnam in 1975, the year after my high school graduation, making this war, in terms of sheer chronology, a bigger fact of my life than that of my own father. He died on June 26, 1969, the same day that another Elyrian—Army specialist fourth class Robert "Bo" Cameron —was killed in Dinh Tuong Province. An ace pitcher for Elyria Little League North, Bo graduated from Elyria Catholic High School in 1966. He was only twenty years old.

According to the Department of Defense's Casualty Analysis System, 58,220 Americans died in the Vietnam War. This is the number of American casualties in Vietnam from June 8, 1956 through May 28, 2006. American military involvement in the Vietnam War ended on March 29, 1973, but Lynn Goodsell, supervisory archivist with the Electronic Records Division at the National Archives and Records Administration, pointed out in an October 2017 telephone conversation that casualty records are updated to include anyone who dies after that date from a cause considered a direct result of the war.

Let's look at that number again and let it sink in: 58,220 American lives were lost in the Vietnam War. The population of Elyria was barely fifty thousand in 1963, according to the Elyria City Directory for that year.

Draftees waiting to be processed into the U.S. army at Fort Jackson in Columbia, South Carolina, 1967. *Courtesy of the Library of Congress, Prints & Photographs Division, U.S. News & World Report Magazine Collection (LC-DIG-ds-07106).*

Lorain County sacrificed ninety-eight young men to the war—two of them brothers from the same family in Wellington. At the tender age of eighteen, two Elyria boys were among the youngest to die in combat—Army private first class David Allen Fowler and Marine corporal Carris Michael Francis. Along with Bo Cameron, they were among the eighteen young Elyria men to lose their lives in the war, to say nothing of those who were injured, maimed, or otherwise forever impaired.

Behind each devastating fact is a face, a family, a life. This chapter concerns two women, native Elyrians whose lives were irrevocably changed by the Vietnam War. One suffered a tremendous loss; the other found an abiding love.

A Boy Called "Bubby"

Mary Ella Jones Mauldin took me into the kitchen of her blue split-level home in Oberlin in the fall of 2017 to show me an old photo album, the kind with thick, black paper sheets. There aren't many filled-in pages in the

album, because there aren't many pictures—just a handful of school photos, each one secured by layers of clear tape, as if to protect the wide-eyed boy with the engaging grin from harm. But here, the metaphor fails, for also taped into the album are news clippings that tell how the boy's story ended.

The oldest of seven, Mary grew up on Elyria's west side. Her younger brother, Norman Junior, whose nickname was "Bubby," was born a scant nine months after she was, so for a brief time every year, they were the same age. He teased her after each birthday: "I'm as old as you are now!"

Mary loved her brother, but this didn't sit well. "I liked being the oldest," she said.

She remembers Bubby as "a hustler, in a good sense." Their mother, she said, would wonder where her son was when he was out riding his red Murray bike around their Bell Avenue neighborhood; she thought he might be goofing off, but he wasn't. "He was working little odd jobs to bring money home to Mama and the family," Mary said. "He'd collect pop bottles and cash 'em in." He could often be seen helping older neighbors—washing their windows, sweeping, raking their leaves—or simply keeping them company on their porches.

So responsible was Bubby that when he was old enough, he was permitted to drive his father's car. He loved to dance and would drive his sisters and friends to dances at Marcell Hall on the south side. (My father once owned Marcell Hall, which was near our hardware store.)

SCHOOL DAYS 1957-58
EDISON

A school picture of Norman "Bubby" Jones Jr. taped into his sister's photo album. Photograph by the author. *Courtesy of Mary E. Jones Mauldin.*

There was, however, one thing that Bubby avoided.

"He didn't do the street," Mary said. "Back in the day, you could do the street just like you do it now, but he didn't. He was a good boy. It was always about family with him."

By the time he got to Elyria High, Bubby recognized that he wasn't, as Mary said, "a pencil and paper guy," and he quit school. His hopes of getting a job at the Ford Motor Company were about to be realized when the draft notice came.

STARRY-EYED, WITH DREAMS OF TRAVEL

Around the time Norman Jones Jr. was figuring out that school wasn't for him, Cynthia "Cindy" Mason was enrolled at the M.B. Johnson School of Nursing. In a phone interview from her home in McAllen, Texas, she described her younger self as "starry-eyed" and in search of travel and adventure. In 1967, while still in nursing school and just two years out of Elyria High, she enlisted in the U.S. Army Student Nurse Program.

Cindy came from an army background. Her father, Donald "Jack" Mason, had served in the South Pacific during World War II. Jack was an electrician's helper at Harshaw Chemical; Cindy's mother, Thelma, stayed at home to care for Cindy and her three younger brothers. The family first lived in a rear second-floor apartment in the Nichols Block on Broad Street. Cindy recalled a front apartment, occupied by relatives, with "a beautiful bay window in an alcove, where we would watch the Halloween parades."

She and her brothers walked to Gates School, taking a shortcut by climbing out their tall back-kitchen window, down a fire escape, through a parking lot, down an alley, past a beer joint, and over to Lodi Street, which she remembers as being lined with big houses. "That's also how we got to Cascade Park," Cindy said. The Masons later moved to 508 Denison Avenue.

Her enlistment set an example for her brothers, each of whom signed up, too, although none were sent to Vietnam. She spoke about her rationale for joining:

> *I really felt strongly as a nurse about going to participate in a helpful way. I've told many people that if I had been a guy, knowing I was going to be in hand-to-hand combat, I probably wouldn't have joined. But it was a very different perspective for me; I knew it would be not only a helpfulness to someone, but that I would learn a lot, personally and professionally.*

The plan was straightforward: Cindy pledged to go on active duty as a commissioned officer for two years and, initially, she would be paid as a private first class. The salary would cover the remaining cost of her tuition at nursing school. She graduated in 1968 and passed her state board exams in Columbus, and by September, she was commissioned as a second lieutenant in the U.S. Army Nurse Corps.

After six weeks of basic training at Fort Sam Houston in San Antonio, she was assigned to the Letterman General Hospital at the Presidio, the

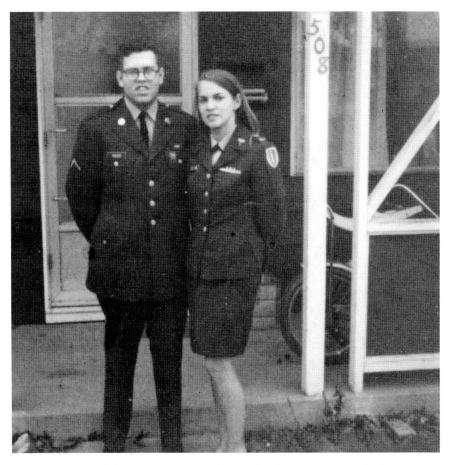

Lieutenant Cynthia Mason and her brother, Robert Ray Mason II, at their family home following her return from Vietnam, March 1970. *Courtesy of Cynthia M. Young.*

U.S. army fort in San Francisco. In the hospital's intensive care ward, she gained valuable experience in the neurosurgery-neurology-maxillofacial unit. Following a brief leave to visit family in Elyria, Lieutenant Cynthia Mason shipped out in March 1969 to the 24th Evacuation Hospital at Long Binh, about eighteen miles northeast of Saigon, in the Republic of Vietnam.

To mail letters and packages to her daughter, Thelma Mason, who didn't drive, would walk every week from their home on Denison Avenue to the post office on Broad Street.

FATEFUL NOTICES

Mary Jones Mauldin doesn't remember exactly when Bubby's draft notice arrived, but she recalls that it was around the time he heard from Ford with a job offer. "We were so upset that he was drafted," she said. "We knew there was a war. There's always the possibility that the person wouldn't make it back home. That was always the fear—that Bubby wouldn't come back."

She also recalled friends of hers whose lives were destroyed by the war. "I had a friend who went to 'Nam, and when he came home, he was just done." Another was "totally crushed" in Vietnam.

As for Bubby's draft notice, despite hating the idea of war and casualties, Mary knew that going was his "civic duty, an honorable thing to do." This was partly because of the family's history of service: their maternal grandfather fought in World War I, and two uncles also served—one in World War II and the other in Korea. Now, it was Bubby's turn.

Still, always, there was the fear. Would he come home standing up? Would he be carried home in a coffin? "Dealing with that is what shook me so much," she said.

Any idea of becoming a draft dodger and running off to Canada was out of the question. "My brother would never have run. 'I got no choice,' he said. 'I gotta go.'" The *Chronicle-Telegram* quoted Mary's mother, Hattie Mary Jones, in an article from the era: "The other boys were there and he felt that he should be there too."

Vietnam was a war fought not only by young working-class white men but also by young African American men, writes Jon Savage in *1966: The Year the Decade Exploded*: "Although only 10 percent of their overall cohort, they [African Americans] formed 31 percent of all combat troops at the start of the war and, during 1965, comprised 24 percent of all deaths in Vietnam."

A press clipping in Mary's album shows a smiling Army private Norman Jones Jr., neat and trim in his uniform. By September 1967, the family had moved to 244 West River Street, North, which is where Bubby spent his twenty-six-day leave. He had completed basic training at Fort Knox, Kentucky, was assigned to Fort Gordon in Georgia for advanced infantry airborne training, and from there, he headed to jump school at Fort Benning.

Bubby arrived in Vietnam on March 6, 1968, a few weeks after Mary's birthday. Their ages no longer evened out. She was officially older.

Wards 5 and 6

During the month that I was interviewing Cindy Mason, she sent me a text: "It is like a tonic to many Vietnam vets to have someone interested in asking. Many people are afraid they will upset us, and it can be painful, but it can also be therapeutic to have it acknowledged that we went through a very tough experience."

She was assigned to postoperative recovery in Wards 5 and 6 of the 24th Evacuation Hospital's forty-bed neurosurgery unit, treating soldiers with head and spinal wounds. With roughly twenty patient beds categorized as being for critical care, the wards were typically full.

Spinal or head wounds, including those from "minor frag" with no penetration of the brain covering, were routinely explored in surgery. "These were million-dollar injuries," Cindy explained. "Once you've gone and had your brain dabbed with a scalpel to see if anything was left in the wound, you've increased the possibility of infection."

A soldier so injured was thus ineligible to return to combat. "Those were the best patients to wake up from anesthesia," she said. "You could tell them: 'You're safe. No one's trying to kill you anymore. You're wounded but not badly and you're going home. You don't have to go back out there again.'" Such was the lot of patients in Ward 6.

Only two types of patients occupied Ward 5: those who had sustained head wounds—some were in comas—and those with severed spinal cords. All were immobile. All required intensive care.

"In addition to neurological injuries, these patients typically had multiple other problems," Cindy wrote in an email. "Amputations, fractures, traction, chest tubes, drains of all sorts, and many other wounds [needed] to be cared for." Given their immobility and the nature of their injuries, patients in Ward 5 also needed to be very carefully repositioned and their arms and legs gently exercised. They also needed to be turned every two hours to prevent bedsores.

Patients with cervical spinal cord injuries have difficulty breathing, according to Cindy. Eventually, their fluids stop circulating properly and collect in the chest. Being on one's stomach for an extended period of time causes compression, which makes it difficult to get enough air, even with a breathing tube. In this case, a patient would signal his discomfort by making a sort of clicking sound with his tongue, indicating he needed to be turned again.

Of everything that Cindy experienced while stationed in a combat zone—including those times when explosions were frighteningly close—it was that sound, the tongue-clicking, that most distressed her.

YEARS OF LIVING DANGEROUSLY

With the Tet Offensive in 1968, American casualties reached a staggering 16,899. The following year, 11,780 servicemen died, making 1968 and 1969 the deadliest years of the Vietnam War, with more American lives lost than at any other time during the nineteen-year conflict.

In each of these years, Lorain County lost two servicemen on the same day. Michael Drennan Milburn of Elyria and John Lyle Murphy of Sheffield Village—both twenty-year-old lance corporals with the U.S. Marine Corps—were killed on February 6, 1968. Army sergeant Richard Matthew Logan, twenty-five, of Elyria, and Lance Corporal Calvin Blanton Jr., of the marines, who was twenty-one and from Lorain, both died on October 26, 1969.

By 1968, Mary Ella Jones was married to Robert Mauldin and living with their infant son in a Westway Gardens apartment. That's why she was not at 244 West River when two uniformed Army officers knocked on the front door. Tears gently rolled down her cheeks while she described how her teenaged sister Jean learned that Bubby was dead.

"She was walking down the street, coming from the store. She saw two officers get out of a parked car and walk up to the porch. She knew when she saw them that something was wrong. And when she got there she found out it was Bubby. She just broke down."

Private First Class Norman Jones Jr. was shot by enemy fire in Binh Duong Province on June 18, 1968, and died outright. He had been in Vietnam less than four months. Mary's mother-in-law and sister-in-law broke the news to her at her apartment. A press clipping taped in Mary's album shows a photograph of her parents receiving their son's medals, among them the Bronze Star and the Purple Heart. Bubby was twenty. Mary had turned twenty-one that February.

LEAVING VIETNAM, AND RETURNING

Lieutenant Cynthia "Cindy" Mason's last day in Vietnam was March 5, 1970. A snapshot taken that day shows a young woman in army fatigues with a relaxed smile on her face. I asked what was going through her mind.

"I was going home," she said. "I was happy. Everybody was around me; that picture was taken on the ward. It was cheerful but bittersweet—more sweet than bitter. None of us wanted to stay a minute longer."

Cindy does have a favorite memory from those days: she met her husband, an infantry officer named Douglas Young, during his second tour. Married for forty-eight years, they have one biological son and two adopted adult Vietnamese daughters. They "unofficially" adopted another young Vietnamese man—he is such a fixture in the family's home that he calls Cindy "Mom."

Douglas Young has written a memoir, *Same River, Different Water: A Veteran's Journey from Vietnam to Việt Nam* (the former spelling refers to the war, the latter to the country's name). In the book, he describes their journeys in the country that they both came to love while traveling on vacation in a van from Ho Chi Minh City (formerly Saigon) to Da Nang. They've returned many times to teach and provide medical aid. They even lived there for eighteen months, from 2005 to 2006, while teaching English for three semesters at Huế University.

TODAY

Mary Jones Mauldin said that Bubby's death broke her mother and father. If she could speak to him today, this is what she would say: "If you were here, things would be a lot different than they are."

Asked how that might be so, Mary said that because Bubby was a disciplinarian, with leadership values similar to her father, he watched over—and was helpful to—everybody. "We would never have had to worry about anything if he was here. He was so honorable; you couldn't help but listen to him. You knew that if he told you something, he knew what he was talking about. He was very wise."

She would like him to be remembered "as an honest, straightforward young man" who had a good personality, was kind and "would give you the shirt off his back."

She adds: "I wish he had been living in this day and age, because he would have been such a help to the young men nowadays. He could have taught them so many things. I could imagine, if he had a son, what that boy would turn out to be."

Cindy Mason Young left active duty in 1975. She still returns to Elyria to visit family. In 2019, on November 23, she will be seventy-two. Mary Jones Mauldin's husband died in September 2017; they were married for fifty years. She is also seventy-two.

On November 30, 2019, Norman Jones Jr.—"Bubby"—would have been seventy-two, as well. Just like his sister Mary.

Elyria casualties of the Vietnam War: 1. Private First Class James Calvin Whitmore, Army, died November 9, 1967, age twenty-one; 2. Corporal Carris Michael Francis, Marine Corps, died March 24, 1970, age eighteen; 3. Specialist 4 George Wesley De Jarnett, Army, died February 29, 1968, age twenty-five; 4. Private First Class Donnie Stanley Kegg, Marine Corps, died May 1, 1968, age nineteen; 5. Specialist 4 William Val Springfield, Army, died May 13, 1969, age twenty-seven; 6. Sergeant Richard Matthew Logan, Army, died October 26, 1969, age twenty-five; 7. Private First Class Norman Jones Jr., Army, died June 18, 1968, age twenty; 8. Private First Class Troy Tony Threet, Marine Corps, died February 10, 1968, age twenty; 9. Specialist 4 Robert Charles Cameron, Army, died June 26, 1969, age twenty; 10. Lance Corporal Calvin Kermit Coon, Marine Corps, died September 18, 1968, age nineteen; 11. Specialist 4 Raymond Michael Enczi, Army, died October 31, 1968, age twenty; 12. Private First Class David Allen Fowler, Army, died January 18, 1970, age eighteen; 13. Lance Corporal Michael Drennen Milburn, Marine Corps, died February 6, 1968, age twenty; 14. Private First Class John Lester Began, Army, died August 16, 1968, age twenty-three; 15. Specialist 4 Joseph George Ambrosio, Army, died September 27, 1968, age twenty; 16. Corporal Glenn Michael Schroeder, Army, died October 21, 1969, age twenty; 17. Private First Class John Steven Gentkowski, Army, died April 19, 1971, age twenty; 18. Specialist 4 William Earl Foster Jr., Army, died September 12, 1968, age twenty-five. *Montage created by and courtesy of Joyce L. Young, archivist of the Lorain County Vietnam Veterans Memorial.*

Vietnam Moratorium Day

The names of eighty-five Lorain County soldiers who had been killed in Vietnam were read aloud in Ely Square on the afternoon of Wednesday, October 15, 1969. A total of ninety-eight Lorain County men would give up their lives to that war, although thirteen of them were still living on October 15, 1969. Two of the thirteen—both Elyria boys—would die before the month was over. Listening to the recitation of the war dead were retirees and teachers, members of the clergy and doctors, busloads of students from Oberlin College, citizen activists, and ordinary citizens. They were among the 450 people who assembled—peacefully but emphatically—in the square to protest the war in Vietnam. They were not alone.

Throughout the country, hundreds of thousands of Americans joined in the largest antiwar protest in U.S. history, as the Associated Press reported the following day. There were rallies, parades, candlelight processions, and church services held in cities across the country—an effort to mobilize broad-based opposition to the war and maximize public pressure to end it. The moratorium's slogan was: "Bring home the troops. All the troops. Now!"

The Lorain County Chapter of the National Democratic Coalition sponsored the Elyria moratorium. Sally Staruch of Lorain, chair of the area coalition, and vice chair Dr. John Katko of Elyria—the local organization's founders—helped organize the protest. Dr. Katko, who died in 1984, had been a delegate for Eugene McCarthy from the Thirteenth District at the 1968 Democratic National Convention in Chicago.

The New Democratic Coalition included members of Citizens for McCarthy groups from across the United States and was formed as a result of the violence that unfolded at the convention. Sally's brother, Martin Ballog, was a student at Bowling Green State University and active in antiwar efforts on campus. It was his involvement, and her experience as a young mother watching the news broadcasts of the convention rioting, that ignited Sally's activism.

In an interview, Sally explained, "What Mayor Richard Daley's police were doing to our students—kids who were not criminals—catapulted me into the antiwar movement." She showed me the coalition newsletter from September 1, 1969, outlining the issues of paramount importance to the organization:

> *Support the Minority Peace Plank on Vietnam*
> *Reorder American goals: stop policing the world and solve our domestic problems*
> *Work to end racism*
> *Democratize the Democratic Party*

Vietnam War protestors in downtown Elyria on October 15, 1969, the day of the moratorium. Photograph from the *Cleveland Press*. *Courtesy of the Lorain County Historical Society.*

The newsletter reported what history has since recorded: supporters of the war were coming to gradually realize and accept that a military victory was impossible, and any struggle should be continued by the Vietnamese people.

An editorial published in the *Journal* (now known as the *Morning Journal*) on the date of the moratorium supported the peace efforts:

> The Journal *has for more than two years been an outspoken advocate of the withdrawal of American troops from Vietnam. We recognize, however, that there are differing viewpoints on the question....In accordance with the policy of this newspaper, we have attempted to present both sides.*

The paper published two articles by Lorain ministers representing the pro and con sides of the war issue but reiterated: "As for the stand of *The Journal*, it remains unchanged."

Editorial page editor Malcolm D. Hartley wrote, in part:

> *American involvement in the Vietnam War is, like the entrance to hell, paved with good intentions. The United States has sacrificed thousands of men and billions of dollars, not for conquest but in an effort to safeguard for*

Sally Staruch (*left*), organizer of the 1969 moratorium, with 1970 Ohio gubernatorial candidate John J. Gilligan. The woman at right is unidentified. *Courtesy of Sally Staruch.*

the South Vietnamese our concept of freedom. Our purposes, though noble and unselfish, were misguided. Slowly this realization has penetrated the minds of millions.... The still, small voice of conscience has asked: 'Why are we fighting? Why are we continuing to kill and be killed?' The small voice turned outward and multiplied by a thousand times a thousand, has become a thunderous national command: STOP THE WAR. That is the message on this Day of Protest. Those who advocate continuation of the war are now in the minority. This means that the protesters have a new and solemn responsibility. They must move toward the goal of peace without violence, without disruption, without failing our soldiers in the war zone and without tearing our country apart.

Included among local opinion pieces written during the week of protest were these, which were printed in the *Lorain County Times* on October 16, 1969:

Excerpt of an editorial by Don Barden: *The Moratorium indicates the thinking of today and of the future. The youth of our country have been the losers. There are no winners. The good have died young.*

Excerpt of an editorial by Ron Nabakowski: *The Moratorium should serve notice to all responsible Americans that democratic government is government subject to continual vigilance of its people....For democracy does not function under the divine right of kings. Rather, its powers are delegated from the people. Ergo, should the people decide that its government's course of action is wrong, the patriotic thing is emphatically not to give blind support; the patriotic thing to do is to change that course of action from wrong to right. And this is what the Vietnam Moratorium is all about.*

Sally Staruch told the *Chronicle-Telegram's* Martha Bergmark that although the Vietnam War and the draft were student concerns, "housewives, businessmen, clergymen, and others are also concerned about the war. We will be passing petitions and distributing leaflets about the war at the vigil."

The petition requested that quotas for the county not be met until U.S. troops are withdrawn from Vietnam and was presented to the Lorain County Selective Service following a march by the protestors to the Selective Service offices in the Baker Building on Second Street.

There were also speeches at the moratorium, and Sally gave one of them:

Take a look at your son, Mr. and Mrs. Smith. Would you let some stranger decide where he will go to college? Or what career he will pursue? Or any other important question about his future? There are strangers who have already decided where he may die....We must go on insisting that our government measure up to the ideals we teach our children to cherish. Democracy works only when we work at it....Today we honored those who died in Vietnam, those who went to Vietnam because they believed (as men believed in World War II) that it was their duty to go: they followed their conscience....similarly other young men are refusing to go to Vietnam because they believe it is their Judeo-Christian duty to refuse to kill. They, too, listen to their conscience....There are many here at the rally who do not like war—especially the Vietnamese War, but are offended because they feel we are speaking out against the government....Well, who is the government? You and me. The military and the president work for us. If we are silent on an issue Washington interprets it as approval.

On that October day, the *Chronicle-Telegram* reported that as a precautionary measure, Elyria safety-service director James T. Tracey had benches removed from Ely Square the previous night "in order to give demonstrators room to

move around. This is supposed to be a peaceful demonstration, and I think they're sincere," the city official said. "We're here to help."

On the following day, the paper reported that Tracey and Mayor Leonard P. Reichlin had "high praise" for the participants' conduct. "They were polite and courteous and I was impressed with their attitude," Tracey said. "I wish all our crowds were like this." Both men reportedly stopped to talk with a group standing vigil at the courthouse that evening, and Mayor Reichlin described the young participants as "a nice bunch of kids."

"It was a good discussion of the war," Tracey told the *Chronicle*. "They told me how they felt and I told them how I felt."

According to the newspaper's report, John Katko was "thrilled by the turnout. It was more than I expected," he said of the 450 persons who gathered in Ely Square. "For Lorain County, this is good, because they're not accustomed to the idea of demonstrations here."

Sally Staruch moved to Fairwood Boulevard in Elyria in 1970 and became a precinct committeewoman. In 1972, she and John Katko were delegates at the Democratic National Convention in Miami Beach. She eventually returned to live on her family homestead in Lorain.

I was in the eighth grade at the time of the moratorium. I remember one of our teachers at St. Mary School—a man of draft age—talking about the protest that was to be held downtown, although I don't recall what he said. I do remember feeling some trepidation about it. I also felt too young, helpless, and inadequate to do anything substantive about the war. I nevertheless expressed my own nascent activism by wearing a POW bracelet, and a silver peace symbol was one of the charms on my charm bracelet.

Two hundred and one days after the moratorium, on Tuesday, May 4, 1970, four students at Kent State University were killed, and nine were wounded, after the Ohio National Guard fired into a crowd of demonstrators on campus. One of those killed was William Schroeder of Lorain.

On January 27, 1973, President Richard M. Nixon signed the Paris Peace Accords, ending direct U.S. involvement in the Vietnam War. Saigon—the capital of South Vietnam—fell two years later, in April, seized by communist forces. The government of South Vietnam surrendered. More than a thousand American civilians and nearly seven thousand South Vietnamese refugees were evacuated by U.S. Marine and Air Force helicopters in an eighteen-hour mass evacuation effort.

4
When JFK Came through Town

Of all my childhood memories, the one of my father lifting me above his head to sit on his shoulders, then enthusiastically running out the door of his hardware store on Middle Avenue, is among the most vivid.

The sudden eagerness to be outdoors on a work day had nothing to do with the weather, although the National Weather Service did record a high of seventy-two degrees at Cleveland Hopkins Airport on Tuesday, September 27, 1960. My father wanted us outside on this pleasant autumn afternoon because history, in the form of John Fitzgerald Kennedy, was about to drive by.

The Democratic senator from Massachusetts and presidential nominee—with his charisma, matinee-idol good looks, and glamorous young family—had captured the imagination of much of the country. Even though I was only four at the height of JFK fever, I was caught up in the excitement of the moment, too.

Kennedy was locked in a close race with Republican nominee Richard M. Nixon. In late September, the election was weeks away. With its twenty-five electoral college votes, Ohio was an important prize.

I knew nothing of this at the age of four. All I knew was that a nice-looking man was smiling and waving at us and others outside our store. People tossed plastic "straw" hats our way—they had Kennedy's name and picture printed on their colorful headbands—and my father caught one of them. I no longer have it. I wish that I did.

Undated photo of the hardware store owned by the author's father at the corner of Middle Avenue and Seventeenth Street. This is likely how it would have looked in 1960. *Author's collection.*

EARLIER THAT DAY, IN LORAIN…

Reading the *Chronicle's* report of his visit, I learned that Kennedy's campaign had scheduled him to speak at a rally at Lorain's George Daniel Stadium. The reporter noted that the stadium was "better than half-filled," and a Democratic official estimated that 5,500 people were there.

According to the *Chronicle*, Kennedy viewed the race as a "contest between two parties." The Democrats, he said, have the vision, vigor, enthusiasm, and foresight to "meet the problems we face and maintain our freedom, too."

In those days, the United States and the Soviet Union—two nuclear superpowers—were locked in a tense, ideological Cold War battle. The threat of communism was, Kennedy said in the speech, "a great danger that is striving relentlessly to destroy us."

"The question is," Kennedy declared, "not only are we stronger than communism right now, but also will we be stronger than the communists in 1970? And in 1980? We need not only be concerned for our security now, but for our children. We can't possibly miss—can't possibly fail, if we maintain our freedom."

Democratic presidential nominee John F. Kennedy and J. William McCray at a Lorain rally on September 27, 1960. *Courtesy of the J. William McCray family.*

HEADING TO ELYRIA

Kennedy and his retinue lunched at the Lorain Moose Club after the rally, then, reported the *Chronicle*, "proceeded through Lorain and Elyria streets lined with spectators estimated at 20,000. Some were just curious, but most cheered and many carried signs, handmade and otherwise."

JFK's caravan consisted of police and sheriff cruiser escorts—a half-dozen cars, including some convertibles—and three buses carrying campaign staff personnel and magazine, newspaper, radio, and television reporters. They passed through South Lorain a few minutes after 3:00 p.m., then "breezed through Elyria at thirty miles per hour." The paper reported a fair-sized crowd in the Ely Park section of Middle Avenue, "swelled substantially by high school students who were on their way home."

At the age of four, I knew nothing about the people who accompanied Kennedy on his whirlwind trip through Elyria. I did not know that the man

Candidate John F. Kennedy in downtown Elyria in 1960. Congressional candidate J. William McCray is seated at right. *Courtesy of the J. William McCray family.*

smiling next to Kennedy in his campaign convertible was J. William (Bill) McCray, an Elyria attorney running as the Democratic candidate for the Thirteenth District. (He did not win.)

Nor did I know that our governor was Michael V. DiSalle or that he and Ohio Highway Safety director J. Grant Keys, Elyria's former mayor, were often at Kennedy's side; both of them were present that September day.

With the help of her daughter, Kim McCray LeMaster, I interviewed Bill McCray's widow, Peggy McCray, by email.

"My mom has always said that Kennedy's presence 'took her breath away.'" Kim wrote. "She said there was such a hush over the George Daniel Stadium when he entered. She said he was more handsome in person."

Asked about the most memorable part of the day, Peggy replied through her daughter that her husband, who died in 2012, told her that the ride from the stadium to Elyria "was intense. JFK's press secretary handed JFK a sheet of paper…which JFK speed-read—gave back to him—[and] sternly said, 'I want this changed—I want an answer on that—and I want it now!'"

The Thirty-Fifth President

John F. Kennedy did not win Ohio and its twenty-five electoral college votes on election day, although he triumphed in Lorain, Cuyahoga, Summit, and seven other counties. Of the 82,848 Lorain County citizens who went to the polls, 43,487, or slightly more than 52 percent, cast their ballots for JFK. And while Richard M. Nixon might have won the state, it was JFK who became president. As of 2019, this would be the last time a candidate would win the presidency without the crucial state of Ohio.

At forty-three, Kennedy was the youngest person ever elected to the presidency, the first to be born in the twentieth century, and the only Catholic, which meant something to my mother and me.

When I was a child and thought about who was living in the White House, I naturally thought of the Kennedy family. I was too young to remember Dwight Eisenhower. And I was too sad about the manner in which Lyndon Johnson ascended to office to imagine him as president. No, it was Kennedy—and the "brief, shining moment" of his Camelot presidency—who represented the golden years of my childhood. Like many baby boomers, I identified with his daughter, Caroline; she was just a couple years younger than I. Her baby brother, John-John, was born soon after his father was elected president. Having such young children living in that grand house seemed natural and right to me. I loved hearing about Caroline and seeing pictures of her in *Life* magazine with her pony, Macaroni. I played with Caroline Kennedy paper dolls. I sat in a child-sized Kennedy rocking chair. And somewhere in our house was that plastic straw hat.

The time it took me to tend to the business of being a child eventually led me to stop paying so much attention to the occupants of the White House. I might have been aware of tension and worry in our home in October 1962, during the Cuban Missile Crisis, but since I was only six, I cannot say with certainty whether I discerned the difference between daily-life worry and worry about the world at large. I do remember that the television was tuned to the news more often than was usual and that the president seemed to be talking to us through our television set more often, but I had no idea what any of it was about.

I was in the second grade on November 22, 1963, when I was forced to pay attention.

Like most American children, when the news reached me, I was sitting at a school desk. Our principal, Sister Mary Vaune, interrupted our afternoon lessons to announce over the public address system that President Kennedy

had been shot. She asked us to pray for him. The first image that greeted me when I reached home was that of my mother trying to prepare dinner. The news was on the television. She was crying.

What Might Have Been

Peggy McCray's reaction to JFK's assassination "was one of utter disbelief," according to her daughter Kim. "She was very pregnant with me. My brother was home sick from school that day, and she was riveted to the TV, waiting for someone to say it did not happen. The following Sunday, they went to church, and it was packed."

John F. Kennedy was only forty-six years old.

Katie Keys is the tenth of Mary and J. Grant Keys's twelve children and was an infant when JFK came to town. She told me that her father—who served on the security detail for Kennedy's inauguration in 1961—would have had a rather different career had Kennedy not been killed.

Members of the J. Grant Keys family watch JFK's campaign motorcade on Middle Avenue. This photograph also appears on the back cover. *Courtesy of the J. Grant Keys family.*

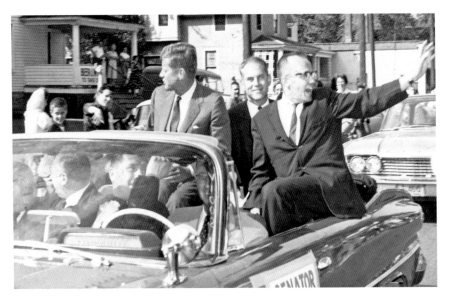

Accompanying JFK on his swing through Elyria, J. William McCray waves to supporters on Middle Avenue in front of Daly's Carry Out. *Courtesy of the J. Grant Keys family.*

The president wanted Keys to serve as the Ohio chair of his reelection campaign. Because final plans were being worked through on the day the president was shot in Dallas, the request never arrived.

Katie showed me a letter that her godfather, former Ohio governor Michael DiSalle, sent to her parents. Chairing Ohio "was something I had wanted for you for a long time," DiSalle wrote on January 17, 1969. "It is unfortunate that it got caught up in that tragedy."

Instead, Keys was appointed Lorain County treasurer in 1963, an office he successfully held through campaign after campaign for nearly twenty-five years. When he retired in 1986, the Lorain County Administration Building, which was built in 1974, was renamed in his honor.

It is human nature to wonder about other might-have-beens. Would the war in Vietnam have played out differently? Would fewer lives have been lost? Would there have been a Watergate? What other myriad ways might John F. Kennedy have made a difference—ways that might still be affecting us today?

Kennedy gave countless speeches during his truncated political career, but those of us who grew up with Caroline and John-John would surely remember the one he gave on January 20, 1961, with his famous and oft-quoted exhortation: "Ask not what your country can do for you. Ask what you can do for your country."

On the eve of the third anniversary of Kennedy's assassination, the *Chronicle*'s Russ Davies wrote that although he did not share the same religious faith or political persuasion as the president, he believed "that had JFK lived to have completed his term, he would have been re-elected and eventually would have gone down in history as one of the greatest presidents in our country's history."

Selected Bibliography

In addition to archival newspaper articles from the Chronicle-Telegram *and the indispensable Mullin-Kille Elyria City Directory for 1963, I found the following sources useful*:

Abramson, Albert. *The History of Television, 1942 to 2000.* Jefferson, NC: McFarland & Company, 2003.

Alfred, Randy. "March 10, 1876: 'Mr. Watson, Come Here….'" *WIRED*, March 10, 2011. www.wired.com.

"Alltel Corporation." *International Directory of Company Histories.* Last modified August 27, 2019. www.encyclopedia.com.

Associated Press. "Moratorium: Protests and Flags," October 16, 1969.

Ayn Rand Institute. *"Night of January 16th."* Novels and Works of Ayn Rand. www.aynrand.org.

Barry, Dan. "At the Corner of Hope and Worry." *New York Times*, October 13, 2012.

Bibler, Frank. "Top Rated Programs." fbibler.chez.com/tvstats/ratings-us.html.

"Billboard Top 100 Songs." billboardtop100of.com.

Bird, William L., and Robert R. Ebert on behalf of the Lorain County Historical Society. *Elyria.* Charleston, SC: Arcadia Publishing, 2014.

Brady, Dan. "The Old Fire Truck in Cascade Park-Part-2." *Brady's Bunch of Lorain County Nostalgia* (blog), March 24, 2017. danielebrady.blogspot.com.

Broadway World. "Broadway Shows by Year." www.broadwayworld.com.

Burns, Ken, and Lynn Novick. *The Vietnam War: A Film by Ken Burns and Lynn Novick.* Aired September 17–28, 2017, on PBS. www.pbs.org/show/vietnam-war.

Case, Weldon W. "Alltel Corporation: Twenty-Five Years of Growth and Dedication to Excellence." New York: Newcomen Society of the U.S., 1985.

Click Americana. "The Rotary-Dial Telephone and How We Use It (1951)." clickamericana.com/eras/1950s/rotary-dial-telephone-use-1951.

Davis, Connie. *The Way We Were: A Selection of Columns by Connie Davis, with Pictures.* Elyria, OH: *Chronicle-Telegram*, 1993.

Easterseals Northern Ohio. "History." www.easterseals.com/noh/who-we-are/history.

Elyria Historic Book Committee. *Elyria—175 Years: Commemorating the 175th Anniversary of the Settlement of the City of Elyria and the 125th Anniversary of the City Hall.* Marceline, MO: Heritage House Publishing, 1992.

Encyclopaedia Britannica. "Dewey Decimal Classification." Last modified July 12, 2007. www.britannica.com.

Encyclopedia of Cleveland History. "Blinky Morgan Case." case.edu/ech/.

Hanley, Robert. "Direct Long-Distance Dialing in 26th Year." *New York Times*, November 11, 1976.

Hansell, Saul. "Weldon Case, 78, Former Chairman and Chief Executive of Alltel." *New York Times*, October 8, 1999.

Hartley, Malcolm D. "Peace Will Be Our Victory." *The Journal*, October 15, 1969.

Hendricks, E.L. *Floods of 1959 in the U.S. Geological Survey.* "Floods of January–February 1959 in Ohio and Adjacent States." Washington, D.C.: U.S. Department of the Interior, 1964.

History.com editors. "Vietnam War Timeline." Last modified February 22, 2019. www.history.com.

Immerwahr, Daniel. "The Books of the Century." www.ocf.berkeley.edu/~immer/booksmain.

Internet Movie Database. www.imdb.com.

John F. Kennedy Presidential Library and Museum. "Campaign of 1960." www.jfklibrary.org.

The Journal. "Vietnam Moratorium." October 15, 1969.

Leip, David. "1960 Presidential General Election Results—Ohio." U.S. Election Atlas. uselectionatlas.org.

Lev, Peter. *History of the American Cinema: Vol. 7: Transforming the Screen: 1950–1959.* New York: Scribner, 2003.

Lewis, Jerry M., and Thomas R. Hensley. "The May 4 Shootings at Kent State University: The Search for Historical Accuracy." Published in revised form in the *Ohio Social Studies Review* 34, no. 1 (Summer 1998): 9–21. www.kent.edu/may-4-historical-accuracy.

Lorain County Commissioners. "Black River Watershed Project." www.loraincounty.us/blackriverwatershed.

Lorain County Metro Parks. "Cascade Park." www.metroparks.cc/cascade-park.php.

"Luke Easter's Career and Murder in 1979." *Misc. Baseball* (blog), December 16, 2010. miscbaseball.wordpress.com.

Mancine, Benjamin J., and Anne Fischer Mancine. *Elyria in Vintage Postcards.* Charleston, SC: Arcadia Publishing, 2004.

National Archives. "Vietnam War U.S. Military Fatal Casualty Statistics." Last modified April 30, 2019. www.archives.gov.

New Democratic Coalition of Lorain County 1, no. 8, September 1, 1969.

New York Times. "Lila Lee, 68, Dies; Silent Film Star." November 14, 1973.

Novak, Mary Ann. "8mm Film Available in 'Mini' Circuit." *Ohio Libraries Newsletter of the Ohio Library Association* 1, no. 3 (December 1970).

Price, Mark J. "Local History: Death Stalks Corridors of Boston Heights Hotel in 1967." *Akron Beacon Journal*, November 12, 2012. www.ohio.com.

Reference for Business. "History of Alltell Corporation." www.referenceforbusiness.com.

Rich, Marci. "Miss Foreman, Grade Two, November 22, 1963." *The Midlife Second Wife* (blog), November 19, 2013. themidlifesecondwife.com.

———. "Where I Come From." *The Midlife Second Wife* (blog), October 14, 2012. themidlifesecondwife.com.

Roberts, William Lee. "A Look at the Evolution of the Dial Telephone." www.arctos.com/dial/.

Sager, Donald J. *Binders, Books, and Budgets: A Short History of the Elyria Public Library, 1870–1970.* Elyria, OH: Elyria Public Library, 1970.

Savage, Jon. *1966: The Year the Decade Exploded.* London: Faber & Faber, 2015.

Schatz, Thomas. *Boom and Bust: American Cinema in the 1940s.* Vol. 6 of *History of the American Cinema*, edited by Charles Harpole. New York: Scribner, 1997.

Sherman, Thomas Fairchild. *A Place on the Glacial Till.* New York: Oxford University Press, 1997.

Silent Hollywood. "Lila Lee." silenthollywood.com.

Thomas, James B. *Down Through the Years in Elyria.* Oberlin, OH: Oberlin Printing, 1967.

Toledo Blade. "Last President Who Didn't Win Ohio." February 15, 2016. www.toledoblade.com.

The TV IV. "Nielsen Ratings/Historic/Network Television by Season/1950s." Last modified August 23, 2019. tviv.org.

UPI. "Mid-Continent Telephone Co. of Hudson and Allied Telephone Co.," July 1, 1983. www.upi.com.

U.S. Inflation Calculator. www.usinflationcalculator.com.

"The Vietnam Veterans Memorial of Lorain County, Ohio." www.facebook.com/LorainCountyOhioVietnamMemorial.

The Virtual Wall. "Vietnam War Casualties from Ohio." www.virtualwall.org.

Whitburn, Joel. *Joel Whitburn's Top Pop Singles 1955–1986.* Menominee Falls, WI: Record Research, 1987.

Wilford, Frank. *Cascade Park: Elyria's Beautiful Natureland.* Facsimile of the first edition published by the Elyria Park Commission in 1936. Elyria, OH: Friends of Cascade Park, 1996.

Windstream. "Company Timeline." news.windstream.com/history.

Index

About the Author

Marci Rich, age two and in period costume, in her father's Cadillac for Elyria's quasquicentennial parade, August 1958. *Author's collection.*

Marci Rich has published poetry, essays, and journalism, and earned honors from organizations and publications as varied as the Academy of American Poets, the *Abiko Quarterly for James Joyce Studies* (Japan), BlogHer, *Huffington Post*, and the Press Club of Cleveland, from which she has twice won Best Freelance Writer in Ohio awards in its All Ohio Excellence in Journalism competitions in 2018 and 2019. The latter awards recognize her local history feature series, "Look Back, Elyria," which she writes for the *Chronicle-Telegram* and which forms the basis of this, her first book.

A graduate of Oberlin College, where she earned a bachelor of arts degree in English with a creative writing specialization, Marci has also studied memoir writing at the Fine Arts Work Center in Provincetown, Massachusetts. She also earned an associate of arts degree from Lorain

County Community College. She is a member of Phi Beta Kappa, Phi Theta Kappa, the Authors Guild, the National Society of Newspaper Columnists, the Press Club of Cleveland, Literary Cleveland, James River Writers, and the Lorain County Historical Society. A chapbook of her poems, *Lights and Shadows*, was published by Bottom Dog Press in 1985 under her former name, Marci Janas. She started writing this book in the Cleveland suburb of Rocky River, Ohio, where she lived with her husband, John, and their Cavalier King Charles Spaniel, Sandy. By the time she had finished writing this book, they decided to return to Lorain County. Follow her on Twitter at @marcirichwriter or visit her website at www.marcirich.com.

Visit us at
www.historypress.com
...